Xaviera Meets Marilyn Chambers

Xaviera Meets Marilyn Chambers

by

Xaviera Hollander

and

Marilyn Chambers

BearManor Bare

2019

Xaviera Meets Marilyn Chambers

For information, visit:

BearManor Bare

www.bearmanorbare.com
Facebook: https://www.facebook.com/BearManorBare1/
Twitter: twitter.com/bearmanorbare

Typesetting and layout by John Teehan

Published in the USA by BearManor Media

ISBN—978-1-62933-470-7

Foreword

I was happily surprised to meet such a sweet and frivolous young slender woman I had only known from her soap announcements as Miss Clean…

Little did I know that she was also the same wild porno actress from *Behind the Green Door* until our mutual lawyer Paul Sherman introduced the two of us to each other and proposed for us to write a fun and sexy book together.

I was, at that time, staying in one of the most fun, quite gay oriented hotels in Toronto Canada, having just left the USA a few months earlier—The Carriage House Hotel.

I may not have had a Happy Hooker empire anymore but I was still quite active in the sex scene of Toronto which was quickly becoming the Gay city of Canada. The Carriage House Hotel offered me quite a few chances to meet all sorts of sexy people.

I even became the steady judge for the transvestite parties where I usually picked the most beautiful and most feminine girly transvestites—not to be confused with transsexuals as the purpose was to stick to men who wanted to be girls, but had nothing fixed yet.

It was a surprise to meet the fresh and spontaneous porno star Marilyn Chambers who wanted to dedicate this book to Chuck Traynor. This went a bit too far to my taste.

At least there was a pretty sharp contrast between Marilyn's submissive, basically sweet personality and my own rather dominant and totally independent personality. There is a saying in French that goes "*les deux extremes se touchent,*" meaning two opposites who attract each other. We soon got along like a house on fire!

Enjoy this book filled with fun and sexy intermezzos between two sex goddesses of the 20th century.

The happy hooker and Marilyn chambers.

Love,
Xaviera
www.xavierahollander.com

Marilyn Chambers sat looking out of the window of the American Airlines jet, staring into the stark white fluff of clouds. It was June, the start of summer, and from all she'd heard, Canada was going to be beautiful. She pictured Toronto as being peaceful and quaint, a place to have a real vacation. She knew her films had not yet played Canada, and there was a sense of relief in that—maybe she could have one complete week in which she would not be recognized.

Marilyn had just finished nearly a year's run in the play *The Mind with the Dirty Man* at the Union Plaza Hotel in Las Vegas. All the tourists who'd seen her movies thronged around the stage door each night, and the new fans she'd gained by doing the play recognized her in the casinos and the hotel lobby. Even when playing tennis at the Las Vegas Racquet Club she was never unrecognized. She'd loved every minute of it, but the trip to Toronto seemed the perfect chance to be incognito for a few days, and she looked forward to that "vacation."

The send-off at the airport was typical of the life of any star—fans, who had spread the word she was leaving, gathered around her until she almost missed her flight because she was signing autographs. A young man had walked up -to her and stared—first at her breasts, which were barely concealed under a crocheted halter top, then at her face. Then his eyes lit up as he realized who was standing in front of him. "You're… you're Marilyn Chambers!" he said, his voice suddenly higher than normal. "I saw your films!"

1

Two of his buddies who'd been standing far behind him moved closer, wondering if he was *really* talking to…

"I hope you liked them," Marilyn said.

"Oh, wow! *Behind the Green Door* knocked me out!" His voice had lowered a few registers, and he was obviously excited. "I just read your story in *Penthouse*…" He reached into his travel bag to pull out the issue of the magazine.

Marilyn hadn't seen it. "I didn't even know it was out yet!" He opened it to the page where her book, *Marilyn Chambers: My Story*, had been excerpted. She smiled when she saw the picture of herself sucking on a Popsicle.

"Man, that story is hot!" one of the other boys said. "Can I have your autograph?"

"Sure," Marilyn said, as the kid pulled out a pen. She figured he couldn't have been a day over sixteen—how had he gotten into a theater to see her movies? She signed her autograph on the back of his plane ticket folder.

"Me, too," the young man with the copy of *Penthouse* said. And Marilyn signed the Popsicle picture. She glanced down and thought for a second that the young boy was getting a hard-on—the front of his jeans had a conspicuous bulge they weren't sporting before.

"What are you going to do next?" the kid asked Marilyn.

"I'm leaving for Toronto right now. I'm going to be doing a book with Xaviera Hollander."

"You mean, the girl who wrote *The Happy Hooker*?"

"Right!"

"My God," gasped the boy, "that's gotta burn up the paper before they get it into type!"

Marilyn laughed and said, "We're taking three or four fire extinguishers along…"

"Marilyn, come on, they're boarding us now." The voice belonged to her manager, Chuck Traynor. He pushed through the group of fans, carrying Marilyn's suede travel bag and his own leather travel case. Taking her arm, he led her away from the people and into the 747.

"Marilyn, what's Xaviera like?" a voice called out.

She turned and looked at the man who'd asked it. "I've been wondering exactly the same thing!" She giggled and then waved goodbye to them.

And now, just thirty minutes from Toronto, she was still wondering what the famous Ms. Hollander would be like. Everyone she talked to seemed to have an opinion about Xaviera when she told them that they had decided, by a mere phone call, to spend some time together and write about it. Now she seemed to remember only the unfavorable remarks. "She'll cut you up!" a man in publishing had told her, but he worked for a rival firm that had wanted to publish Xaviera's book, so she wasn't sure where his words were coming from. "You're crazy to do a book with her." another man said. "I've heard no one *survives* doing a book with her."

"But no one's really done a book *with* her before," Marilyn had reminded him. "She's had a co-author only with her first book; all the other books she did by herself. This is a joint effort." She stressed the word "joint" and that seemed to please the man and make him forget his opposition to Xaviera.

What did she really think herself? She was looking forward to capturing their meeting on paper. It would be an interesting experience, something very different in her life. She wanted to meet Xaviera because she was a famous woman who seemed to have lived a fascinating life. Obviously she was curious to find out for herself just what she was like. She hoped the tales of Xaviera-the-Bitch had all been told out of jealousy. Marilyn knew from her own experience how jealous people could be.

She turned from the window. "Chuck, wouldn't it be great if we really got along, if we turned out to truly like each other?"

"You still worrying about that?" Chuck closed the copy of *Xaviera Goes Wild* he had been reading. "What does it matter? It would be kind of controversial if you hated each other."

"But we've gotta work together all week!"

"Judging from this," he said, looking at the book, "she's gonna be something else."

"That's just what I'm worried about," Marilyn said with a rueful smile.

Xaviera Hollander was sitting beside the pool at the Four Seasons Hotel on Jarvis Street in the heart of Toronto. An acquaintance from New York was sitting next to her on one of the lounge chairs. She asked him for the suntan oil, and when he handed it to her she looked at him and said, "I have the strangest feeling she's going to turn out being nothing but a dumb little porno *cunt.*"

"Give her a chance," her friend said.

"Of course I'll give her a chance. Why not? But, honey, everybody's been telling me, 'Xaviera, don't do that book with that silly girl. You are a well-known author. You don't need anyone else's help. Xaviera, you're crazy to do anything with a person who does nothing but giggle and wiggle her naked ass in front of a camera.'"

"So what are you doing this for? Why the hell are you doing a book with her?"

Xaviera closed her eyes and let the sun envelop her. "Well, somehow I like the idea of two sensuous women, sex symbols of the Seventies, comparing views and ideas. People like to read that kind of thing, no? Sure they do." She paused and bit her finger.

"What's wrong?"

"I only hope the publishers will allow us to talk and write about emotional relationships and feelings as well as sex in this book."

"You mean, it's not just another fuck/suck book?" he laughed.

Xaviera grinned and opened her eyes a bit. "Well, fuck/suck will never go out of style, but there has to be more than just that. Because sex books without a good story can be very boring. Somehow publishers don't want to hear about sentimental feelings, at least not in my books. They say the public doesn't want to read about how much I loved my father and how sad I was when he died. All they want is fucking and sucking. I think they are wrong. I am a human being and not a sex machine. I am entitled to show my human side as well as the sexy part of life. Huh?"

"What kind of book is this one going to be?"

Xaviera laughed. "Who knows? Maybe Marilyn knows. No, she doesn't know, either. After all, I have the writing experience, and she's just a beginner. I think it will be like cinema-verite, you never can tell what's gonna happen next, right? I have a pretty good idea what subjects I want to cover in this book. Marilyn Chambers sounded pleasant when I talked to her for a few minutes on the phone, but from there our lawyer took over. We have the same lawyer, of all things. Of course, I can't tell how bright she is from one short phone call."

"Did you read this?" her friend asked, picking up the same copy of *Penthouse* that Marilyn had just seen so many miles away.

"Yes. Not bad. Very horny, actually. But I still think she's going to be nothing but a dumb little porno actress. Oh, well, I'll find out tonight. Want to swim?"

Howard Kaminsky, President of Warner Books, waved to Xaviera from the doors of the hotel. "Hey, Xav," he called, walking toward her, loosening the tie around his neck with one hand.

"Hello, Howard," Xaviera said as he leaned over and kissed her hand.

"Xav," he said, shortening her name to tease her, setting down his briefcase, "good to see you. I'm gonna take a swim and then we'll talk business. You met Marilyn and Chuck yet?"

"No, I got a call that they're coming up on a later flight."

"They'll meet us for dinner," another voice said. Xaviera turned to see Gene Light, Warner's art director, and his lovely wife, Marilyn, standing behind her. "Hello, Xaviera," Gene said, "haven't seen you in a long time."

"Hi!"

Gene introduced *his* Marilyn and they all sat around the pool for a few minutes to get acquainted, before they changed into their bathing suits. "So, what's on the schedule?" Xaviera asked.

"Photo session tomorrow morning," Gene said. He explained that Neil Slavin, the photographer who was going to take the cover photo for the book, would be joining the group for dinner that evening also.

"And the rest is up to you and Marilyn," Howard said. "You just do whatever you want, go wherever you want, but make sure you get it all down on tape so you won't forget any of it."

"Tell me, Gene," Xaviera said, "what's the cover shot going to be like? What kind of pictures have you got in mind?"

When Xaviera entered the restaurant that evening, she was most interested in Marilyn Chambers, the girl she'd only read about and talked to briefly on the phone. Xaviera was dressed in a clinging peach-colored outfit, a long skirt, slit to her thighs on the side, and a halter top. It was elegant, perfect for a summer night, and very, very sexy. Her breasts pushed against the halter—and Marilyn looked at her cleavage first, then up at her eyes.

Marilyn was wearing a denim pants suit that fitted her perfectly where it counted, with a blue jacket that highlighted her blue eyes. On her head she wore a big, floppy hat, to match her suit.

"My God," Xaviera said, "your photographs don't do you justice, you are much prettier in person!"

Marilyn smiled, shyly. "You look wonderful," she said softly. She thought Xaviera looked terrific, much sexier than she'd anticipated, much softer, too, very womanly. Some of the apprehension seemed to disappear as they all sat down at the long table. Xaviera sat right across the table from her. Marilyn couldn't help but admire Xaviera's tan—it was deep and made her look even more attractive. And her breasts, they were so firm, and so big…

Xaviera was talking to everyone at once. She knew most of the publishing people present, since they had published some of her previous books. She was used to crowds and people, and she naturally took the spotlight, which Marilyn liked. Marilyn dug strong women, women who are always "on." Xaviera had a great flair and the words just flowed from her sensuous mouth. The men seemed fascinated by her.

During dinner Xaviera got along fine with Marilyn. This silly little girl wasn't so silly and giddy after all. She seemed almost reserved and very charming. She didn't say much—Marilyn is very quiet when she's with people for the first time—but there was some-

thing about her, something in the back of her eyes, that told Xaviera she could really loosen up and be fun.

Xaviera had suggested one of Toronto's most exclusive restaurants for dinner. It proved a great choice indeed. The dinner was a success. Howard Kaminsky proposed a toast to the meeting of Marilyn and Xaviera, and all ten people seated there clicked their glasses together. There must have been a waiter for every person, and the food kept coming, course after course. Vichyssoise and Caesar salad, crab and lobster cocktails, never-ending platters of pheasant, lamb, and duck, asparagus, squash, every sort of vegetable with wine and cheese sauces, and enormous desserts of chocolate mousse, peach Melbas, crepes Suzette and fresh strawberries. And, through it all, many bottles of the finest wine in the cellar made the rounds at the table.

Coffee was finally served and everyone realized it was way after midnight—it had been one of the longest dinners on record. The headwaiter gave the ladies each a red rose and everyone was given a booklet of matches, imprinted simply, *Ms. Xaviera*. When Howard was brought the check, he seemed pale for a second, but quickly recovered. After all, it had been a successful "launching" of the book—Marilyn and Xaviera were getting along fine.

A few moments later, when Xaviera was deep in conversation with Howard about the success and sale of her other books with Warners, Marilyn whispered to Chuck, "You know what? I really dig her!" She didn't need to tell him that, he aheady knew just by the way she looked at Xaviera. "I think I'd really like to get it on with her!"

Chuck put his hand on hers. "Take it easy, Marilyn," he said, "remember you two are supposed to do a book together. That's why we're here."

"Well, why can't we do both?" Marilyn giggled. Chuck just shrugged. He actually thought it was a great idea, but there wasn't time to think about something like that. They had work to do, and only four days to do it in. "She's got great boobs," Marilyn said. She could see Xaviera's prominent nipples through the soft material of her halter.

"Hey," Chuck whispered, "you haven't found out if she's the bitch you were worried she'd be."

"I'm not talking about her being a bitch," Marilyn said softly, "I'm talking about her being sexy."

Xaviera and Howard were talking to the photographer, Neil, about the photo session the next morning. Xaviera looked across the table to Marilyn and said, "They want us naked together in front of the camera. How about that?"

Marilyn purred. "That's fine." She felt a shiver of excitement run through her.

Xaviera rested her head in her hands. "I think this is going to be fun," she said, her voice loaded with overtones and with a twinkle in her eyes.

"I'll drink to that," Howard said.

In the lobby, as they said good night, Howard told Neil to give Xaviera the address of the studio—she would meet the rest of the group there the next day. While the others began to disperse, Gene Light, who'd been a friend and associate of Howard's for many years, pulled him aside and said, "I saw your face blank out there when you looked at the tab. How much, just for the hell of it?" .

Kaminsky didn't speak. He pulled his American Express receipt out of his pocket and showed it to Gene. "Hmmm," the art director said. "Ten people, four hundred dollars, that's forty a person. Well, the chocolate mousse was out of sight, right?"

Marilyn Chambers fell asleep that night still amazed at how nice a person Xaviera had turned out to be. She felt relaxed and was looking forward to seeing her the next day... in the buff.

They took two cabs to a deserted church, of all places, on an obscure street in a quiet section of Toronto. The church was no longer used for services, but for gatherings of any kind; bowling league parties, bingo, folk-dancing, weddings, and now even photo sessions with nude girls. "Oh, wow," Marilyn said, walking into the cavernous structure, "this is something else!"

That was everyone's opinion. There was even an electronic organ—left over from the dance the night before?—sitting in one corner, and someone turned it on and plinked out a tune while Marilyn found a small space that was supposed to be their "dressing room." She found the idea of a dressing room funny, for she'd brought only the clothes she was wearing, and one dress. She knew it was going to be mainly a nude session—the way she liked herself best.

No one had really talked about what to wear. Gene had told Xaviera the night before to bring along a few things, and she did—she entered the church with two suitcases full of gowns and pants and tops. "I couldn't decide what to wear," she explained as she entered, looking as though she were about to board a plane, "so I brought half my closet!" She laughed and showed her sparkling white teeth, and everyone felt at ease.

Neil set up the lights and the backdrop, and Gene sketched a fast drawing of what the cover would look like. "Lots of hugging," Gene said to the girls, smiling. "And maybe one of you kissing?"

"Gene, you're so horny this morning! Where is your wife?" Xaviera said, taking her pile of costumes into the dressing room.

9

Gene called after her: "Sleeping and shopping, she'd be too jealous seeing me with the two of you."

"How do you want us first?" Marilyn asked Gene.

"First the dressy ones," Gene said.

"You mean the boring ones," Marilyn joked.

Gene just nodded. Marilyn walked into the dressing room and Xaviera held up two dresses. "Which one do you think would look best on me?"

"I think that one," Marilyn said, pointing to a lovely salmon-colored dress.

Xaviera hung the salmon-colored gown on the door and tossed the other on the table. Then she pulled her light sweater over her head and revealed her firm breasts barely covered by a flesh-colored bra. Marilyn stared. "I sometimes wish I could wear a bra, just to see what it feels like," Marilyn said.

"Oh, no," Xaviera replied, "you have beautiful breasts, the kind that shouldn't be covered by anything."

"Thanks," Marilyn said, sitting down on a stool, undoing her faded patchwork jeans while she sipped a mug of coffee.

"Last night was very nice," Xaviera said.

"I know. I was really worried about meeting you."

Xaviera smiled and said, "Why? Did you think I would be some kind of cold bitch?"

Marilyn smiled and nodded. She wondered if she could bring herself to tell the truth… ?

'Now, you must tell me what you were expecting!" Xaviera prodded her. "And I'll tell you what I had anticipated. Let's be honest."

Marilyn said, "I had a preconceived idea. I thought you'd be a tough cookie. I figured, man, she's gonna be some real nasty chick. I was convinced that you would play up the snotty celebrity!"

"Hmmm," Xaviera murmured, with a wry smile "Were you scared?"

"No, I wasn't scared."

"You thought you could handle me, hey?" Xaviera drew her feet up and wrapped her arms around her knees, sitting like a caged ti-

ger, looking at Marilyn with fascinated eyes. Marilyn seemed a bit apprehensive for a moment about being so up-front and open. She continued, but avoided Xaviera's knowing eyes.

"Yeah… well… I mean if you came on like gang-busters and played the Super Bitch role, I would just clam up and walk away. See, I'm very submissive, in any situation. I wouldn't open my mouth if I thought you were a real bitch. I don't try to provoke people or get them mad at me. I hate arguments. I would rather just sneak away. I go into things with an open mind, all the time, but in this case, from all that I'd read and heard, I just couldn't help but think of this image of Xaviera sitting on some kind of throne, with an imaginary whip in her hand—to me that was a little exciting, of course. But then I guess you probably think I'm nothing but a dumb cunt."

"Um-hum," Xaviera said with a smile. "Some kind of nitwit."

"Yeah. I wanted to appear demure and subdued, you know, the nice little chick, when I met you, so when we met at dinner last night…"

"To begin with, my apologies," Xaviera interrupted, "I was late! That isn't the best way to start off a friendship, much less a book!"

"You know what surprised me more than anything? How much smaller you were than I thought you were going to be. Of course, pictures always do that to anybody, I should know that by now, but it really hit me. You weren't ten feet tall!"

"I hope that didn't disappoint you!' Xaviera said. "You're right, photographs do that. Mae West is a giant in photos, but in life, she is a tiny little thing. Same with Barbra Streisand. You saw Roger Daltrey in *Tommy*? He's short. Absolutely short. On screen he looks like he could touch the moon. Anyhow, after you saw I was fife-size, five feet six inches, what did you think?"

Marilyn turned away and blushed.

"Come on, the truth now," Xaviera prodded.

"Just like that, right off the bat? Well, I had heard…"

"I can imagine what you heard. Don't tell me. What I liked was that you kept complimenting me, saying I looked like twenty-five, and that flattered my ego. Particularly because my birthday is this

coming Sunday and your remark was good to hear before I gained another year." Xaviera smiled and stretched her legs out again. She was relaxed.

Marilyn blinked and said, softly, "I hope you'll have a happy birthday."

"Thanks," Xaviera said. Already there was a bond between them. They felt it, and it would continue through the photo session—even be caught on camera—and through the next few days together. It was a kind of energy which seemed to grow and grow every moment they spent together.

Marilyn continued. "I had figured you were going to look much harder and older. I really did. Kind of lived-up, you know. But you looked so young and fresh and sexy. I thought that was really far out, especially because you hardly wore any makeup last night and then your great suntan made you look so healthy! Anyone who doesn't smoke or drink has got to be healthy." It was true—while all the wine-glasses were topped up with *vino,* Xaviera's had been filled only with orange juice. "Besides, you were so so alive and bubbly." Marilyn said. "Oh, God, I guess I should be cutting you up and saying I can't stand you—doesn't that make for more interesting and controversial reading? This is a book, after all. But the truth is, I liked you right away."

"I don't know if it makes it more interesting," Xaviera said. "I think it actually cheats the reader if you say *I can't stand her,* when you don't mean it."

"It's like those terrible gossip columnists. They feel they have to write bad things only because theirs is a gossip column in some rag, right?"

"Exactly. So we tell the truth, whether it's hatred or love." Xaviera paused for a moment. "So, to be honest with you. I had read about you and seen you on the soap box, but no one had shown me a good picture of you. I was intrigued. I wanted to know what this little dish was really like! I am afraid I never saw your porno pictures, because here in Canada they don't—"

"They don't allow hardcore flicks in this country?" Marilyn exclaimed.

"You're right," Xaviera explained, "we're rather open-minded here, but still a bit Victorian when it comes to sex in books and movie theaters. So your films have not played here yet."

"But you read my book," Marilyn said. "You wrote to me and said you liked it. Didn't you see all the photos in there?"

"No! Howard Kaminsky had sent me the galley proofs only. I haven't seen it in its finished form."

Marilyn reached into her bag. "Here, this is for you!"

Xaviera looked at the book and smiled. "So, this is what it looks like… nice cover. Did Gene do it?"

"Yes," Marilyn said, "and Chuck took the cover shot. Here, I'll inscribe it to you." She pulled a pen out of her bag and inscribed: *To the Happiest Hooker I Ever Met, Love, Marilyn XXX.* She handed it to Xaviera, who pressed it against her breasts.

"The only picture I have of you is the one in *Penthouse*, where you're sucking the lollipop, or was it a Popsicle?" Xaviera explained. "I thought… well, she's fine, a horny-looking young chick. You fitted the description I'd had in mind of you. I had seen lots of pictures of Linda Lovelace, and I figured—"

"God!" Marilyn exclaimed, gritting her teeth. "Everyone compares me to Linda Lovelace. It's ridiculous!"

Xaviera explained, "You can't help but know Linda Lovelace in Canada, because her terrible R-rated movie played here. She was here to promote it, so her face was just about everywhere in the papers and on TV. I figured, well, Chuck Traynor must have improved, that you had to be better than Linda Lovelace. I had heard a lot about Chuck."

"Really?" Marilyn seemed very interested.

"Sure. Well, obviously, we both have the same lawyer, Paul, and he had talked about Chuck more than you. When I asked him to cut out all the business talk and tell me about Marilyn, he said you were a nice girl, an All-American cutie-pie."

Gene called in to them, "In a few minutes, ladies. All right? We're nearly ready out here."

"Okay, fine, we're dressing," Xaviera called out to him.

Marilyn slipped her blouse over her head and exposed her young breasts to Xaviera's view. "Umm, you have fine nipples," Xaviera said. Marilyn smiled and said, "Yes, they're hard because it's so chilly in here."

"Have some more coffee?" Xaviera reached down to put on her open shoes.

"No, I've had enough," Marilyn said. She put on a little see-through shirt. "Are most hookers intelligent?" she asked.

"Well," Xaviera said, looking up, "I've met quite a variety of them. Some smart, but unfortunately most of them are not too bright, and they're very gullible, too. However, I did talk to Margo St. James, the editor of *Coyote,* a magazine for the 'working women'—that is, prostitetes—of America. She's an ex-hooker, bright and fanatic, and she'll fight for the rights of the American hookers. They even had a strike of French hookers this year, who took refuge in a church. You see, even prostitutes seem on the way to become some day a more 'accepted' profession. I usually refuse to participate in discussions on the subject of *legalizing* it, because it has been so many years since I was actively involved. Then, too, I've had some problems with this government and it is better to keep a low profile. But as far as I am concerned, it is a victimless and complaintless crime, provided we are talking about good, honest hookers. Like any profession, there might be some dishonest people amongst all of us!

"I've not met many porno actresses, but one figures it as a rather dumb profession. I mean usually the more intelligent women don't become hookers and porno actresses. They hook themselves a rich husband! So, I should admit, I didn't expect you to be a very 'brainy' lady!"

Marilyn smiled. "The nitwit, huh?"

Xaviera nodded. "You know, when I saw you at dinner last night, I thought, well, she fits the description I had of her, though you, too, were more petite and fragile-looking than I had thought, and you were very quiet. I didn't quite know what to make of you. But after the conversation got going. I began to like you. And I even

liked Chuck after a while, because I thought I wouldn't, from what I had read in interviews with or about him. I figured here would be this mean, sadistic character, a real creepy manager, an ex-pimp who exploits first Linda and then you through sex movies and rips you off of all your money. I felt sorry for you already. And he turned out to be a hell of a nice guy who means the best for you."

"He is," Marilyn said, sincerely and with love, "he's a really nice guy and he does handle all my affairs for me."

"Ready, girls!" someone called from the other room.

"Well," Xaviera said, "let's give it a try as the happy huggers."

They started out in their dresses, as the camera clicked away. They posed for various shots, hugging and smiling seductively at one another. What happened was interesting—as time went on, the room got charged with sexual electricity. It was more than just a photo session. When Xaviera took Marilyn in her arms, she seemed to mean it, as if the action were real. And Marilyn appeared to tremble with excitement as she felt Xaviera's luscious body pressing up against hers.

When the first set was finished, they shed their dresses and stood naked for the first time, facing each other. Xaviera, curious, looked down at Marilyn's crotch and said, "Oh, you shave!"

"Yes," Marilyn said, almost proudly.

Xaviera looked closely. It wasn't that Marilyn Chambers's pussy was completely shaved—it was sort of landscaped. She had left a small line of soft pubic hair down the center, down over the lips of her pussy. From a distance—to the people sitting at the back of the church—the little thicket of hair looked like a tiny penis. And the hair was a beautiful shade of blond.

"Do you dye it?" Xaviera asked.

Marilyn giggled and said, "Only my hairdresser knows for sure!"

Xaviera laughed. "Well, it looks very pretty!" Xaviera put her arms around Marilyn and let her fingers walk slowly down toward her pussy. *Click.* The camera caught it. Marilyn closed her eyes as Xaviera pressed her lips to her neck. *Click.* Then they embraced each

other, Xaviera's breasts covering Marilyn's, their pelvises thrust forward so the hair between their legs entwined. *Click.* Xaviera brought one hand down to rest squarely on Marilyn's buttocks. *Click.* And Marilyn finally pressed her cheek to ' Xaviera's breasts, her lips just inches away from the standing hard nipple. *Click, click, click.*

All of a sudden, the door opened. Everyone turned to see a man, dressed in a white jacket, holding a tray of coffee cups and a bag of doughnuts. The man, in his early thirties, stood frozen and dumbfounded. He had been told to deliver coffee and doughnuts to the church. That was unusual in itself. But to open the church door and find a group of people sitting around watching two beautiful and very naked women holding one another under a bath of hot lights? That was a complete freak-out! The deliveryman must have thought he was daydreaming. "Jesus," he mumbled as his face turned red, "my wife's never gonna believe this!"

Gene paid him for the coffee and rolls. Then, as the surprised man was about to leave, he turned around to take yet another glance at the two nude women. "Listen," he called, "you ever need more coffee, just call…"

During this coffee break Marilyn and Xaviera each nibbled on a doughnut—Xaviera hardly had a bite—and then they slipped into some other clothes for the next set of photos. Marilyn ran her hands through Xaviera's beautiful flowing hair as the camera caught every movement. "That's great," Neil said. "Take five while I change the set-up. Next we'll do some shots in jeans, bare from the waist up."

"You know," Marilyn said to Xaviera as they sat down on stools at the back of the room, "that was fun." Howard was off in the corner talking to Gene Light about the cover. Neil was changing the flats behind the lights. "It was even kind of erotic," Marilyn said, shyly.

"Umm, yes, it was," Xaviera said. "I like to turn myself and others on, specially this early in the morning when we're all full of energy."

"What's the most erotic time of day for you—night?" Marilyn asked.

"For me, I think… well, a very erotic moment is about three in the morning. I usually go to sleep rather late, around three a.m. Maybe I already made love earlier that evening and I am tired, you know, really beat, and as lam lying on my back with my eyes closed, the lights low or even out, I can still hear music or any other sounds around me, but my body begins to get really light and floating. Physically, my body is already asleep, or practically asleep, and a tingling sensation goes through my arms and legs. Then my man starts eating me, sliding his tongue slowly between the lips of my vagina; I move a little, floating on clouds and half asleep, half aware of what's going on. Then he inserts his penis inside me, slowly, and I feel it moving in so smooth and hard… and deep, and everything tingles and feels so fantastic and relaxed. I'm totally passive, I just receive his gift."

"Umm, yeah," Marilyn said, sucking on her little finger.

"That's the moment when I have my most erotic fantasies. I never fantasize about other cocks and other men. Not with the man I love. Sometimes I simply dream of sliding down the banister, feeling it on my pussy, or climbing up and down a tree. That wood sliding under my cunt, you know, *whizzzzz!* I have dreamed I was a little kid playing with other boys and girls on a seesaw or on a swing, with the wind swishing up between my legs and everytime the wind goes up, my skirt goes up and a beautiful cock goes in."

"I think about lying on a beach sometimes," Marilyn said, tossing her hair back. "I think beaches are erotic, and I'm such an exhibitionist…"

Xaviera interrupted her. "Or lying on the warm dunes near the beach on your stomach, making a hole in the sand with your Venus hill, so the warm sand moves around and warms your cunt, which in my mind is also a warming-up exercise to let the penis enter it once it is moist. I often have wilder, different fantasies that never occur during the daytime, and I seldom recall them, unfortunately. They only seem to happen at that moment of twilight, I guess you can call it, between being awake and dropping off to sleep."

"It's the same for a guy, I think," Marilyn said. "Like when he wakes up, or is just sorta waking up, and he realizes someone is sucking his cock. I prefer to wake up a guy that way, rather than letting the alarm go off. I love to go down on him in his sleep, gently. Most men are hard when they sleep."

"At least when they wake up. But then they usually call it a piss-hard-on." Xaviera looked around. "You know, this is something, no? Talking about this in church?"

"Yeah," Marilyn said, "telling about sexual fantasies." "Do you fantasize, when you're with someone, about that person? Or do you think of others?" "No," Marilyn said. "I think about others." "How about women, do you fantasize about them when you're with a man?"

"Usually not," Marilyn said. "I don't think it's much of a fantasy if you think about the person you're with. That's reality, in my opinion. To be a fantasy for me, it has to be really different from what's happening, really wild. But you can fantasize about your lover doing something else to you, really talking dirty or being mean."

"I sometimes dream about two cocks," Xaviera said, obviously relishing the thought. "I must be somewhat hung up on two cocks. With my man, I sometimes wish I had a cock so we could suck each other. My greatest fantasy—and I lived it out, too—is seeing two or three or four guys suck and fuck each other, different ways, up the ass, in the mouth, leaning forward on all fours, on their knees… standing up."

"Me, too!" Marilyn exclaimed.

Everyone in the church heard her. "What're you two gals talking about?" Howard called to them.

"Never mind, Howard, you just wait and read it," Xaviera said.

Marilyn said, softly, "You said you lived it out. What happened? Tell me!"

"Well, I did get involved in such a scene and had a ball—literally. I lived it out, but I still dig it, it's still a good fantasy. What do they call that? A recollected fantasy, yes, that's it. The excitement doesn't wear off just because you act it out. I have a very dear gay

friend called Serge—he's originally from Dubrovnik in Yugoslavia, where his entire family is still living. Serge is a man of all seasons. He has many talents but prefers to call himself a painter. He paints beautiful portraits and plays a few musical instruments quite nicely. If he gets good and drunk he will even sing a few folk songs from his home country. Serge has been a practicing homosexual since he came to Canada in 1959. He is a cheerful man, in his late thirties, stocky build, handsome, charming, nothing effeminate about him. During the winter months he sometimes grows either a curly mustache, which he waxes at the ends, or a beard and mustache. Women love him... alas, he prefers young men particularly those he can convert from straight to gay or, at least to being bisexual. He loves to take pictures. Specially of people. Whenever there is a party, Serge is always snapping away with his camera. And in the house where he lives, a beautiful old townhouse, he has quite a set-up for developing his pictures. Next to his artist's studio, his easel and paintings and his musical instruments, he treasures his huge collection of photographs, specially the *erotic* ones.

"We have been buddies for almost three years now. And whenever he sells a painting for a few hundred dollars, he invites me to paint the city red. So we go bar-hopping from one gay bar to the other until I almost have to carry him home, so drunk he gets. I love him. He is a true romantic. Can laugh or cry in an instant. Yugoslavs are such sentimentalists. I have seen him cruising the bars. I have seen him falling in love with some bad-ass young pretty boys, who all were out to rip him off. And Serge gets so carried away, even to the point of getting 'sticky,' and that turns most young boys off—they want a one-nighter and no serious lover. I have seen Serge through many stupid one-week love affairs, and he has shed a lot of tears on my shoulder. He was very lonely, after all, and definitely in need of a serious man in his life. Anyway, when he is happy—and he bounces back and forth—Serge is always horny for new fresh blood. He too can be unemotional and just look for "fucks." Once I fell in love with a gorgeous young eighteen-year-old blond American boy, Robert, whom I had introduced to Serge. So one Sunday he took Robert to the beach."

"Ah," said Marilyn, all eyes.

"I had committed myself to playing tennis with some girlfriends and was wondering what was going to happen—I envied Serge, talk about a fantasy! I knew Robert was straight. He got along well with gay boys, but wasn't gay at all—he was just horny. I knew that Serge, who was quite inventive and charming, could convert him with a little patience, some horny stories, and his camera."

"What did he do?" Marilyn asked.

"They went to this semi-nudist island near Toronto, called Hanlan's Point, where mostly gay people go. When Serge had asked me what kind of lover my new friend was, I told him, well, when he's soft he's not really that big. Some men are soft and long, but when they get hard they don't grow much in length. I talked all about that in my last book, *Xaviera on the Best Part of a Man*. Anyhow, I also told him that although he was small, when flaccid, he sure grew an awful lot when he was erect! So Serge, all excited and curious, had been telling him, I'm gonna be like your big brother, don't worry, baby, I won't touch you—that kind of talk. So that is why, of course, he took him to the beach, which is very secluded. They took along a.picnic basket full of sandwiches, fruit, and drinks for the day, his sketchbook and, of course, his Hasselblad camera."

"Well, by five o'clock in the afternoon, most of the fairies had gone home and Serge told my lover, still very shy and soft, to go into the bushes and beat his cock a little and come back with a nice hard-on so that Serge could take a few good pictures. Serge was dying to see the three-hundred-percent erection I'd been raving about for weeks. After a few minutes, the kid came out of the bushes with a big hard-on flopping awkwardly in front of him, kind of embarrassed about his big cock, and Serge, obviously drooling, started clicking away with his camera."

"Oh, I'd like to see those pictures," Marilyn said, with a certain amount of delight.

"They are great, really, not only of the closeup of Robert's beautiful big cock, but some shots of his perplexed boyish face with the silly grin around his mouth. Anyhow, as Serge was clicking away, he

got a big erection himself. This, of course, made my lover even more embarrassed. He couldn't help noticing Serge's stiff cock, but he did everything to avoid looking at it. Suddenly Serge changed roles. He put the camera into my lover's hands and ordered him to take some pictures of him and his cock, which forced the kid to look right at Serge's stiff cock. So Serge used psychology on my young lover, and how exactly that afternoon ended there on the beach, I never quite found out, because I'd get too jealous and horny at the same time if I let Serge tell me! I believe Robert would rather forget about the whole incident."

"Using photography to seduce someone is an old trick," Marilyn said. Then she glanced at the lights set up in the church, to Neil (who was reloading his camera), and said facetiously to Xaviera, "Are they getting us to seduce each other?"

"I don't know about them," Xaviera replied with a laugh, "but I don't think it's such a bad idea!"

Marilyn giggled. "In a church?"

"Well, maybe not in a church!" Xaviera replied.

"Using photography reminds me of when I was a model in New York and still going to high school," said Marilyn. "The guys who wanted to fuck me were all photographers and they made their play from behind the cameras. I wasn't doing porno then, nothing like that. Straight commercial work. And they would tell me how nice my tits looked and could I see that I was giving them a hard-on because I was so cute and all that crap."

"I would like to see two naked men up there under those lights... making it with each other. That would get me all hot and juicy! Does the idea of watching two men making love turn you on, too?"

"Sure does!" Marilyn said. "I wouldn't want to see my own man do it, but I've always had a voyeur fantasy of looking through a peephole at two or three guys or fifty guys, however many you could get into one room, and seeing them fuck and suck each other's cocks. To me that would really be a turn-on, because I've never seen men fucking in person."

"You really haven't seen that?"

"No, I've never been right on the scene."

"Even in the movies you made?"

"Porno films and porno film sets are basically straight," Marilyn explained. "I've seen guys suck each other a little, on the set of *Behind the Green Door*, but I've never seen them fuck."

"Have you seen the gay porno movie *Boys in the Sand*?"

"No, but I've seen guys doing it on the screen. That isn't the same as real fife. I'd really like to catch them while they're going at it."

Xaviera said, "You mean being a real voyeur, a real peeping Tom, where you look through the keyhole and they never know you're watching?"

"Yeah! That would turn me on so much! Ohhhh!" Marilyn squealed. "Then I'd love to have someone else come up behind me while I'm watching it and fuck me..."

"In the ass?"

"Anywhere," Marilyn said, her eyes bright and sensual.

Chuck walked over. "What are you two gossiping about over here? Did I hear the word *ass*?"

"Marilyn said she'd like to be fucked in the ass while she's watching two guys get it on," Xaviera explained.

"Jesus! Hey, what's the thing with chicks wanting to ball homosexual men?"

Xaviera answered, "Oh, we would just love to watch them in action while a straight guy gives it to us from the back!"

Chuck said, "I'm talking about wanting to get the gay guys in the sack. Isn't that the great attraction nowadays? Isn't it a great accomplishment, huh? Like the impossible dream come true?"

"Sure, that's quite a thing," Xaviera said, "for a woman to get it on with a man who sleeps only with his own sex. It makes her think it's much more of an accomplishment and challenge."

"It's a real power trip," Marilyn said. "That strange aspect of a kind of virginity of the gay guy is there, and you are the one woman who got him excited. It's a mind trip."

Gene asked Marilyn and Xaviera to come back into the lights, with bare tops. They stood there, facing each other, their breasts nearly touching, waiting for the lights to be adjusted. "What we were talking about..." Xaviera said, "a lot of women fall in love with gay men. There's something about that, too. Also... some of the most gorgeous-looking men turn out to be gay. I often think to myself, what a waste, so many women would love to get hold of such a man."

"Sure," Marilyn said, "because there's no competition, no opposing force from other women, at least. And there's no trip—like having to impress the guy—because he's gay. There's a strong feeling, I think, of wanting to be the one to convert a homosexual to heterosexuality—the woman wants to be the one to do it to him. Quite a feather in her cap."

"Something like trying to sleep with your shrink?" Xaviera asked.

"Yeah," Marilyn nodded.

"That's not only with women," Xaviera said. "I knew a man once who was like that, too. He wasn't really interested in anyone else but me, except one girl we both knew, who was totally gay and once had been my lover for a few months. Something about her intrigued him—probably the fact that she'd never had cock, since she was an all-out lesbian. Though she'd long ago lost her virginity to some girl's finger or dildo, in a sense she was still a virgin—to him, at least, and that's what gets a straight man all excited. Some men really think that girls are gay because they simply never had a good cock and that they don't know what they are missing. So they want to be the one to convert them."

"There's that great feeling of conquering," Marilyn said.

"And you know what, had he been able to fuck her, then it would have been in a sense a therapeutic fuck. He would do it just to straighten her out... but my girlfriend probably would have crushed his ego and said, 'I don't like cocks. I like men, but I can't stand the sight of a cock; let's be friends, but leave my body alone.' "

"Ready, girls?" the photographer asked. "Just put your arms around each other, okay?"

They pressed their breasts together. Xaviera said, "We must talk more about homosexuality later, hey?"

"Umm," Marilyn said, feeling the heavy warm breasts against her smooth skin. "Yes, definitely."

"Okay, ready?" Neil asked, standing behind his camera.

"Ready," Xaviera said. She and Marilyn took their places in the lights and the camera clicked away again. They hugged and caressed each other. Xaviera's nipples hardened and Marilyn could feel them pressing into her skin. The hell with the photos, Marilyn thought, I'm going to enjoy this. She closed her eyes and let Xaviera take her in her arms. The photographer told them they were doing just great, to keep it up… assuming they were posing, faking it. What he didn't know was that Marilyn and Xaviera were really getting into the mood and feeling desire, passion, and warmth creep up between their legs. They could only get carried away to a certain extent, for there were people watching, and after all, this was a photo session for the book cover.

The morning ended with a kiss, a long and tender kiss. Neil had said, "There are only a few more shots left, what do you want to do?" They looked into each other's eyes. Neither one had to say a word. Marilyn submitted. She closed her eyes and opened her lips just slightly. She pressed her crotch against Xaviera's leg. She shivered with anticipation until Xaviera's lips pressed against hers and her warm tongue explored Marilyn's mouth. Then they held the kiss for a moment, until a voice said, "Terrific! That's great! We're through!"

As they broke apart it was as if a big rainbow bubble had burst. They cafe down to earth again and gathered their belongings to go back to the hotel.

"Okay," Xaviera said, lying back in her bikini by the hotel pool, "what were we talking about when we had to go back to the photos?"

"I guess why we are writing this book and for whom." Marilyn unfastened her robe and revealed the skimpiest swimsuit imaginable, just enough material on little strings to keep her legal and incredibly attractive. All eyes were on her as she stood next to Xaviera, rubbing sun-tan oil into her skin.

Xaviera looked up. "It seems we have an audience already." Several men—and some women—were ogling them. "If they can see this tape recorder, they must wonder what we're doing, jabbering so much."

Marilyn sat down and rubbed her legs. "You know, I think this should be a book about women and our advice on how to keep their men happy. I believe that the male readers would also like to know what to expect from their women and how to cooperate in a good healthy, sexy relationship."

Xaviera remarked, "It is not for male chauvinists, because we want the men to do some work as well. Let's not make the book only about how to please your man or woman. Let's discuss anything that comes to our minds. Of course, somehow between two women, known for their expertise in the sexual field, we can't avoid the subject *sex*. But it should not be just another 'how-to' book. Why don't we surprise our readers and let them find out for themselves? *How do you please a man?* is one question we're going to answer."

Marilyn set the lotion at her feet and stretched out in the hot sun. Her nipples were visible under the soft little triangles of material on her chest. "My idea of pleasing a man is different from yours, I think. To me, pleasing a man is doing anything he wants you to do."

"I think first we should say what is a sexy man. What is your idea of a sexy guy?"

"Well," Marilyn said, shielding her eyes from the sun as she turned to Xaviera, "I'd say a sexy guy is one who is really masculine, manly."

"The real macho type."

"Yeah, macho, the guy who is strong and knows lots more than I do, who can tell me what to do, and if I'm out of line, he'll order me around and put me back in line. I never thought I'd be saying this! I've changed totally in the last three years."

"But this is your feeling now?"

Marilyn nodded. "I love the dominating male. I love being like the Japanese woman, doing everything for her man, even walking behind him, not speaking unless spoken to."

Xaviera looked a little surprised at Marilyn's candid answer. "You enjoy that?"

"Yeah."

"Do you get pleasure? I mean do you do it to please him, or do you get satisfaction?" Xaviera was interested, probing.

"No, I like it, too. Also it's a good lesson in discipline for my own head, for my own well-being. I love being disciplined. Someday, I might have to be on my own, maybe as a businesswoman or just being a woman-woman, and I need help reaching that point, to be well-disciplined in my thinking and behavior."

Xaviera seemed more than interested—downright fascinated. "Would you be able to be independent if Chuck were not around?" she asked.

"Oh, yeah," Marilyn said, sure of herself, "sometime in the distant future." She closed her eyes to the sun once more as a man walked by and took a long, hard look at her. "But for now, he's my guru. What's a sexy man in your eyes?"

Xaviera sat up and wrapped her arms around her knees, looking at the people in the pool. "Well, I have to think back to what I considered a sexy man before I was a hooker—my ex-fiance, for instance, in New York, might be the type that you describe, very well-built, athletic, a champion Olympic swimmer. He was the All-American beautiful boy, beauty in his smile, his teeth, in his strong jaw, and in his head, too—an economist, very bright. He was a great lover, had a lovely big cock and a hairy chest. He was kind of dominating. I was in love with him for over two years, and it took me that long after we broke up to get over him. When I think back on it now, I was submissive. I did whatever he wanted. I didn't even look around..."

"I can't imagine that!" Marilyn gasped, opening her eyes.

Xaviera smiled a wise, knowing look. "Love is blind," she said. "At that time I didn't look at anybody else. He was jealous if another man would just look at me with appreciation. He didn't let me get out of my cage—he kept the cage closed, and I loved it, the silly bird inside. I loved to be owned and possessed. He made love two or three times a *day* and we rapidly became slaves to each other's

bodies, rather than to each other's minds. Because mentally we were on a different level and after a year bored with each other. Besides I was turned off by his selfishness—his main concern was about his own orgasm. I think that happens in a situation where the woman is submissive. The man becomes selfish because he makes her do anything *he* wants and is not at all concerned about how to make her feel good and satisfied."

"Only sexually?" Marilyn asked.

"Oh, no, in many ways. Over the years, I've gone through some changes. I've been a hooker, I've been used to many short-term relationships sexually… and I often found myself digging a man not because he was bright and witty, but simply because he had a nice pair of legs, a nice ass, a handsome face, or he looked good in a bathing suit…" She nodded to a handsome young man sitting on a deck chair across the pool. He was wearing tight red swimming trunks and sported a deep tan.

Marilyn saw him and smiled. "Sex isn't everything," she said, "as we all find out sooner or later, I guess."

"Yes," Xaviera sighed.

"It's a lot, but it's not everything."

Xaviera said, "Ummm, but it can be so nice! Sometimes I don't even care to know the man's name or anything about him. All I want is a beautiful cock and a good wild fuck. No more, no less, no strings attached."

The good-looking man, whom Xaviera had recognized as Alan N. a well-known actor in Toronto, had been sitting on the other side of the pool, but now he slid into the water and both women saw him staring at them. He was treading water near the end of the pool, close to the big waterfall, when Xaviera said, "Let's go in for a swim and say hello; you know, he's quite famous and a lady-killer, so I have been told."

Marilyn was game. She stood up and in a fast, beautiful dive, moved into the water like some golden fish. Xaviera, taking the longer route, descended the steps into the shallow water, watching her lavender bikini suddenly turn a deep shade of purple.

The young actor, Alan, swam toward them and said hello in a low sexy voice as they were splashing around in the deep water. The three of them swam around, near each other, and then Alan asked Xaviera if she wanted to ride on his shoulders. She did, of course, and soon he was carrying her around on his shoulders. Her pussy pressed hard against the back of his neck, and when she fell off and came up to get air, she pressed her body close to him—he had an erection and it almost was popping over the top of his trunks.

Marilyn was asked if she wanted to "go under" and do a sommersault with him, but she demurred. "I really don't like getting my ears full of water," she lied. So she paddled away and then turned to float on her back, giving the actor a close shot of her wet, tiny bikini, and her almost visible pussy. He stared at her. "Where are you girls staying?" he finally asked, with a hand under water in front of him.

"Any place we hang our hats," Xaviera joked as she swam around him.

"But you're not wearing hats," he said.

She stopped and looked down into the water in front of him. "I think you are the one who could use a hat!" she laughed.

"Yeah," he said, blushing, "I really got turned on by the two of you. You... um, together?"

Xaviera gave him a secretive grin. "Just for a while," she said.

"You are La Hollander, and who is our lovely girlfriend?" he asked.

"You're right. I am Xaviera and she's Marilyn Chambers."

The man's face registered shock. "Jesus Christ!" he finally said. "When I did a guest appearance in New York once I saw your film." He whistled and said, "Quite something else."

"We're writing a book together."

"Listen, could I take you to dinner or..."

"We have to get back to work now. Stay happy." And with that Xaviera swam to the edge of the pool and joined Marilyn. They let their feet dip into the water, on which the afternoon sun cast a silver sheen. Xaviera leaned back and looked up and squinted. "That poor fellow won't get out of the water for an hour. His cock's too hard."

Marilyn laughed. "I know. That's why I left. I like to be a tease."

Xaviera looked her up and down, "Umm, I'll bet you do."

The waitress came around and they ordered an orange juice and an iced tea. Then Xaviera said, "We were talking about what exactly is a sexy man? I guess *he's* kind of sexy." She pointed to the handsome actor, who was still in the water, letting the spray of cool water from the falls hit him on the head. "He's in there, maintaining his hard-on, which is pretty difficult in the water."

"He's pretty macho. I guess I could dig him if he was strong with me."

"You really like playing the passive woman role, don't you?"

Marilyn nodded. "I really fit into it. No, I should say it fits me. That's what I mean."

"I've gone from being attracted to the macho, the superman, to an 'earthier' kind. In other words, the down-to-earth guy, like for instance a George Segal fellow; someone who isn't necessarily the sexiest, most handsome-looking man, but someone who has personality, charm and a sense of humor, and who, all in all, strikes me as a sensitive fellow. I am sure that type is more satisfying, both sexually as well as spiritually. Without being obvious and outwardly sexy, he radiates more virility than, say, a pretty boy like Robert Redford, who probably has a very fragile ego. Yet those down-to-earth men are often quite capable of a wild roll in "bed, and they don't need muscles to prove that to you. Besides, in nine out of ten cases, supermen have been very mind-boggling as well. Well, to get back to pure physical sex appeal. I must confess I like men who have a good torso, a relatively slim waistline, and most of all a nice round tight tush."

"I like legs."

"I like hairy chests."

"And a nice hard cock."

"And a nice hard cock, but... preferably circumsized, or else real clean!"

They giggled and the waitress who set their drinks down by the pool, looked a bit red-faced. Evidently she'd heard their last few comments. "We should watch our language out here, no?" Xaviera asked.

"Oh, they love it," Marilyn retorted. She looked at Alan, who was still in the water, only his head above the surface, occasionally glancing at them.

"I wonder if he's masturbating under there?" Xaviera asked with a grin.

"I hope so," Marilyn said.

"Do you look at a man's legs? That guy has nice legs."

"Yeah. Chuck's legs are long. I love it."

Xaviera paused for a second. "Funny, most of my friends have rather slim legs, except Serge, but he was a professional soccer player in Europe before he became an artist. He's got strong legs."

"I like them long and strong."

"Again, like a cock," Xaviera said, sipping her orange juice. "But what are we talking about the body for? That's all superficial, on the outside. It's the inside of a man that counts more. What is important, to put it squarely, is the head job before the bed job. Years ago I would say, well, that guy is a handsome fellow, he has a great cock and will ball me good. Now I say, well, what will you do with him before and after sex? What do you talk about?"

"*Can* you talk to him is the question."

"Yes. That's why I stopped dating Greek men. They were gorgeous men with thick accents and lovely cocks, and they're great lovers. But usually their knowledge of the English language is little, so what do you say to them afterwards? That's why I like Jewish men. I even speak a *bissel* Yiddish, and Jewish people anywhere in the world are like part of a big *meshpote* family. I seem to be hung up on Jewish men because they make the best lovers and they seem to like my non-Jewish *shikse* features, even though I call myself the *half-jiddishe maidel* from Holland.

"Are you Jewish?"

"I'm only half Jewish, so... I only have half then-hangups. Some Jewish men are real shnooks and women can walk all over them. Those men I don't like, and I hate the women ever more. I shouldn't generalize, but I do it all the time. Don't we all? A Jewish man, unlike say an Irishman, generally doesn't smoke or drink too much, and if you treat him right, he usually won't cheat around."

"I think they're loyal."

"If he's a one-woman man, he's a true one-woman man. Unless you drive him up the wall—then he'll go out chasing."

"How about you?" Marilyn asked, "Do you like a one-woman man?"

"I like a man who respects me and accepts me as an equal and yet has more power and a stronger personality than I. In an argument I prefer a man who simply *looks* at me and tames me down, rather than one who yells and screams. I hate loud, hysterical fights.

Xaviera sat up straight and continued, "I love a one-woman man. I wouldn't have it any other way, at least not if it was a long-lasting love affair. I must confess that I do suffer from double, or maybe quadruple, standards. I may even seem hypocritical. I don't understand it if my man gets mad at me when I'm having an affair and I tell him about it, because I feel too. guilty if I don't confess. Then I say: 'Look, I'm telling you the truth; at least I'm not cheating behind your back, right?' Because I can enjoy sex for the sake of sex as well as for the sake of love. But if he were to tell me that he's having an affair for a week or so, I think I would die of jealousy, because my present man is the type of guy who can only have sex with a woman when emotionally involved and *not* for pure sexual gratitification. Maybe I could understand if he was away on a business trip and slept with some unknown hooker or stewardess and forgot her name. I could accept that, or if he was on vacation and ran into some sexy girl in his hotel or at a party. Temptation! But if he were to cheat right under my nose in our own hometown and someone told me about it or he confessed, I'd go crazy. After all, I do everything to please him and never refuse him."

Marilyn looked surprised. "That is a double standard."

Xaviera nodded and continued. "If I knew the girl's name I might even call her up and warn her to take her hands off him. I realize that is very mean of me—everything for me and nothing for him, but, dear, Marilyn, isn't it about time we women change roles? For centuries men have treated their wives like that. Cheating around like hell, but if they catch their wife in an affair, a divorce is next."

Marilyn shook her head. "It's hard to believe you have that attitude."

"Well, I guess I am lucky I have never been in such a situation, since my man simply never fucks around. He tells me he has the best at home, why settle for second best? For him, half an hour of fun with some strange lover isn't worth the guilt and aggravation afterwards. Well… I think about that differently, at least when the roles are reversed… sometimes. Basically, I try to be faithful as much as I can, but the flesh is weak occasionally and temptation is great. If your man were to cheat on you, would you accept it?"

"I'd have a fit!" Marilyn said, sure of herself.

"You'd have a fit, maybe, but you'd still say, well, if that's what pleases him, I'll put up with it, I'll accept it." Xaviera gave her a look which implied *Am I not right?*

Marilyn softened. "Well," she said, turning around, "it would be hard, but I guess I would. After all, he is the boss."

"Wow!" Xaviera whistled. "How slavish." Then she changed the subject. "Before anything, though, the man has to have the right equipment. I've had men who were lousy lovers in the beginning, but they had all the right tools, and then it was just a matter of teaching them."

"Oh, you know," Marilyn said, "I don't want to be a teacher. If a guy doesn't know what to do, I don't want to be a mother or an instructor and give him the facts of life. I guess I would have done that at one time, but not now. I think men are too hip these days—there's no excuse for them to be lousy lovers. They ought to know what turns them on and how to turn women on. Sex has opened up."

"Right!" Xaviera said, raising her fist in mock defiance. "Let's hear it for sexual liberation. No more skeletons in the closets!"

"You know, if a man isn't a good lover," Marilyn continued, "all he has to do is pick up any guidebook—even our books, I guess—and learn from them. I think also that sex is instinctive, and if people would just be more relaxed about it all, their own sexual inventiveness might come out. I wouldn't toss a guy I really dug out of bed, but I would tell someone I wasn't ready to have an affair with to

hit the road if he didn't know what he was doing. I guess that all has to do with my being passive and submissive. I don't want to be the teacher. Let him teach me new tricks."

"Marilyn," Xaviera remarked, "it is not all *that* easy. Books don't necessarily teach a man how to be a good lover. We women have to be responsible. We can either make a man or break a man."

"That's true, too," Marilyn admitted. "We must cooperate if we like the fellow."

"But some men, for instance, have said to me: 'Oh, you are Ms. Hollander, you must be the world's greatest lover. They think I am some kind of sex. goddess and they expect me automatically to be a super lover, the best on earth. Well, if that's his attitude and if that man's a lousy fuck, I'm gonna be as lousy as he is, or what's more likely, won't even touch him with a ten-foot pole."

Marilyn kicked her feet into the air, splashing in the water. "Right on!" she squealed.

"If I don't really dig him, but already am in bed with him," Xaviera continued, "and he says, 'Eat me around the world!' and waits for action, I simply say, 'Man, I don't dig you and that's that. Eat yourself.' I'm not a hooker any more so I don't have to do anything I don't feel like. After all, I'm not getting paid for what I'm doing."

"Never?"

"Never!"

"That's funny—I'm no longer a porno actress and you're no longer a hooker. *Xaviera and Marilyn Meet in Retirement!*"

"We may be retired, but we still know what we're doing, right?"

Marilyn lifted her glass in the air. "Right!" They clicked glasses and climbed back onto the lounge chairs.

"It's a good thing for my head," Xaviera said when they sat down, "not being a hooker any more and being totally independent. It means I don't have to thank anyone with a fuck just because they took me to dinner, or screw them because they took me to Las Vegas, or give a guy a blow job because he tore up my bill at the supermarket. Now I can say, man, 'I paid for my own meal, I

bought my own plane ticket, I paid cash for those T-bones.' I've out-grown that whole prostitution syndrome of thanking a person for something by going to bed with him. Funny thing is, I never treated men like that. I was always so horny that they didn't even have to buy me food or dinner. One orange juice would do the job. How-ever, thousands of women who look down on a real prostitute—one who takes cash for sex—have been fucking men for treats like that all their life. Whether you fuck for a fifty-dollar meal, a fifty-dollar dress, or a fifty-dollar bill, it is all the same to me."

"Sex shouldn't be a reward," Marilyn said, "it should be a plea-sure, a mutual pleasure. You shouldn't have to *do* something for a fuck, you should be able to have it because you damn well both are turned on and want it together."

Xaviera sat up and reached for her bag. "That reminds me, this letter I got yesterday, I wanted to show it to you." She found the letter and opened it. "It's from a woman in Chicago who wants to know about helping her husband to enjoy sex more. And then later she says, *'Tell me, Miss Hollander, what is the best way of pleasing a man sexually? Not specifically someone you already know intimately and also not my own husband. Just any man you just meet and like instantly. You don't know what it is he wants exactly, so how would you go about giving him full pleasure?'*

"What satisfies him the most?" Marilyn asked.

Xaviera said, "Yes, but not psychologically... she obviously wants to know some technical aspect of sex." "I think all positions can be terrific. I would say that all men love to have their cocks sucked. I always start like that. I think it loosens a man up and makes him very horny and, yet, relaxed at the same time. I always say, whatever he wants is fine with me. I want to find out what he desires, and if we don't actually say it, there are ways to find out. If you nibble on his cock and he really gets hard and moans and moves his hips and his balls swell up, you don't have to be a genius to know he'd like to come in your mouth. If you tickle his ass and he seems to really get off on that, try sticking your finger up there. You'll find out if he loves it or hates it."

"Lots of men like that," Xaviera said, from experience. "But," Marilyn continued, "coming together is the grooviest thing there is. A chick can always make herself come, by playing with herself or whatever. But if you can do it together, I think that's the most satisfying thing there is. It joins you on more than a physical level—it's a far-out mind trip to know you're coming at the same moment. He'll be really satisfied to know he made you come, that he satisfied you. Men love to have their egos boosted, especially in sex. And I love to boost them. All men want to be good lovers. And they can be, they really can." Xaviera didn't say anything. "What do you think?" Marilyn finally asked.

"Well, I think making a man sexually happy begins with the whole preparation, not just with his cock, but the whole spiel—getting turned on while still dressed. Dancing, caressing, kissing, feeling each other up. Then the next step could be undressing each other or doing a striptease or belly dance for him, then taking a bath together, soaping his cock up, maybe just up to the point of no return and stopping, getting him ready to come again and then preventing his orgasm by holding his penis tight. Of course, you can't do this too often. I mean, you don't want to give him blue balls!"

They both heard a man's voice, a kind of gasp, and looked toward the water. The young actor who'd been in the pool for what seemed hours had been eavesdropping, and the words had evidently gotten too hot for him. He swam away flustered. "I wonder if he came?" Marilyn said, laughing.

"I hope so," Xaviera added. "If you take a bath," she said, continuing, "then you dry each other off with a big soft towel and maybe you sit down on the toilet seat and suck his cock a while, or you go to bed and then you start caressing each part of the body, you suck his toes, his ass, give his neck little love-bites…"

"Some men don't like that, though."

"Young men don't seem to like that; maybe they're not seasoned as lovers yet. Men over thirty really dig that."

Marilyn posed a question. "What if some man has said to you, / *like anything and everything. Please me the best way you think you can.*"

"I would caress his whole body, running my tongue and finger-tips all over him like this…" Xaviera ran her fingers down Marilyn's long shapely legs. "In other words," she said softly, taking her hand away, "you just don't turn him on his back and say I'm gonna suck your cock."

"I agree," Marilyn said softly, as though Xaviera were still rubbing her thigh. It had sent a chill through her, and her nipples peaked under her bikini top.

"And kissing," Xaviera added, "kissing is so much more sensual sometimes than fucking. In kissing you can feel, taste, and smell, and when you combine it with fucking it can be great."

"That's why the old-fashioned missionary position can be so wonderful," Marilyn said, "because you can kiss when you're fucking, you can see and touch and feel while his cock is sliding in and out of you."

"For me, the greatest orgasm comes using the sixty-nine position, because I definitely am most sensitive in my clitoris. To suck a big hard cock and have a man sucking my clitoris at the same time makes me dizzy with excitement."

"And he comes in your mouth or against your breasts or holds it back and then comes inside you…"

Xaviera pressed her hands down between her legs. "Ooh, I'm getting all horny!"

Marilyn giggled. "That guy should hear us now!" They looked to see Alan climbing out of the pool, his erection standing sideways inside his small red trunks, trying to cover it with his hands as he leaped for his towel.

"He'd be good in the sack. I'll bet you, with that nice cock," Xaviera said.

"Mmm, remember we are here to work and not to daydream!" Marilyn laughed.

"Okay. What makes a sexy woman?"

"You know I like big boobs," Marilyn said, glancing at Xaviera's breasts. "What's a sexy woman to you?"

"I know too many who are not."

"That's funny. I never think much about women who aren't sexy, I just concentrate on the ones who are. I like large, shapely breasts. I liked feeling yours against me at the photo session."

"I'm glad." Xaviera smiled as she reached over to brush Marilyn's hair from her forehead.

"Ah, I love the way the sun burns on my shoulders," Marilyn said.

"Were you breast-fed for a long time?" Xaviera asked. "Yeah, my mother told me she breast-fed me for almost a year!"

"I thought so. Many chicks I've talked to who have a thing for big-breasted women were breast-fed for many months. My mother only breast fed me for a few months."

"I told Chuck that once, about remembering my mom and sucking at her breast, but he said I couldn't possibly remember that. But it's true, I am sure I remember when my mother was feeding me, and when she would comfort me. I always felt safe when I was pressed up against her warm breasts."

"Did she have big boobs?"

"Yes, she did. It was the warmth I'd feel when I pressed my head against them. It's like a whole psychological trip. To me a real woman is a motherly chick with big boobs. A woman like Ann-Margaret or Sophia Loren, a bit taller than I am, nice ass, you know, firm and shapely and strong. My buttocks aren't so small, either, by the way!"

"I noticed you have a beautiful ass, a nice size for your body, almost boyish." Xaviera paused for a moment and then said, "You know originally, I had the same idea about what made a sexy woman as you do. In my first book, I wrote about my love for Helga, who had big breasts and was tall and statuesque. She reminded me of my mother because my mother had peach-like skin and big firm breasts. I always envied my mother when I was a teenager. I remember saying, 'Compared to you, Mom, I have such small ones!' And she would say, 'Wait until you grow up, then they will get big.' And they changed indeed, just as I changed my mind about being attracted to a man who is Joe Macho. I don't look at people any

more in a superficial manner checking out their tits, ass, cock, or legs. I look at a woman and I ask myself, has she got personality, does she make an 'entrance' when she walks into a room, like Eartha Kitt does? Eartha Kitt without makeup might very well look like anybody else, right, but when she is dressed to kill and walks into a room, all eyes are glued to her, the way she moves like a panther. She oozes sensuality, and she is no spring chicken any more! It is not just one aspect of her body, she is a total woman. It's a hard thing to define. So is a much younger woman, full of sex appeal, called Joey Heatherton. The men are absolutely fascinated by her when she moves on stage. She is like an angel."

"Sexuality can ooze out of men who look very plain. Often it's the energy oozing out of them that counts."

"I think you are right," Xaviera said, feeling some of that energy herself. "Same with women, they have a sexual energy. That's why you can say there is a sexy or elegant or charming or beautiful woman. Well, I think the word is really sensual, it's more important to be sensual. Another kind of sexuality is, for instance, the Way Charro Cougat appears onstage. She is not so sensual, but more pure sexy, like a playful kitten. She gets a man plain horny, while Eartha and Joey can make a man dream away with lustful fantasies. Charro lays it on too heavily, both her accent as well as her sexiness. I think men like to look for some little secret in a woman, and Charro is like an open book. I once met her after a performance at the Royal York Hotel in Toronto. When I went to her dressing room, I was wondering about her accent and asked, 'Tell me, Charro, is your accent really that heavy or do you put it on somewhat like Zsa Zsa Gabor?' You know what she answered? She laughed quite loud and threw her head back and said, 'Ha, ha, mine is rrreally rreal and Zsa Zsa's, well, she is full of chit!!"

Marilyn laughed.

"I have met women who did not really have pretty faces, or the nicest hair, or shapeliest tits, but boy, they had, for instance, a way of talking or walking, a way of moving and looking at you that makes you weak in the knees."

"Energy comes from inside you," Marilyn said. "You can turn someone on just by sending them vibrations. You don't have to strip in front of them and shake your body in their faces."

Xaviera said, "I have a gorgeous girlfriend in Montreal. This black girl from Barbados. She has very small tits but a streamlined big ass and long legs. She has her head shaved bald and with or without her Afro wig, she looks stunning. A few months ago she was working in a bar which was about to die, there was so little business, somewhere in the Laurentian mountains. A blond, husky German guy owned it, some ex-Nazi, I was told. He sure was a real son of a bitch to his personnel. He couldn't keep any girl as a bartender because he was such a bastard, but he kept her—because she was so super sexy. He really dug her ass and the way she'd wiggle it as she walked up and down the lounge. He used to say to her 'Wear anything sexy to turn the clients on and keep them coming back, but… wear a wig, don't ever show your bald head.' If only he knew how much more sexy she was bald! But he was still too conservative. A miracle happened; she made business boom again and they all came just to see her or slap her gently on the ass. She knows how to look like a million dollars even if she only dresses herself up in scarfs or a long shawl around her body. She knows just how to accentuate her best points and does miracles with accessories—such as clips, earrings, beads, bracelets or chains. She never ever looks the same. Each day a different woman, and all that with almost no expense. Just originality and a lot of sex appeal for instance, the way she comes down the stairs, the way she wiggles and lets her tongue slide over her lips can drive a man crazy. Pure animal energy. Same as with men. There has got to be some animal instinct in them."

"Right. Whether they're gay, straight, or bisexual…"

"We're not talking about the stereotypes, right?" Xaviera asked.

"Right. Just average sex-loving people. No matter who you like to ball."

Xaviera nodded. "As long as they've got something animalistic, they've got to be good in bed."

"Animalistic, that's the perfect word," Marilyn said. "That's the word I'd use for the kind of man I like. It's like, when he orders you brutally, 'Get on your knees and suck my cock!' or 'I wanna fuck you, so get on the floor and spread that pussy with your fingers so my cock fits right in!' I'll say, 'But I don't wanna…' and then he forces me to do it, physically, sticking his big cock down my throat as he holds my neck so I can't move. That's animalistic."

"That's not so much the animal," Xaviera disagreed, "that's more the sadist."

"I get off on animalistic sadists, if that is what you want to call it."

"Hmmm. I think the animal in a man comes out when he doesn't need words. He doesn't need to order you around or whip your ass. All he needs is to look at you—and you know the thunder is coming!"

"Yeah, I like that," Marilyn said, almost purring, "but it's the thunder, when it comes, that really gets me off. But you've always been a bit of a sadist, huh, haven't you?" she asked.

"Yes, I guess so. Years before I became a hooker I began to hate men because I finally realized I was just being used. So, once I became a hooker, there was a time when I did love to beat the shit out of them. I can be damn sadistic, very easily, to men in particular. Luckily I have changed a lot. I love them now, and I need this love and tenderness. Occasionally they can treat me rough, but not very often. There are even days when I like getting spanked myself, but not really beaten up."

"Were you ever a sadist to women? Are you still?" Marilyn seemed to ask it with more than general interest.

"Hmm, I hardly ever really hurt women. Not like I could beat and torture men." Xaviera looked upset. "I don't think I would like to hurt a woman… unless… she really begs me to hit her."

Marilyn looked perplexed. "But you've beaten women and…"

"Yes, but that was my business at one time. I was a madam and famous for my sadistic talents, so I had to do some heavy whippings for lots of money. Once, and only once, I had business dealings in

this field with a famous stage and movie actress. And I couldn't stand ever repeating that scene. It was revolting to see her beautiful body get bruised. I felt more like kissing her. Prostitutes deal mainly with male masochists, that is the safest. I seldom met a female slave or sadist. I wore the leather pants and the whip and no one else.

"I'm a masochist," Marilyn said. "I mean physically and everything."

Everything? Xaviera seemed to be asking with her eyes.

"Total," Marilyn said. "I really am, and I love it. To me that's the ultimate for getting turned on. But not many people will do everything to you, because they're afraid of hurting you physically. And sometimes they don't have it in them to be that harsh and animalistic."

"So we mean animalistic to really be two things—a sexual energy that is dominating without being sadistic and then in terms where it is real beat-the-shit-out-of-you sadism. Right?"

Marilyn smiled. "Right. I should explain," she said, so that Xaviera would not think she liked motorcycle gangs beating her up with bike chains, "that I don't go as far as drawing blood, things that would show and really hurt badly. A good hard spanking is great, and something like three dildoes shoved up me at once."

"All in the same place?" Xaviera asked, surprised.

"Yes," Marilyn giggled.

Xaviera put her hands up over her head. "Oh, you're so tiny and sweet and fragile, and you like three dildoes up you at one time?" She laughed.

Marilyn laughed too. "Yeah, it's a trip. That's part of it, having a fragile and petite build. Most chicks would say don't put three dildoes up me, it's going to hurt. I say I know it's going to be terrific, it's not going to hurt me, so go ahead and do it. It's all psychological. You don't have to bleed to feel debased. Someone can piss on you and you'll feel as low as you could ever possibly feel."

Xaviera raised her eyebrows. "You like that, huh?"

Marilyn blushed a bit and said, "Yeah."

"Do you think you look submissive?" Xaviera asked.

"Yeah, I think so. Why?"

"Well, I was thinking about your image. It's interesting to me that you look quite strong in a sense. You're very feminine, your hair and your clothing, and yet you look very strong at moments."

"Masculine?" Marilyn asked.

"No, not masculine. You have... well, a boyish quality about you that I think is wonderful. I was thinking earlier at the photo session, when you were being photographed alone, how from the back you could be taken for a boy at first glance. That's part of your appeal. I think you bring out the latent homosexuality in people."

Marilyn rubbed her chin with suntan oil. "You know, in Vegas a few months ago, a woman came up to me and told me she had seen my play five times. She said that I brought out the lesbian in her, though she was happily married. She had never been to bed with a woman. She said I made her lust for women because my body was so boyish."

"You're lucky," Xaviera said, "because that look is the vogue now."

"I know. Cher recently said she has the perfect body for the 1970s because it is like a clothes hanger—you just hang a dress on it and the line of the dress is not altered because there are no curves and bumps to get in the way!"

"Oh," Xaviera said, laughing, "but with your body, you wear the clothes that show off your firm little breasts and the curve of your ass. You'd better show off that boyish body."

"Chicks with big boobs always seem to dig me. Big boobs crave little boobs."

"Yes, that's true. *Les deux extremes se touchent,* which means opposites attract. My favorite woman now is a much more feminine type. What I mean by feminine is small and fragile and very slim. Well, like you, except your legs are much longer than I'd thought. They are just great!"

Marilyn looked at her shyly and said, "Thank you." "I'm generally bigger than the average girl I date and I like to hug her between my breasts, like a mother does, as you said, that warmth, giving her

that kind of warmth. One of the women I truly love, a journalist from Jamaica, had very tiny breasts and her nipples were actually inverted until you sucked on them long enough and then they would pop out like a rose bursting into bloom from a hard bud. It was the most exciting thing in the world. She was also the only girl I loved with lots of pubic hair. Usually, when I have an affair with a girl, I like a trimmed pussy patch."

"Oh, really?" Marilyn asked. "I thought because you asked me all about shaving it at the photo session that you didn't like it."

"Oh, no, but yours is a masterpiece," Xaviera said, "I love it. I usually trim it short because I don't like to get involved with all the spaghetti down there. My Jamaican girl friend had pubic hair so thick and blond and curly, it smelled like the Jamaican woods, a nutlike flavor, unforgettable. I never cut hers short because it was just so nice that way. She came to my shoulders, had long blond hair, green eyes, small breasts and a slim frame... Well, to talk about an unemotional three-way scene with a really well-stacked chick, now... I once knew a girl with really big full tits, something like size 34 DD, and somehow one day I had a scene with her and a man. Now she had always had a crush on me, was married to some boring Canadian, and she even became a fan club member. Sofia was her name. She was very pretty, but rather innocent and naive. I could do anything with her, but she wouldn't fuck another man, still a bit conservative, 'married' as she was. So I would eat her delicious clit and then she'd allow my friend to jerk off between her tits while I was buried between her legs. She was rather passive and docile and even let me shave her pussy short so I could eat her better. It was summertime, and it was hot down there! I wonder what her square husband thought of that when she came home that night with an (S) crewcut!"

Marilyn curled up into a ball on the chair in the sun, turning on to the story...

"And since it was a warm summer night, Sofia was perspiring heavily between her tits, which made for the right natural lubrication for my friend's hard eight-inch cock to slide back and forth be-

tween them like he was fucking her. She was lying on her back, and I was on my stomach between her legs with my face, looking up to see him sitting on her face, his balls pressing at her mouth, sliding his big cock down between those huge boobs."

"Wow!" Marilyn murmured, rubbing her legs together.

"And then when he shot off, it hit my face! He shot that far, he was so excited. And I rubbed it all over her hot pussy! That was one time I was into a chick with big boobs. It sure was 'different.' "

"I'm really intrigued by redheads," Marilyn said, noticing a woman walk by who was a redhead. "And they usually have big boobs, right?"

"I don't know. I'm not into fair skins. Although I like dark-red-haired ladies, I don't care for the carrot color and freckles."

"All the redheads I ever had anything to do with have been big buxom chicks. You know, like…"

"You must have liked young girls, then, 'cause usually when a woman with big boobs gets older, gravity will start pulling them down."

"Well," Marilyn said, "I don't even care if they're sagging."

"Just so they're big, hey?"

"Something to bury your nose into."

Marilyn giggled. "Yeah. Oh, it must be a mother complex."

"Do you feel role-playing between two women is important?"

"Yes," Marilyn said, "I don't care for women my size. I like a big domineering woman. Yeah, big and aggressive."

"So you want a woman who actually plays the male role?"

"Yeah, I guess so. But so far, in the few gay affairs I have had, I was usually the one who had to say what to do because those chicks are so inexperienced and far too passive. So, it took all the fun away for me."

"Yes," Xaviera said with a laugh, "it must lose some of its appeal when you have to give the orders yourself to the other person how to dominate you. What is the point?"

"Well, I don't order them, exactly."

"Even suggesting it, that takes away from the thrill."

"Uh-huh."

"So your thrill, your great fantasy, might be to find the girl who will just let you have it without you ever mentioning a thing?"

"Yeah, that's it."

Xaviera gave Marilyn a smile. "You haven't had me yet," she said.

Marilyn looked into her eyes, just for a quick moment, and said, "No… not yet."

There was a long silence. Finally Xaviera said, "You know, we have been through a lot. I have been through more because I was a hooker and because I traveled all over the world and because I'm older. But we've both had a different kind of experience than most women. *Do* you think you are straighter because of it? Do you think you've seen it all?"

"Sometimes I think that, but only for a minute." Marilyn ran her finger through her nearly-dry light brown hair. "I guess I'm just as horny and kinky as I ever was in my fantasies or on screen. How about you?"

"Oh, I've straightened out considerably. I've seen it all, I've done it all. I have mellowed to a certain degree. I definitely have become far more selective about the people I choose to be my lovers. However…" Her face lit up. "Every year when spring is in the air and I see the young boys walking around in their T-shirts and tight jeans, I feel that warm tingling feeling creep up between my thighs… Boy do I ever get horny when the sun is out and everybody looks happy!" "*How* young a boy?" "Oh, I've had plenty of young boys." "What was the youngest?"

"Two brothers twelve and fourteen. I wrote about popping the fourteen-year-old's cherry. See, I love initiating them, and when I take a young boy's virginity, I give him the best treat he could ever dream of. I usually don't want to see him again after that. One lesson ought to be enough. He's on his own then and ought to show his own initiative in conquering girls."

"But," Marilyn said, knowingly, "you love it while it's happening."

This past summer, for instance, some friends asked me to go camping with them in the Sierra Mountains. I was really excited about getting out in the wilds, where I could shed my clothes, but even more excited when I learned that my friend Daphne was bringing along her fourteen-year-old brother. I really hoped that I might be able to get the kid alone and see how horny he was. When the time came for our trip, I was *all* ready.

From our meeting place, we drove for about two hours in separate cars to the camping area. When my car passed the one with Daphne, her old man, and her brother, Earl, I was able to get a good glimpse of Earl. Not only was he young and innocent looking, but he was a gorgeous blond—a strong, sexy boy, with potential to grow into an incredible man. That is, if he learned some sex tricks from old Chambers—and believe me, I was ready for that kid!

We reached the camp area a little before dark. Earl and I took an instant liking to each other, and decided to gather wood together before it got dark.

On the way out of the camp area and away from all the people, I accidentally brushed up against his lucious crotch. What a surprise! I felt a big bulge pulsating in his tight pants! I couldn't hide my amazement that this young boy was getting turned on by just being alone in the woods with me. I fell on the ground and pulled him down to me. I could hardly control myself in anticipation of what was to come.

I kissed him with my hot tongue and whispered in his ear. I asked if he'd ever made love to a woman before. He blushed and looked away mumbling something about how he never had, but he'd love to, only he didn't know how. Just what I was hoping to hear! It was too good to be true!

I slowly removed his clothes and looked at his young, muscular tanned body. Yum! Just like candy melting in your mouth!

When his pants came off, I could hear myself gasp as his cock raised up stiff and hard, struggling to get free of his pants. Next, I asked him to rub his throbbing hard-on while I took my clothes off for him. I did a very slow strip-tease, and played with my tits and fingered my wet pussy.

I put his cock in my mouth and started to give him the tender-est blow job I could without attacking him full force. I got excited hearing him gasp for breath, watching him try to hold back his long awaited come so that it would go at last into the body of a real wom-an, instead of his hot hands!

I took his cock out of my mouth and squeezed it gently but firmly, which kept him from coming for a few minutes. I asked him what he would like me to teach him next. He wanted to learn how to eat pussy.

So, I put his head down to my quivering cunt and told him to lick in flicks (like flick my Bic) my pulsating clit. I showed him where the spot was, and he took over like an old pro! Then it was time to put it in. His eyes said, Ooh, please, I can't wait any longer! By now, he's almost ready to explode any second, so I told him to fuck me. He got on top of me and nature took over from there. He pumped away until he couldn't hold it any longer, and I watched his beautiful face while he exploded in my cunt. Then, I came, too, and it was one of the most spectacular orgasms of my life. What a super turn-on, knowing that it was the first time ever for him. "Ummm, yes! Not only do I love young innocence and an eager pupil, it's also an ego trip for me. It's like, baby, you'll never forget this moment of your life. You often see cherry-popping done in a bad way. Like in the movies where a bunch of young brats take their virgin friend up to a local hooker to get laid for the first time, or to the back of the car with a much older trashy-looking woman and she just throws him a half-minute fuck. I know it can be traumatic for kids to have a bad affair the first time. The same with a woman, if she has her virginity taken by some rude selfish bastard, she might well become a man-hater, turn gay forever, or be frigid for the rest of her life… well, being a lesbian may be the best choice. But I can proudly say that if I have a young boy I really like, I'll do everything to make him feel good. I'll even switch off the phones."

"And with you, that's really something!" Marilyn said. "Yeah," Xaviera said. "It's like my umbilical cord, my lifeline."

Marilyn remembered reading about Xaviera's love for the tele-phone—and how necessary it was to her when she was a madam. At

dinner, the night before, Xaviera had told Marilyn how her phones still ring at odd hours in her apartment. She had asked Marilyn if she had the same problem. Marilyn said that if Chuck was there, he answered them, and if he wasn't, she usually just let them ring. Marilyn had had some crazy phone calls, even some threats on her life, as well as the heavy breathers and assorted nuts, and she decided she'd rather skip the telephone altogether.

Marilyn said, "Xaviera, to get back to young boys. Don't they fall in love with you when you take care of them so well? I mean, a first affair is something you really never forget. God, I'll never forget my first night with that crazy football player and his brother in the same room…"

"Yes, I read that in your book. I laughed myself silly. Do you find a lot of your letters come from teenagers?" Xaviera asked.

"Not many girls. Boys, yes. I never realized they're all so horny and so unfulfilled!"

Xaviera nodded. "They're all walking around with hard-ons and most young girls are prick-teasers. I've had so many boys write me and ask what to do because the girls won't go all the way."

Marilyn said, "I guess it's kinda like when I was in high school. I was the biggest prick-teaser there was. Everyone knew sex was a groovy thing, despite what your parents and teachers said, but man, you never carried it through. We all masturbated."

"Some of them feel quilty about masturbating. Today, in 1975!"

"It's really a rough time," Marilyn said, "when you're an adolescent. The boy is part kid and part man, he's just shedding his skin and coming out of the cocoon as a male, a real man. I think his cock leads him."

"That's the time I think the sexuality of his life is pretty much determined."

Marilyn asked, "What do you mean?"

"Well, if he has good healthy sex experiences, without fear, guilt, or other hangups, he's likely to be a well-adjusted citizen. Otherwise he could become a transvestite, a voyeur, a flasher, a sadist, masochist, a rapist. You name it!"

"What's wrong with those things?"

"Nothing, in themselves," Xaviera explained. "But if that is all his sex life is going to be about, there could be problems. All those little quirks and fetishes are fine if you have a healthy outlook to go along with them and if you give in to them occasionally, as a game, but if your head is not screwed on right... Well, listen to this horrible story. The other day all the newspapers and radios were full of the story of a multiple rape-murder case. A young eighteen-year-old French Canadian boy had tied a seventeen-year old girl to his bedpost, gagged and blindfolded her, then raped her and shot her to death with a shotgun.

"Subsequently he tried to set his parents' house on fire. He only halfway succeeded in burning the house down. Then he went to high school with his gun, stormed in during religion class and started shooting his classmates, just like that. Two more kids died, and then the murderer himself committed suicide in front of all the others. A true bloodbath. At the inquest it turned out that the boy was very shy, a virgin against his wish, kind of ugly. He wore thick glasses, never had a date, loved to play war games with a friend, had stacks of porno magazines, the kind with bondage scenes and M/S pictures. He also had in his possession a life-size, do-it-yourself rubber inflatable doll. They found his diary among the porno magazines and the psychiatrists concluded that this boy was an extremely lonely, frustrated, horny, misunderstood, people-hating kid, who wanted revenge for his miserable life. In his diary he wrote, among other things, that he originally intended to kill his parents and brothers and sisters, as well, but decided against it because to him "death" was "heaven" and he didn't want his parents to enter the kingdom of heaven with him.

"Well, dear Marilyn, this gruesome story shows you how miserable and criminal people can become when there is a lack of understanding and sexual satisfaction. The jury in that case is trying to persuade the government xto change the gun laws and also take a close look at distribution of pornography among teenagers."

Marilyn shivered, and goosebumps rose on her legs. She didn't utter a word.

So Xaviera cheered her up and said, "Under normal circumstances, it's a great time, though, to be young and horny. It's the time the boy has his first orgasm, and I think the time he first shoots his load is one of the most magical moments of his life!"

Marilyn smiled again and moaned. "I'd give anything to see a hot little stud shoot his first shot!"

"I'll bet you'd lick it all up for him!"

Marilyn nodded, smiling. "Oh, yeah, and then suck him off so he'd come again. That first time must be wonderful!"

"I've had boys for their first sexual experience, but not, I think, for the first time they had actually come. That would be hard to time, just to know when you are first going to ejaculate and to get it into my mouth or my cunt. It usually ends up in the sheets with a hand job."

Marilyn laughed. "I can see you waiting for months and each time he says, 'I think this is it!' and you get ready and it doesn't happen. The one night he has a wet dream, and you missed it."

"That would be unforgivable. You know, that is one thing I have never seen, a wet dream."

"How do you mean?"

Xaviera explained. "I would love to watch a young man sleeping, with a pair of shorts on, a nice tanned body, you know?"

"Mmm, I know."

"I would just lie next to him on the bed and watch his cock grow in his shorts. He would move around and grunt as he dreams of fucking some chick in the ass or something that really turns him on. Then he'd give a little gasp and all of a sudden his shorts would fill up with his come, while his cock jerks up and down trying to break out of the material. I would just watch all that beautiful semen gush out around the elastic of his shorts and see the white against the dark skin of his leg, moving on his hairy thigh. Oh, I would love that! I would love to lick it up for him while he slept..."

"I think most guys wake up when they come in a dream," Marilyn said.

"Then I would say 'Here is my mouth, just let me suck you some more and you can have another orgasm!' " Xaviera laughed.

Marilyn was turned on. "That would be terrific. I'd like to watch some hunky teenager sleeping naked. I would be kneeling at the side of the bed, his cock still soft, but inch by inch it Would grow, slowly but surely, until it was rigid, standing up against his belly in a curve like all cocks on young guys seem to stand. Then he would roll around in his sleep, thinking he's fucking a chick. Meanwhile I'd be kneeling there playing with my pussy. Finally he turns over on his back and spreads his legs, and I can see his balls are all tight. He comes, and it shoots straight up on his body, up to his neck, and he moans and cries as he keeps spurting. And yeah, I'd lick it all up."

"Most games boys and girls play together are sexual," Xaviera said. "You know, the doctor and nurse thing…"

"I played doctor all the time, and I wanted to be the doctor!" Marilyn laughed and tossed her hair back. "Honest, I really wanted to be the doctor because he got to do everything, he got to feel everything!"

"You mean if you were the nurse you could only watch?"

"Yeah. He would play around with my girlfriends and make me watch and see if someone was coming."

"Well, I played it, too," Xaviera said, "but never all the way. I never saw any man naked except my father, until I was about fourteen."

"I keep thinking, we were all so full of sexual ideas, when we were young. Why weren't we open about them? It's so frustrating to find out you wanted to touch some jock's cock as much as he wanted to get into your pants. What a waste of energy."

Xaviera agreed. "Thank God the sexual revolution, if you want to call it that, has changed things. It has freed people. Kids are more open about sex these days, the family structure is changing, and monogomy does not seem to be too much in vogue nowadays. Divorces are up! But the kids are having a ball."

Marilyn said, "I think kids masturbate more freely. I think the guilt has been erased."

"What did you think about when you masturbated as a kid?" Xaviera asked.

Marilyn paused a moment. "Oh, I don't really remember specifically. I guess in general I thought about getting it on with some guy or another."

"Ever your father or brother?"

"Not consciously, maybe types like them."

"You think incest is bad?"

"Oh, not really, if your head can handle it. I would think about guys I knew at school, maybe, like the guy who finally balled me that first time. I really wanted him. I can remember sitting on the cold bathroom floor once, naked, rocking back and forth just before I took a bath, and feeling the floor pressing against my pussy. I was fantasizing it was his big cock. I used to think of him in his jock strap. I don't know why, but I wouldn't really picture him naked, I'd picture him in his jock strap in the locker room."

"Clothing, even a little bit like that jock strap, can be a turn-on. That's why women in G-strings often excite men more than the women who show the whole bare pussy."

"Burlesque lives!" Marilyn bumped. "Another fantasy I had… you really want to know this?"

"Of course," Xaviera assured her with a gleam in her eye.

"Well, I'd think about two women and a man. Sometimes the guy would be a movie star or some idol I had. But I would think of him with two chicks, and they would be doing all kinds of things to him. I mean, he'd be lying back on the bed with his hands up under his head, smoking a cigarette, maybe, and both girls would be' caressing his cock and licking his balls and rubbing their boobs up against his thighs… and then… well, then the chicks would start to kiss his cock, at the same time, and they'd find themselves kissing each other and his cock just happened to be in the middle."

"I've had that happen!"

"Wish I had." Marilyn scowled. "Anyhow, he would really get an erection when he saw the girls were starting to turn onto each other, and he just lay there watching them as they made love on top of him. You know, their boobs would rub all over his cock and balls, and they would be hugging and licking each other on top of him.

I think that was the first time I realized a gay streak in myself, but I didn't admit it, really. I thought of everything through the guy's eyes, like I wasn't one of the girls, I was him."

"In other words," Xaviera said, "you were guilty only of being a voyeur with a gay tendency."

"Uh-huh."

Xaviera was silent for a moment and picked at a broken fingernail. "I think everyone experiences homosexual urges, especially in fantasies, at early ages, from perhaps nine to fifteen or sixteen."

"Do you think young people have to be taught how to make love? I get plenty of letters saying, 'Miss Chambers, I'm nineteen and horny and don't know how to do it.'"

"You mean where to put what?"

Marilyn nodded. "Yes, they really scream for help."

"Well, they ought to know where to put it, that's pure instinct. Maybe getting there, that's something else again. A lot of boys don't even know how to go about taking off a girl's bra, much less slide her panties off. I have talked to girls who have said, 'Xaviera, young boys are so crude, why do you like them?' That isn't true, or doesn't have to be the case, if they learn a little technique and if the girl is helpful!"

"How to be suave getting to a cunt?"

"Yes, I would say so. We're kidding a bit, but we're not. How suave was that football player who poppe your cherry?"

Marilyn howled. "Oh, Jesus, that was a riot! He was so clumsy. I'll never forget that he almost got his shift knob up my pussy instead of his prick."

"Well, there you have it. The boys should really learn from professionals how to go about making love with some finesse."

"Send them all to prostitutes, you mean?" "Maybe to a good one. That's helpful in some cases, but they can also get advice through magazines, friends, doctors, by means of letters to columns such as the ones we write. And if a boy like that is lucky enough to find a cooperative young lady who realizes that he is new at the ball game and needs some practice, she can assist him with her bra and make him think he snapped it open on his own."

"You have to admit, though, that the kid at the end of such a session is usually a nervous wreck. For years he has been beating off, thinking about this event, and now it's really happening. That's mind-blowing."

"Which means he needs even more guidance in that line, he needs more help. I firmly believe in sexual education."

Marilyn asked, "In the schools?" "It won't happen at home, unless the parents are very progressive. But it ought to happen in the schools. There are textbooks on cooking, why not on sex? We have *The Joy of Cooking* on the shelves in the bookstores, and we also have *The Joy of Sex*. I think more people need the books on sex. But how many kids can afford to buy such books? Besides, they might also get trapped in the jungle of sex books, because there are so many of them on the same subject, and how does a young person know which one suits his or her purpose? Today there is a great pictorial sex education book on the market, called *Show Me*. It's an excellent book for young kids between, say, five and fifteen. It shows little boys and girls from the time they are a baby until adolescence. Their curiosity, their touching each other's genitals, kissing, sucking cock, circumsized and non-circumsized penis, vagina, breast development, intercourse, pregnancy, and ultimately the family together with a newborn baby as a result of a sexual-loving relationship. The book is very tastefully done, and yet in certain areas in Canada it was banned for many months, as pornography! Now it is back on the bookshelves again and selling like hot cakes. What *Joy of Sex* is for the older lovers, *Show Me* is definitely for the very young inquisitive children. They should have free instruction at school, simple but clear, no Latin names and medical case histories. This is a cunt—show a picture—and this is a penis, and this is how you insert your penis in a cunt—and show a couple fucking."

"Oh, that sounds better than the garbage they taught me in school," Marilyn purred.

"Maybe we should write a textbook on sex technique for adolescents!"

Marilyn giggled. "I wonder. Some of them could teach us a thing or two."

Xaviera looked at her slyly. "Want to know a secret?"

"Uh-huh!"

"Some of them *have* taught me a thing or two!"

"But don't you find young boys wanting to love you forever after you taught them what fucking is all about?"

"Oh, yes," Xaviera said, "that's also why I never want to see them again, not to give them the chance to get those romantic ideas about me."

"I met this little boy one time and we had a kind of affair. He was ten years old." Marilyn said.

"*Ten?*" Xaviera gasped.

"No, I take that back," Marilyn said, "I think he was only eight." Xaviera looked shocked.

"Xaviera, it wasn't what you think. I was out on Long Island for a weekend and this kid kept following me around. His parents were there someplace, but I rarely saw them. He would come into the house my girlfriend and I were staying at and wander into my room when I was naked and say. 'Oh, I'm sorry, excuse me!' and I would say, 'That's all right, don't be embarrassed, come in.' I knew I was going to turn him on, I just knew it. But then I chickened out and said I thought maybe he had better go back to his parents. I didn't really want to do it so quickly. I admit I would have liked to have seen what it was like, because despite his age, he was mature enough to be seeking some kind of stimulation. That's why he came up to the room, after all."

"But, maybe he couldn't do anything, anyway, being that young, "Xaviera said.

"Maybe not, I don't know. But for me to really want to do it with that kid, I wanted privacy, I wanted time, I wanted to do it right, not to freak him out, because he didn't really know what he wanted, he just had some curiosity and feeling which he probably couldn't really explain. He obviously knew he was attracted to me but didn't realize that it was already some kind of sexual attraction. The idea of it really turned me on, it got me all horny... wouldn't it be strange?"

"Eight years old," Xaviera said in a soft voice. "I almost wish you had done it so you could tell me what it's like!"

Marilyn laughed. "When I do, I'll call you and give you the first report!"

"I think I would have done it,!' Xaviera admitted. "Okay, then," Marilyn said, offering her hand, "we'll do it together!"

And they shook on it.

"When I was living in Johannesburg, my little nephew," Xaviera said, speaking of children, and slipping a towel around her shoulders, "my sister's child who was then eight years old, would come sneaking into my room while I was napping and slip under the sheets..I would pretend I was asleep. This was in South Africa. He would start to feel my tits, and I thought it was very healthy for him. In the swimming pool, he would hug me and press his strong body, in particular his little stiff cock against my belly or tits."

"Did anything ever happen?"

"Oh, no, he's my nephew and I love him. I am not a child molester. That was just his experimenting with Auntie Xaviera. I haven't seen him in eight years because they live so far away. Would love to see him *now!* But what about that kid you talked about? Do you think that was a natural urge?"

Marilyn agreed. "Sure, I felt it when I was young. I wanted to see guys naked, I wanted to play 'doctor' or sit on men's laps and hug them. You know what? The kid—on Long Island—his father knew what was going on, and I think the father really would have liked me to do it with him. He even said to me once, 'My son really loves you and loves to be with you.' He kind of insinuated that I should take care of his boy, and that startled me. "What did you tell the old man?" Marilyn shrugged. "That it wasn't the right place, it wasn't the right time. But all the people up at the house kept saying, 'Fuck him, fuck him!' They would have loved to watch. That's too kooky even for me. Poor kid, he was so young, he hardly knew what was going on. It really wasn't cool, if you know what I mean.

"If it would have happened, the conditions had to be different, better. Like in *Summer of '42,* where the relationship meant some-

thing to the boy."

"The idea of a virgin girl would appeal to me," Xaviera said, "but not to you as much, because you like women who are experienced." Marilyn nodded.

"Do you like to pop cherries on girls as much as boys?" Xaviera shook her head. "I don't care about girls being virgins, literally. I mean having a hymen or not. But seducing a girl who has never been with another woman, that is a terrific challenge. I guess everyone likes to be *number one* sometime or other.

Marilyn stood up and wrapped one of the big blue pool towels around her. "How come it's so cold suddenly?"

"The sun just seemed to disappear." Xaviera realized it was almost four o'clock. "It gets chilly at night."

"I like that, though," Marilyn said. "I hate hot, sticky nights."

Xaviera stood up and looked into her eyes. "Nights here are only hot and sticky when you make them that way."

"Umm, sounds interesting," Marilyn said, smiling.

"Now, I'll call you after dinner, all right? I have an appointment and then I'll grab something to eat and we'll see about tonight…"

"Super," Marilyn said.

Marilyn and Chuck had dinner with friends in the hotel, and the lamb chops were delicious, cut thick and aged as they are served in England. They had a desert of fresh strawberries and then went for a walk around the pool. The night was calm, peaceful. "I really do like her," Marilyn said to Chuck. "I'm… well, I think she's very bright and I really felt turned on to her during the photo session, but I'm not sure it's going to go any further."

"Why not?"

"Oh, I don't know. Maybe because it seems as if she's not all that turned on by me. And when do we have time, anyway? We only have two more days together."

"Don't worry," Chuck said, putting his arm around her. "What happens, happens."

"So reassuring," Marilyn said, sarcastically.

When they had gotten up to the room, they checked the TV set to see what movies were on the in-hotel films channel. They had seen both *The Towering Inferno* and *Emmanuelle,* but not *My Pleasure Is My Business*—starring Xaviera Hollander. Marilyn called down to the desk; in a second the TV set came on, and there was Xaviera walking down a Toronto street, looking radiant. "She photographs so well!" Marilyn exclaimed.

Just then the phone rang. Chuck answered—Marilyn was watching the movie intensely, wondering what kind of an actress Xaviera was. Chuck had to tap her on the shoulder to get her away from the screen. He informed Marilyn that Xaviera was having a party. Would they like to drop over to her apartment? She was having some friends up, and some of them, who were in her acting class, wanted to meet Marilyn. "Sure," said Marilyn.

"We'll be over. Can you give me the address?" Chuck grabbed a pen and began writing.

Marilyn was still glued to the TV set when Chuck told her they'd better get going. "Can we watch this tomorrow? I really want to see her."

"We're going to see her in person in about ten minutes," Chuck said with a smile.

Marilyn clicked off the TV set. "I'm sure it won't be a boring party!"

Xaviera lived in a brand-new high-rise building on the twenty-fifth floor. She had the use of a swimming pool, sauna, and sundecks. Her apartment had a view of the entire city of Toronto. Her building was so new, in fact, that Marilyn and Chuck realized hers was the only apartment on the floor that had been finished. Marilyn knocked on the only closed door in the hallway, and in a moment Xaviera greeted them.

The view from the living-room was spectacular. The apartment itself was unpretentious—a colorful mixture of yellow, brown, beige, and white. There were modern comfortable couches and several big bookshelves filled to the ceiling, and the apartment was cozy with lots of plants and flowers. Over her white dining table she had a very

original lamp: an old grammaphone horn hanging upside down. All the lights were on dimmers. The decor was a combination of contemporary primitive mixed with antique lamps and candle holders. Marilyn had had visions of Xaviera living in a million-dollar Victorian mansion, with red velvet wallpaper and servants. She was surprised that she was... well... real—and lived in a beautiful two-bedroom apartment, with dishes in the sink like everyone else, and had an office filled with tons of fan mail, a tape recorder and an electric typewriter. The bedroom lived up to expectations—it was nearly wall-to-wall bed and lots of mirrors. The bathroom was filled with colognes, powders, and makeup articles, which Xaviera hastily said she seldom used.

"Our place up near Tahoe is very much like this. Simple," Marilyn said to Xaviera as they went out on the balcony and watched a boat moving in the water on the edge of the downtown section of Toronto. Xaviera pointed to a very tall tower that was nearly finished being built and explained that that was the tallest building in the world, the CN tower, a radio and TV tower with a rotating restaurant on top.

"I know what you mean," Xaviera said. "I live the way I want to live and not the way people expect me to live. Everything here is what I'm comfortable with and need right now. Because we're stars of some kind, our fans think we live a Beverly Hills kind of life. That life must be so boring after the first excitement wears off."

"I know," Marilyn said, well aware. "We just moved out of Beverly Hills for that reason. And the smog."

"None here," Xaviera said. "Some day, however, I'll buy a nice house, when I am really settled. Now, come, I want you to meet my friends..."

Marilyn and Chuck were introduced to about two dozen people in the apartment. Most of Xaviera's friends were involved in the entertainment field. Actors, TV producers, a gay fashion designer, a photographer, and a funny disc jockey were among the guests. There was also a very quiet, but observant, Englishman who turned out to be a well-known poet. Marilyn noticed that many differ-

ent languages were spoken, and she soon found out that Xaviera's friends were rather international and from various age groups.

There was also a young nineteen-year-old Austrian chap, who sat in the corner with a sketch pad and crayon on his lap. A beautiful Chinese girl sat in front of him. When Marilyn moved closer to them, she noticed that he was drawing a pretty good caricature of the girl. The two young people communicated not with words but with drawings and hand signs.

In the kitchen, Chuck bumped into a very drunk, but beautifully and artistically dressed, woman, who turned out to be a Dutch sculptress. She hung on to him for a while and then introduced him to her boyfriend, a film maker from California. He wore tight-fitting white pants and a green voile shirt, open to the navel, revealing a good deep tan, lots of black curly hair, and a string of white shells around his neck. Marilyn talked briefly with some of the young people who were in Xaviera's acting class. They asked her how it was to be a porno actress, then they returned to their conversation about the improvisation they had done on stage earlier that evening. Xaviera's acting teacher was a very reputable man, Eli Rill, originally from New York and a pupil himself of Lee Strasburg. Rill, a fan of about fifty, stood in a corner, chatting away with a young twenty-five-year-old brunette who was interested in joining his classes.

After an hour of conversation, the music was turned up and a couple of people gyrated their bodies to the music of Gloria Gaynor and El Bimbo Yet.

Everybody had a good time, and the atmosphere was relaxed. There was a cool breeze coming through the open sliding glass doors. Chuck Traynor and the Los Angeles producer were discussing the film business, and Marilyn met Serge, the gay friend Xaviera had talked about. Serge, as usual, was quite charming with the ladies and helped Xaviera out with food and drinks. He also carried his camera and, from time to time, electric flashes lit up the room as he took pictures of everyone present. There was a young Hungarian who kept asking Marilyn where he could buy some of her films.

He was getting hornier by the minute. Most people, however, were quite casual, and it was nice not to be treated as celebrities for a change and to be just one of a crowd.

Around 2 a.m. most people began to leave. Chuck was still deep in conversation with the film producer. Xaviera told Marilyn she had something to show her. She took her by the hand and pulled her into the master bedroom. On the wall was a picture of two horses; the stallion was ready to mount the filly, his penis nearly touching the ground, hard in anticipation. "What do you think? Ever seen one *that* size?" asked Xaviera. "Great conversation piece, huh? And good to give any guy an inferiority complex."

"I love it, if only you knew how much I dig horses. And I am not the only one!" Marilyn said, grooving on the photo. She wandered around the room and finally sat down on the bed. "I'm glad you invited us to your party. Such groovy people. Didn't meet too many Canadians. You seem to like a mixed crowd! You know what we were doing when you called?"

"Umm, maybe a little nooky schnooky?" Xaviera asked.

Marilyn shook her head. "We were watching your movie on the TV set!"

"You're kidding! How much did you see of it?"

"Only about ten minutes."

"That's not enough to tell anything."

"You looked great so far. I'll reserve judgment until I see the entire movie," Marilyn said. "Come to think of it, I'll be in hotel rooms for the next two months without interruption. All that for the book promotion trip!"

"Book tours," Xaviera said, exasperated, "they can drive you crazy and, yet, I enjoyed every bit of it. After all, you're selling yourself and a product you stand fully behind."

"I'm excited. I like the attention and the people." "Well, it can be quite boring, specially after a few weeks."

"You just have to keep up a good spirit and face each day with a smile. Never sound bitter or harsh or moody or nasty, even if you feel like kicking the interviewer in the groin if he tries to put you

down. You have to have a sense of humor and grow elephant skin against insults and put-downs."

"What do you mean?" Marilyn asked in surprise. "Well, for the sake of sensationalism, journalists usually twist the truth around, and if you are on the air, radio or TV, you can at least defend yourself, argue or debate."

"Oh, no. I hate that. I'd rather shut up than fight. You are so much stronger and aggressive. I hope things are easy for me."

"I wish you luck," said Xaviera. "But never let an interview get dull or boring. Put a lot of enthusiasm in your words, and smile. The public likes to see a happy face."

Marilyn paused and thought for a moment. Then she said, "You know what I'd like to do? I'd like to pretend I'm doing an interview with you."

Xaviera got up, nodded, and settled back into the chair near the bed. "This is going to be fun," she said, "mainly because I've never had a woman interview me who's so good-looking! So what do you want to know?"

"Umm… what's the most striking thing to you about your first books, after you re-read them?"

"Good question. I think when I read them I'm almost sad that I wrote so little about 'true love.' Maybe it's as they say in French: *les gents heureux n'ont pas d'histoire,* which means that happy people really don't have a story to tell…"

"But you've obviously been happy, and you've lots of stories to tell," Marilyn said.

Xaviera nodded. "But being happy and being in love is not necessarily the same. You can be happy at work for instance and write about that. When I'm truly in love with a person, male or female, that's when I really radiate happiness. Then I am no longer the happy hooker, but the happy woman. I find it difficult to write about a real love affair, however, particularly if it is still going on. If I am honestly in love with someone, I think I owe it to that person to keep our love affair a secret and I don't go spilling the details out over the pages. Some kind of unwritten code of ethics. You do that,

too, in your book. You don't tell us what you and your man do in bed, the way you tell us what you've done with other people."

"Right," Marilyn said. "Did you find interviewers trying to probe into your private love life?"

Xaviera sat up straight. "Oh, yes. They always want to know how much money you have and whether you are in love. So when you shut your mouth about money and say that you are indeed in love, they immediately want to know all the details. Can you really love one person? Is he rich, famous, good-looking, and young? How often do you have sex? Whether I still give orgies. Whether I am faithful or not, and so on. They are out to get a sensational story. Most of those questions are so repetitive. Sometimes they get really nasty and almost vulgar and pushy."

"I try to answer those questions with taste when I'm on TV or radio or in the papers. I don't use four-letter words, so they don't have to bleep me. My forte is double entendres. I always end up being the lady and never the tramp. See, in other words I have been trying to change a bit, not to change the Happy Hooker into the Happy Cooker—nobody wants to read about Xaviera in the kitchen making an omelette—but to show them there is more to me than just a raving sex maniac. Of course, telling the public you're in love with a nice guy, live with him, play tennis, dominoes, backgammon, music, etc., go to the theater, do a lot of entertaining… that is not exciting press material. They want scandals and excitement."

"Have any of the men you've been in love with gotten mad because you talked about them?" Marilyn asked.

"My man once said, 'I don't like the fact that people see you as the Happy Hooker, but if you feel that you must keep on writing, please let the books be based on past memories, on the advice you can give, but leave *me* and our relationship out of the picture. Let's keep some things in our life sacred. I hate to be Mr. Hollander, like Larry, your ex-boyfriend used to be.'"

Xaveria paused again slumped back into the chair. "You know, Marilyn, I could go on and describe all the beautiful things about my man, but I won't. I seldom make public appearances with him.

He hates the limelight. Serge is the one who usually accompanies me. My man's all I want for now and all I can handle, and he has a very strong personality. He satisfies me fully. Our relationship is based on love and freedom, and not on jealousy."

"How much freedom do you give each other?" "As much as possible. At times it *is* difficult. I need more freedom than he does because I'm that kind of person. I need lots of people and parties. He is a much more private person, satisfied with me and me alone. Yet we are compatible, and that's what is important. He understands my need to spread my wings. I always fly back to the nest."

"I often get asked by interviewers if it is difficult being Marilyn Chambers and having a lover, as opposed to… well, I guess, Jane Doe and a lover. What about you?" "Of course. I'll tell you what's interesting about that, being who I am, most young lovers will expect me to pick up the tab. They just assume that. If it's a young boy or girl who's my date and who hasn't got any money, I don't mind picking up the tab. But if I go to dinner in Montreal, say, with friends and their hangers-on who all make a reasonable living, and they expect me to buy the $250 dinner, I might get sucked into paying that one, but the next time around, I warn them that we go Dutch. Everybody assumes that 'she is getting rich,' so let her pay, let's order another bottle of champagne." "Everyone thinks we're multimillionaires." "If only they knew how many books you have to sell to be… comfortable. But you, Marilyn, were kind of bragging in your book about the fact that you lived in a $100,000 home… that is not very humble."

"We did. And the new house up near Tahoe was expensive, too."

"Well, see, I don't think it is good to say that." "Why?" Marilyn asked.

"Because the average man or woman reading your book cannot afford living in your style and will maybe envy or even hate you for being somewhat of a snob. I guess it is just a very American habit to put dollar signs on everything. I often notice the jealousy among journalists."

Marilyn nodded. "Yes, maybe you are right. I am just so happy about being able to live in such a beautiful house."

"A lot of underpaid journalists envy our success as writers because in a way some of them are frustrated book writers," Xaveria continued. "For years they have been trying to sell their manuscripts to publishers to no avail; even if their writing talents are superior to ours, they don't have the celebrity name to go with it, to make the book a commercial success. So they stick to covering accidents and interviewing people like us, who have made it. They keep on struggling to make a buck, to support their wife and kids. And when they come to interview La Hollander, they're always trying to probe—how much was the advance? How much money do you make? How much this and how much that?

"They even ask if I wrote the books myself. Now, I must confess I had some assistance with the first one, but the other ones I've done on my own, and some people just can't believe I had talent to write. They just think—and why should I blame them?—that I'm nothing but a dumb hooker, just the same way they think you're nothing but a dumb porno actress. See? I'm even guilty of that! I thought that about you at first, too!"

"But, to get back to what I was saying, I think if you tell the world in your book how much money you make and how expensive your home is, the average person will get up-tight because he really doesn't wish some hooker or porno star to be *that* successful. In a way they are right, because who wants to read about someone saying, 'I'm so rich, look at me!' while they are struggling to make a living?"

"I only put it there because to me it was the dream come true. Before I became successful I was just an average person. Suddenly the dream of stardom materialized, and the big house and making more money than I'd ever thought of. I put that in the book because of joy, being happy about it."

"Well, Marilyn, maybe I'm too skeptical." "I guess no one ever thinks about the expenses famous people have."

"You're telling me! By the time I've paid off my lawyers, the tax people, the lawsuits, accountants and everything else," Xaviera said, "I'm borrowing a dime for a cup of coffee. No, that isn't quite true, but very little is actually left. People are ripping you off left and

right—particularly those lawsuits—so I don't think it's sensible for me to blow $250 on a meal for people who don't mean all that much to me and are obviously parasites."

"Do you spend a lot of money on yourself?" Xaviera looked a bit puzzled, as though she really didn't know how to answer. "I don't live like a queen, you know. I have a comfortable apartment in downtown Toronto, where the rents are the highest, but I don't own a $100,000 house. I usually don't buy extravagant gowns that can only be worn once or twice. I am too practical, and I like clothes that last and yet look good. I'm over my $300 Pucci habit. I prefer clothes that look like me, rather than those with some name designer's signature. Once every few months, however, I get the urge to spend a lot of money in one afternoon and then I buy a thousand dollars' worth of clothes—but even then I usually know the manufacturers and wholesalers. Other times I drop by a thrift shop to get rid of some old clothes and I see something to my liking there and buy it. Who cares, secondhand or not? I hate to waste money. If I know there is a one-hundred to two-hundred percent markup on clothes in a boutique or department store and at the same time I know a place where they get the same merchandise for one third of the price, I'd be stupid not to go there. I don't think anyone can knock me for that. Maybe it's because of my combination of Dutch and Jewish economic sense. *A Jiddische kopf.* There is a way of making money and a way of holding on to it. I mean a lot of rock stars make a million dollars in a hurry and then it's gone a few weeks later. They drive around in golden chauffeured Rolls-Royces, take their entourage around the world in private jets, and then one day, pffft… all the money is gone. Then they have to set up another tour to get some bread in the bank." She shrugged. "Oh, money, let's not talk about that any more."

"How am I doing as an interviewer, Miss Hollander?" Marilyn asked facetiously.

"Just fine, Miss Chambers," Xaviera answered, warmly. "Tell me, do you make a distinction between being in love and loving someone?"

"I think it's pretty much the same. Well, being in love is the more screaming feeling you feel in the beginning of your love affair—Ah! I want to be with him!"

"When you do that eight time a day after three days, is that when in-love time begins?"

Xaviera laughed. "Yes, eight times a day I open the windows and scream to the world, Ah! I want to be with him! Love is everything, you want to be in love all the time. Loving is a more mature settled-down feeling. Love can be watching television together, enjoying a meal, him washing the dishes and peeling the onions and garlic, while you cook and make the coffee—it's a sharing. Mutual respect is important, but don't worship the other and understate yourself. In love both should feel equally capable to give and take. There must be equality. It's more than just sex: a friendship, it's a buddy-buddy relationship, a companionship... common interests, the feeling of not wanting to be without one another for any length of time."

"And it's having differences, too, isn't it?" Marilyn asked. "Otherwise two people could bore each other to death."

"I must confess, no matter how intelligent a person is, the brightest comedian around, like Myron Cohen or Jackie Gleason, or some brilliant statesman like Henry Kissinger, they must bore their partners from time to time. If I were married to an entertainer I would get sick and tired of hearing the same stories all the time, the jokes and 'Oh, have you heard the one about...' There is nothing worse. So you must try not to be boring, and that can happen many ways, especially sexually, because there you can create your own variety.

"To get back to the joke-tellers," Xaviera interrupted herself. "I have an uncle who is a cellist. Now he's eighty-two years old. He's been in the radio studios most of his life, and he always heard the funny jokes and stories first because they were usually made up by the entertainers during work. Then he would repeat them again and again, to his friends and acquaintances who hadn't yet heard them. But his wife had heard them dozens of times, and yet she put up

with them and laughed when she was expected to laugh. That's part of loving, too—putting up with each other."

"How about sex, Miss Hollander?"

Xaviera licked her lips. "How about it, Miss Chambers?"

Marilyn smiled. "How about sex in a relationship?"

"Well, as far as the sex is concerned, loving is not only that, it is also being happy to just hold each other, cuddling up spoon fashion, and falling asleep and waking up on his shoulder or chest, or even if you wake up miles from each other with pillows in between, it's just nice looking at each other and knowing that there's love. Touching his toe in the middle of the night...

"Married or not, when two people live together, having sex every day at first seems quite exciting. But then after a few months or weeks the excitement wears off, and it might even become boring. The nice thing about sex is the anticipation. So if you wait a day or two, then the explosion is much stronger. Some people think once they are bored with sex at home, they can save their relationship by swinging. For some it works, for others it fails.

"Let me tell you another story about the eighteen-year-old hitchhiker I once picked up in Montreal. He is the one who went with Serge to the beach. He was from South Carolina. We spent a few weeks together and he really fucked my pants off, like only eighteen-year-olds can do. He was a terrific lover for one so young. One day when we were together he said, 'Let me call my parents.' I thought he was kidding! I'm going down on him and he wants to talk to his folks? I asked him why. He had not spoken to them for over two months. Also he suspected that his parents were swingers. Once he had found some swinger's magazines under their bed. His parents were very devoted to each other, and I think he was jealous of them. His mother had had a stroke when she was thirty-one, and was paralyzed. It took her seven years to recover, and now his father loves her to death and treasures her, while the children feel kind of neglected and unloved.

Anyway, his father is only forty years old—he'd obviously read my book—and my lover boy wanted to hear his dad's reaction when he told him with whom he was keeping company and what we were

doing. So, when Robert handed me the phone after he talked to his dad briefly, I said, 'Hello, this is Xaviera Hollander.' And on the other side there was a short silence. Then a beautiful voice spoke, 'What? Are you really the girl who wrote *The Happy Hooker*? I don't believe it!' I said, 'I'm here with your son, Robert, Jr. I guarantee you he is well taken care of, we are getting along fine, and he sure knows what he's doing, we're having some vacation together!"

"The father said, 'Far out!' Then he mentioned that he and his wife were coming to Toronto soon, because he had won a free trip in some kind of contest, so I said politely, 'Well, if you're as nice and handsome as your son is, I'd love to meet you and your wife.' Then his father said, 'Miss Hollander, if you think my son is something, you haven't tried" me yet!' So I teased and said, 'Okay, fine, we'll see.'" Xaviera tossed her hands into the air "Whee! Robert jumped up and danced around the room and was as hard as he could be. He was so turned on by the fact that his parents were going to get together with me that we had one of the best afternoon sessions ever."

"A few days later, the phone rang. I said, 'Who is this?' and the voice said, 'Sandy.' Sandy? I thought it was some hooker, because hookers usually have names like Candy, Sugar, Cindy, and Sandy. I said, '*Who* is this?' And she repeated her name, this time with a slight slur. Oh, my God, this woman had a slight speech impediment. Then I suddenly realized it had to be Robert's mother, because he had told me she slurred a bit as a result of the stroke. She said she and her husband were coming up on June 7th and were very anxious to meet me. I was polite, but not really all that eager. Then Sandy said she had something to tell me that Robert, Jr., wasn't supposed to know. She confided to me that she and her husband were swingers and had been for a long time. I told her, well, I know that, your son Robert told me!

And she gasped and asked how he could know such a thing and I told her he had found some underground sex paper with ads from swingers they had crossed off...

"So anyway, she suggested we swing together. I said, how about a get-together with your husband and son, yourself, and me? But

that was too much for her. *That* liberalized I don't think they were yet. That was also the end of the conversation. That night I really was super horny thinking about an all-in-the-family swing. I told him what I had suggested to his mother, and Robert got somewhat uptight. I think it wasn't such a bad idea for more advanced swingers, but Robert was somewhat new at it—yet it seemed on the phone as though he was ready to compete with his old man. I didn't really care one way or another. I preferred it to remain just another incestuous fantasy."

"Did you ever have a swing with a father and son?" Marilyn sounded more interested in Xaviera than Dick Cavett had ever been in his guests.

"Yes, in England, actually with one of the most famous swingers I know in London and his seventeen-year-old son. While I was sucking his son, a handsome boy who was averagely endowed, his father, a real super stud and great-looking man, built like a horse, was fucking me from the back. It sure was different. The old man, of thirty-nine, was a real swinger from way back and very much into it, the whole scene; the whole house was full of swingers. But for the son it was his first orgy *en famille.* A real freak-out. The son soon left the house and married some American girl. Now he's working in New Jersey and he can't handle sex very well. Someone told me he became a Jesus freak, but got out of that scene again. I guess when you are seventeen, you shouldn't be brought into a swinger's scene with all that fucking and sucking, especially when your dad steals the show as a superman. It really must destroy a young man's ego.

"You know, it's the same as nudist camps. In nudist camps everybody takes off their clothes. Some camps have lots of little kids running around, but usually you don't see many boys and girls between twelve and fifteen, because they're too uptight at that age. I've been thrown out of virtually every nudist camp near Toronto, because they all have this silly unwritten law which says: two people of the opposite sex can't touch each other. Or you can briefly hold hands or slap shoulders, but no erections allowed. Well, I not only like to touch, but I'm also a super voyeur, and when I go to a nudist

camp I have to watch others, no matter .what the real nature-lovers say about going there as a sun-worshipper."

"Nudist camps are a trip," Marilyn said. "I've never heard of anyone going there just for the sun."

"It's very funny sometimes, the women start comparing notes—which guy is hard or soft, circumcised, uncircumcised, big or small, whatever, I went to one and was told by the management that men could not get erections. So I said, what are you telling *me* that for, I'm not a man. They said I would be able to cause some poor devil to get a hard-on.

"One day I went to a nudist camp with this beautiful young eighteen-year-old girl who was really built, long legs, delightful tush, and big beautiful tits, just like a Penthouse Pet. The two of us were sitting on a blanket and after an hour in the hot sun, I began to rub some suntan lotion on her legs, around her pussy, her belly, and up to her nipples, which had popped up nice and hard by then. Then I noticed this boy who was staring at us with his mouth half open, fully admiring our sensual massage. He got more and more excited by the minute. The boy couldn't have been older than fifteen and he was lying near us on his stomach, between his parents. They were facing the other way. With this audience, my girlfriend and I of course put on somewhat of an extra show. Good thing he was on his belly. The more we looked at him, the more excited he got. Actually we both got very horny, too, thinking of what he had to hide underneath his stomach. He was so cute. All of a sudden he got up. His parents suggested that he join them for a swim. Guess what? The kid indeed had some hard-on standing up—ten after two, you know—boy, what a size for a young fellow, and he began to run toward the pool, to try to keep his parents from noticing, but they did, and they complained that I had purposely turned their son on. So, I got kicked out because I was simply rubbing oil on my girlfriend's body."

"We have quite a few nudist camps in California," Marilyn said, "and some of them are famous—Sandstone and others—but they're more than nudist camps. Did you go to them when you were a madam in New York?"

Xaviera nodded. "Yes, I saw a TV interview with the people who manage a camp in California. It is like a whole community. Again, quite a bit of group sex, nothing forced. I used to go to New Jersey. It was the same there—there were swingers but they were very discreet. You have to go into the cabins to make love. I wrote all about that in *The Happy Hooker.*"

"What didn't you say about nudist camps that you might want to say now?"

"Hmmm. You see, I find nudism exciting to a certain degree, but it can be very awkward, too. Say a girl goes out with a man for the first time. She is all dressed up and it's a nice day, for instance a Sunday, and he proposes to go to a nudist camp and get a good suntan. He probably thinks he's going to challenge her because he will soon see her stark naked and in his fantasy he's going to make it with her right there. But when they both get undressed, the excitement wears off instantly. They both become conscious of their deficiencies. He started the day off wrong: with sex on his mind and not *sun*. She realizes he's just another horny voyeur and wants to have a look at the merchandise. That's the moment of revelation, where she suddenly becomes aware of her heavy thighs, scars on her belly, or saggy breasts… facts she could have hidden with clothes on, and she suddenly feels terribly unsexy and wants to run in the bushes and hide. It can backfire, nudism."

"Are you terribly conscious of your body?" "Oh, yes," Xaviera said, "especially now, in the summertime. I work on my body, play tennis daily, do exercises, and swim a lot. In the winter I can eat and not worry so much. In the summer it is an on-and-off suffering with diets… I love ice cream and milkshakes!"

"Being a sex symbol also makes you conscious that people are looking at your body all the time."

"Right, Marilyn, that's why I can't afford to gain too much weight. You can't disillusion your public. Ever heard of an overweight sex symbol? How do you manage to stay so slim?"

Marilyn flashed her eyes and giggled, "Sex."

"I'll buy that answer," Xaviera said.

The movie producer who'd been talking to Chuck Traynor entered the room. "Hey, where's the party?" he asked.

"Marilyn and I were having a heart-to-heart chat," Xaviera explained.

"Well, we're on our way," the man said, "so I wanted to thank you for another nice evening. You are indeed a great hostess. See you next time I get to Toronto."

Xaviera got up to walk him and the sculptress to the door.

Chuck was waiting for Marilyn in the living room. "We'd better get going, too," he said.

"Yeah, it's been a nice evening," Marilyn said, looking into Xaviera's eyes.

"I'll ring you late in the morning, hey?" Xaviera asked. "Maybe do some shopping and then talk a while?"

"Super," Marilyn said.

"Bye," Xaviera called as they walked down the hall to the elevator. She closed the door and went directly to the telephone. She dialed and waited for the party to pick up. After seven rings, she said, "Josef, too bad you missed a good party! Marilyn is just great. I have got this strange feeling that she wants to go to bed with me. You like that idea, hey? Well, you want to know something? I kind of begin to like the idea, too… Sleep well, and *auf Wiedersehen.*"

Marilyn sat alone on the balcony outside her suite at the Four Seasons. The pool was a turquoise square in the dark night. A million stars filled the sky. She pressed her hands down between her legs and tossed her head back. She was thinking about Xaviera—sitting so close to her on the bed, her breasts moving up and down as she talked to her from the chair. She was remembering Xaviera in her skinny bikini at the pool, the softness of her large motherly breasts at the photo session. She wanted to go to bed with her so badly now, but she knew Xaviera had to make the first move. The trouble was, Marilyn thought, would she ever do that?

She pondered the question until she fell asleep there under the stars.

WEDNESDAY

It rained during the night, and when morning arrived, the leaves and grass and deck chairs around the Four Seasons pool were covered with water. The sky was dark, with little beams of light breaking through the clouds, as though the sun wanted desperately to appear. Marilyn Chambers stood on the balcony of her suite, looking down at the little outdoor cafe near the pool. The umbrellas looked dark and wet. Marilyn hoped the sun would soon break through and make everything look bright again.

Chuck Traynor stuck his head out of the door. "Marilyn, I'm leaving for the day."

"Oh, right. I'm going shopping with Xaviera, if the weather looks good. I was hoping we'd get to swim this morning, but it doesn't look like we will."

"How's it coming?"

"What?" she said with a grin.

"The book."

"You know, Chuck," Marilyn said honestly, "I really can't think of it as a book. I mean I'm not conscious of it. I know we've got the tape recorder going all the time, but I just put it out of my mind. It's kinda like the audience is out there, but I'm not really aware of them."

"Maybe that's the best way to think of it," Chuck said. "Listen, this business deal will take all day, and I have to be up and out of here early tomorrow, same story. I'll see you late tonight then, all right?"

"Sure, and you'll be back tomorrow night, right?"

Chuck nodded. "Yeah, and we'll fly to New York on Sunday."

"That's Xaviera's birthday," Marilyn said. "She's having a big party for a hundred and fifty people out in the country, and we're invited."

"Honey, you've got a show to do at 7 a.m. Monday morning, and we've got that newspaper interview set for Sunday night. We have to get a flight out of here before noon."

Marilyn frowned. "Yeah, I know… I was just hoping maybe there would be some way we could fly out later."

"We can't," Chuck said.

Marilyn saw that he was right. "Xaviera's leaving for the country Friday night. I guess Friday afternoon is the last I'll see of her."

"For a while," said Chuck.

"Right," Marilyn said, "for a while."

Chuck kissed her on the cheek and left. Marilyn heard him close the door of the hotel room, and then she went back inside. It was a dreary morning. She wondered whether Xaviera was up yet. No, she wouldn't call her. Xaviera had told her at the party that she would ring her late in the morning.

Marilyn crawled back into bed and fell asleep.

"No, just orange juice, one English muffin, and that's it," Xaviera said to the waiter.

"I'll have the same," Marilyn said.

They were sitting in the hotel coffee shop. Xaviera had called at eleven, and Marilyn awoke instantly at the sound of her voice. She agreed, it was a lousy day. Did they still want to go shopping? Neither of them could decide. So they planned to meet for a small breakfast and decide later.

"Chuck went to Montreal on business," Marilyn said.

"When will he be back?"

"Tonight," Marilyn said. "He has to go back tomorrow, too, but he'll be back at night, so we'll have all Saturday to spend together."

Xaviera asked Marilyn if she was coming to her party on Sunday, but Marilyn explained that she couldn't. Xaviera understood

and told her that she would be missing the social event of the season. "Will it be an orgy?" Marilyn asked with wide eyes. • "Better than an orgy."

"What's better than an orgy?" Marilyn asked.

"*I am.*" *A* low voice said. They looked up. It was the young waiter, standing there with two glasses of orange juice in his hands.

"Is that so?" Xaviera said, sensually. "You want to come to my birthday party and make it better than an orgy?"

"Can I bring someone?" the handsome lad asked. "How old are you?" Xaviera asked. "Nineteen."

"Well, you're a consenting adult. I think you should be able to bring someone along. Who?"

"My lover."

"Who's your lover?"

"His name is David."

"Aha." Xaviera smiled. "Okay. You're both invited, just don't go about seducing the straight folks."

"Of course not." The young waiter grinned and sauntered away, making sure he swung his ass a few times for their benefit.

"My God!" Marilyn said, amazed at this conversation.

"Isn't that something? That kind of thing happens to me all the time. I egg them on. It's fun."

"I love it. And you know something else? I really liked how up-front he was about being gay."

Xaviera said, "I don't like the queens who lay it on too thick."

"No, I don't, either," Marilyn said. "But he was just being honest, if a little provocative. He must know who we are."

"Of course he knows. I'm sure he doesn't do that routine on just any tourist who might be in this place, or else he could lose his job. Talking about jobs and job discrimination with homosexuals, I am happy so many gay people are being honest about their sexuality, even though to some it might still mean embarrassment, humiliation, being ridiculed or discriminated against. The gay lib movement is fighting against job discrimination. Quite a few homosexuals, who are open and proud and yet 'private' about it, have

been fired from their jobs and they have had the guts to take their case up to the highest courts of Canada. Not so much to defend their job position as to prove to the world that they are within their rights and that what any person chooses to do in his or her bedroom should have no consequences in respect to their jobs. If a man is married to a woman, he can talk about that at the office, so why can't a person talk about his or her lover of the same sex?

"I think both women's lib and gay lib, as well, have made more people aware and proud of their love feelings that they have long been hiding. Talking about women's lib, ten years ago, men walked out on their family leaving the kids with the wife. Now more and more women walk out on their family, leaving the kids with their husbands. Having no children of my own yet, I cannot really choose sides. In my opinion, young babies and kids do need their mother more, but if they are over the age of ten, for instance, I am sure the father could take care of them just as well."

"Male homosexuals are so much more obvious in this city than lesbians," Xaviera said. "Maybe it is because women throughout history have been able to walk around holding hands, going to the ladies' room together, sleeping together, even, and nobody thinks anything of it. But two men? Forget it!

"Too bad people always see the wrong side," Xaviera continued, "the criminal aspect that the newspapers often write about. Like the Houston murders."

"Yeah," Marilyn agreed. "That would never have been as sensational as it was had the man been murdering little girls. It would have been grisly and horrendous, but not quite as startling as it was because of the homosexual implications."

"The sadness of gay life is often emphasized," Xaviera said, "and there is some truth to that, but I don't feel it should be dwelled upon. I lived in a hotel for about two years that had two gay discotheques and bars and almost totally gay personnel. I really had a marvelous time. It was nice to go in after a night on the town just for a last drink or dance. The music was always good. Everybody knew me. If I felt like it, I could pick up any gorgeous-looking girl. Some nights

there was a rather mixed crowd of 'straight' couples who were not too straight, but interested in picking up a third party to join them. Then there were the swinging couples, with gay tendencies, but that was usually on Saturday nights. During the week it was predominantly a gay crowd. There is a Dutch expression: *Elck wat wils*—which means, for everyone there was something. The majority of people, however, were gay men in their multicolored outfits. It was nice to be recognized, but sometimes those gay boys became too familiar with me. I don't mind the 'Oh, hello Miss Hollander, how are you's?' and 'Do you want to dance?' but oftentimes it got a bit too much for me, a bit *too* tacky and pushy. The nice thing, however, was the rule in a gay disc, that one could dance with whomever one chose. Boy-boy, girl-girl, boy-girl, boy-girl-boy, girl-boy-girl. And *that* most straight disc's will forbid. I once tried to dance with a girl-friend of mine in a 'swinging' straight disc, and the manager tapped me. on the shoulder saying, no two people of the same sex allowed to dance. So I made a male friend join us, but within minutes again we were warned: no go. Pissed off, we all left, including a group of ten friends, and went to the gay disc where we could at least carry on with whomever we wanted. Gay bars are sure more liberal as long as you don't pick a fight or ridicule the gay folks.

"The lesbians are usually much less obvious… but the big bull dikes, those bitches, can claw your eyes out. They often are tougher fighters than men, and jealous as hell. The average gay girl is quiet, peaceful. They sit around in couples, while the guys more often than not are unattached and nervously cruising for a new lover. A lot of them are super insecure and they keep running in circles to the gay bars or baths. Eventually they end up lonely. There's nothing more depressing than an aging homosexual."

"*Boys in the Band*," Marilyn added.

"Yes. it's so much worse when the older man falls in love with a young chicken, and then the older guy gets fucked around by this young boy who really is nothing more than some cheap hustler who's constantly cheating behind his back. The same happens to an aging man who falls in love with a girl thirty years his junior. If

she hasn't got a father complex, she can only be after one thing: his money."

"Have any lovers done it to you?" Marilyn asked.

"Not too often," Xaviera admitted. "Some have tried. I'll pay as much as *I* want until I feel they are trying to take me for a sucker. Luckily, that doesn't happen often. Among gay men it seems more difficult to maintain a stable relationship, in particular when they get older. Also, because of the fact that two people of the same sex can *not* get married, they tend to break up quicker. I think if homosexual marriages were allowed, a lot of these problems would clear up. There is still a great feeling of security in marriage, and I think gay people need that, even more than straight. I know two men in Toronto who did get married officially. They have a nightclub transvestite act here. They somehow found a loophole in the Texas law and went there and got married. So now they also have a lot more social benefits married people have."

"Texas?" Marilyn exclaimed. "That's terrific!"

"Dallas, I think. I wonder why the male homosexuals in general are always trying to attract everyone's attention by being so obvious in the way they talk, walk, or dress? Why be such an exhibitionist about your social preference?"

Marilyn said, "Because for so long it was not accepted. You can compare them to the female liberationists nowadays. They want acceptance and aren't afraid to shout it to the world. I think you're generalizing too much, though, when you say that most of them are obvious."

"Well, yes, but I'm doing it to make a point. I'm talking, I guess, about the obnoxious types, the stereotypes, and not about the gray-flannel-suit man who is also gay but keeps up a straight appearance. But they are never the ones who shout I'm proud I'm gay."

"Oh, yes, they are," Marilyn said. "At least in California." .

"I have a few gay friends here and you'd never notice they're gay, you'd never know it."

"They're everywhere. No one notices them because they look and act and talk like everyone else, and often they have top positions."

"I keep seeing the guys going to bars, one after another, cruising all the time. I wonder why?"

Marilyn said, "Well, look at the swinging singles bars, I think that's the equivalent. Those places are full of so-called swinging-but-straight people on the make, looking for sex partners for that night; it's noisy in there. Everybody does his or her whole ridiculous number; they wear whatever is in vogue—puka shells, now—it is a constant competing and comparing, Afro style hairdos, crew-cut, Beatle cut. They are always trying to imitate someone else, and you seldom find originality in those bars. They are all coming on to each other like gangbusters, and often the men are disgusting, loud, drunk… bragging about the chicks they laid, and how many times. All a lie! And to top it off, they put down gays!"

"I think you have a point there," Xaviera conceded. "I think the basic thing is that those people are lonely—gay or straight. The bar is an escape from their flats, parents, or TV sets and TV dinners; a social place to make contact and find someone to talk to. There are still numerous so-called 'straight' men who are really closet queens. I notice them sometimes, dressed in business suits, shortcut hair, still a wedding band on tfteir finger, getting drunk in a hurry, looking around hungrily, searching but not quite knowing for what. They go about it so very awkwardly, and again the young husky hustlers spot those closet queens right away. Make him pay through the nose for drinks, dinner, and… sex. But he's got what he wanted… maybe after ten years of straight married life. So what if he paid for it? It was maybe worth the experience. Next time around, the same man will get smart, maybe change his hairstyle, suit, or mannerisms, and become accustomed to the gay scene. Or… he is turned off for life and runs back to his wife, or lives a perfectly bisexual existance, equally happy in male as well as female company. It is often easier for gay men to pick up a boy who wants to ball. In Toronto, right close to where I live, there is a street full of male hustlers. The girl-hookers are all working bars and massage parlors, but the boys, all young, from age thirteen to twenty-five, freeze their balls off outside when winter comes, but business is booming, lots of tourists and

conventions in town. Then, of course, if homosexuals know their way around town and don't need to pay for sex, they can get all the activity they want in the gay baths where there is a great selection of horny men and, if they want to be totally anonymous, even a dark orgy room where everybody can fuck and suck and grab everybody else. Not very personal, mind you, but it beats beating off at home. My friend Serge used to do the orgy room scene occasionally. Fun as it was, about once or twice a year he'd pick up a little souvenir: a case of gonorrhea. That's the chance you take, gay or straight. A few good penicillin shots cured him—a sore ass and no booze or sex for a few weeks was the price to pay.

"By the way, there was a great play I saw with Serge a few months ago. It was called *Tub Bath* and it showed the whole steam bath scene, intrigues and scandals. Excellent play! Didn't require too much acting talent. The boys were just playing themselves!"

Marilyn nodded. "Yes, I've heard the critics rave about that play. If I have a chance I'll go see it."

"Men always seem to be much more obvious about being sex-hungry; sometimes their games are absolutely ridiculous and im-mature. And that's why I believe more and more women prefer to be in female company. Maybe not sexually, but emotionally, it's more peaceful. And if two women get along well they might just settle down and spend the rest of their lives together. Sometimes just as friends and often eventually as lovers, as well. Women are not so hung up on sex as a basis for a good relationship."

"I think women are more patient than men," Marilyn said, "or they're supposed to be." She finished her muffin and curled her legs up under her in the booth. "Men are hunters. Men turn off when you're too aggressive and too strong in your come-on. Some want you to be a nice soft chick all the time, others get mad if you are too docile. The challenge to me is to be disciplined to the point where I can just tell myself, this is how I want to be and I love it, so I'm not gonna fight it any more."

Xaviera asked, "Do you think you could have the kind of rela-tionship you have with your man with a chick?"

"Not unless she's the dominant one."

"In other words," Xaviera explained, "could you live happily with a chick?"

"No."

"What would be missing?"

"Cock," Marilyn said.

"Cock, you need real cock. No plastic penis with a squirter inside will do?"

"Nope. It's... well, the thing that kills me is that girls actually think those dildoes are the real thing! The great thing about a real live man is that he can say, 'Ready? I'm ready... I'm gonna come... do it with me!' or he just asks if you're ready to come... ooooooh, that's the exciting part!" She put her hands between her legs and let out a whoop. "I can feel it right now!"

"Could you ever have a... say, married existence with a girl, Marilyn?"

"I don't think so. Could you?"

"I don't think so. Well, I almost did with the Jamaican girl I already mentioned, my blond angel with the boyish figure. It was much more emotional than sexual. In other words, sexually she was very passive. I was the aggressor, the butch, so to speak. I always pleased her. She had a low sex drive and I went down on her only a few times a week, but for at least an hour each time—sore tongue sometimes, once I even got fever blisters on my lips in the summer time, from the sun and that beautiful hairy, kinky honey pot.

Marilyn smiled and licked her lips. She loved Xaviera's stories—they were just like her books.

"But J loved every minute of it and did it to please her. Seeing her happy made *me* happy, as well," Xaviera said, "and it took her that long to have an orgasm. I would never stop until she had one. Her cunt tasted so delicious I can still taste it when I close my eyes. But there was 'love' in the sense that if she would walk from the bathroom to the living room and she had maybe just washed her hair, her neck wet with water, smelling fresh like a daisy, while I

was sitting in the living room reading a book or listening to music, I would just feel this tremendous warm glow for her, just looking at her excited me. No matter how much I loved her, though, physically I knew there was something lacking. And to put it very simply, I needed cock. So I will never be totally gay. Men at least have all that equipment to use."

"Did she give you anything at all?" Marilyn asked.

"Very little sexually, but an awful lot of affection. You know, sleeping cuddled up against my breasts, on the beach her head on my stomach, holding my hand, kissing me. She was like a kitten, soft, warm, moist, purring, adorable. And what I loved very much about her were some of the love poems she wrote. She wrote the most beautiful things anyone has written to me."

"Did you live together?"

"I was living a divided life," Xaviera explained. "During the week, I lived with her in my own apartment, and on the weekends I would be with my man from Friday night till Monday morning. In Jamaica, the gay life is really very subdued, if not nil, and she liked to go out to some local gay bars. She loved good music and dancing. I introduced her to quite a few gay friends, male and female. But she was very faithful. I didn't expect her to spend every weekend celibate, yet she'd sleep alone and wait for me to come home on Monday."

Xaviera paused a moment and reflected. "My life was very complicated, living a totally active bisexual life between my man and my girlfriend. Somehow, it seemed that he was more selfish, which maybe wasn't the case, but it seemed so, because she was so totally unselfish. After making love to her, we caressed and kissed and ate and drank in bed, listened to my records, talked for hours until we dozed off. After sex with him, he would often light a cigarette and jump out of bed or be so tired he'd fall asleep soon after he had reached an orgasm. It disturbed me. Our foreplay was always great. Sex with him was more satisfying, but the aftermath was occasionally very quick and cool. With her, sex wasn't all that gratifying, but afterwards we would be in heaven."

"So her unselfishness emphasized his selfishness. Also the fact that she wrote you love poems, that shows a lot of feeling and affection. You probably wanted the same thing from him."

"Right!" Xaviera said. "I love to be romanced. Very old-fashioned of me, maybe. She would buy me records with what little money she had and she would give them to me with poems. Here, I brought some of our poems along to show to you. I wrote to, her as well. It was so idyllic. This poem I found after I had been away for twenty-four hours with my man:

> … Last night when I came back you were gone
> gone for twenty-four hours
> and on the pillow was a lovely note
> saying you missed me
> but I doubt you missed me more than I you.
> It was so empty.
> No sound of water running in the tub,
> no typewriter banging away
> no telephone ringing
> no warm body next to mine
> … just nothing
> but the lingering aroma of your presence you left.
> I fell asleep thinking of you,
> my hand resting on your panties
> guarding the woods of Jamaica
> Yes, I missed you too.
> Another one:
> You, without the people
> You in the soft light of the bedroom
> no makeup, no pretenses.
> Silver cups of rich, thick juices
> so warm and tender.
> Close together… touching
> no hustle or bustle
> (other than the fucking phone)

Satin sheets that we glide across
trying to catch the other
or merely just trying to keep still
… and the laughter
of our shared secrets.
Your flirtatious eyes tease
and taunt me and I know then that I've got to run for a while
to eat alone while you belong to another
for an hour, a day, or a weekend
don't you ever get tired of it?
I come back
(as always)
to the one I left
to the familiar cuddles
no hustle no bustle
Just you alone.
The you I love.

August, 1973.

"You're really a romantic!" Marilyn interrupted.

Xaviera took a breath and seemed miles away when she nodded. "Oh, yes, I was and still am. Her favorite poets were Pablo Neruda and Leonard Cohen. Sometimes I could cry. There was one record she gave me, Hubert Law's *Morning Star*, and if I listen to that record today, I still break up. I was once making love to a man I'd been dating—this was a year after she had left for Jamaica—and I accidentally put her record on. I thought, I'm over this affair, right? This music won't bother me, when all of a sudden Hubert Laws's flute began with "Amazing Grace." In the middle of intercourse, I started crying all of a sudden, and in my fantasy, his body melted and changed into her body. I missed her so tremendously. My body craved her, so much that my legs and arms began to ache. He didn't know what went on in my mind. I just squeezed him and put my head on his chest and for the duration of that entire flute solo, I cried and when

I later tried to tell him, he didn't understand, he couldn't... he just couldn't. I simply *cannot* compare the love for a woman with that for a man. It will take many long philosophical talks.

"You mean he couldn't grasp it?" Marilyn asked. Xaviera nodded. She was obviously a little upset, remembering the girl now so vividly. "Yes, he was unable to grasp my feeling, my sudden desire to be with her and hold her body close to mine! And it was a whole year later!"

"I find jealousy is always the biggest problem in a love affair," Marilyn said. "Did you get jealous of her at all?"

"Mmmm, yes. Especially when she was on the phone and I didn't know who she was talking to. She didn't laugh very much, but somehow when she was on that phone with her friends—her platonic friends—she was laughing like a waterfall, and I was so jealous of anyone but me being on the receiving end of her chuckling laughter. I tried to make her laugh myself sometimes, but with me she was serious, soft and romantic. With others she was a friend and she shared humor rather than deep emotions."

"Do you try to stop yourself from jealousy? Do you think it is a bad thing?"

"I hate it and I love it. I am a very possessive person. Love is beautiful, but sooner or later it hurts. It is a pain/pleasure feeling, especially when there is jealousy involved. Sometimes when a love affair is almost over and you're struggling to pick up the pieces, you finally realize some of the stupid things you did. How you hurt the other, teased or cheated. How painful you made it all for both of you. When it is too late to repair, one feels remorse. Why? Why did I do this or that? In a way, I am undiplomatic and tactless. I always realize too late that you can't walk over people unpunished. I can't help it. I have always had a tendency to be somewhat overpowering. I am usually completely in control and have certain people in my power. I am under their skin, whether they want it or not. And then... then comes the pain. Once I know, for instance, that a man loves me a hundred percent I know he is most vulnerable then. Subconsciously I will hurt him by teasing him, making him

jealous, or giving him some kind of inferiority complex. I know he won't leave because of his strong love for me. So he crumbles before my very eyes and hurts. That is why I need a very strong man with a much stronger character than I have. Then… I won't play those silly games, because he can kick me right back." Marilyn said, "Then she—the Jamaican girl—she must have suffered as well, loving you that strongly, and you must have been more and more selfish as she wanted or needed you more."

"Yes, right. I was always in command, but she was headstrong in her own way. She could be quite demanding, she wanted me to give her everything. From the beginning she had to understand I lived a double life and could never be hers one hundred percent. She put up with that. And though she might have suffered, she seldom complained. On the contrary, she was very complimentary."

"Chicks, if they really love you," Marilyn said, "will always tell you. With guys, well, sometimes you can't get a compliment out of them for all the money in the world."

"You are right, men can be outright horrible. Let me tell you a story about 'compliments.' While I was living with my Jamaica girl I weighed about a hundred forty-five pounds. I was really getting quite hippy, you know? When I think of it now, I can't imagine why I let myself go. Now I'll stick to a hundred thirty pounds."

"I know what you mean," Marilyn said.

Xaviera flashed her big eyes at her. "Oh, come on," she said, "you haven't been overweight a day in your life!"

"That's what you think!" Marilyn said with a grin. "Well, take it from me, I do know. One evening when my man and I were supposed to go to a fancy party, I met him at his apartment wearing a new skirt I had just bought, a long black velvet skirt with pink flowers and a green silky blouse. I still remember the combination of colors because it made me look slimmer. He was still living on his own then, in a loft with wooden beams and a skylight. Very romantic, a real love nest, brass bed, candles, cozy pillows all around." "Sounds like a movie."

"Well, he hadn't paid me a compliment in a long time. He knew my Jamaican girlfriend was living with me those days and he obvi-

ously knew about my bisexuality, which must have been somewhat frustrating to him, but he really didn't show it until much later. Anyway, I was standing in front of him, waiting for a compliment. He didn't say a word. 'Don't I look nice?' I finally had to ask him. And he uttered the words, 'What do you want? A compliment? What's underneath is fat and ugly.'"

"You're kidding!" Marilyn exclaimed.

"No. And he had a mirror hanging on the ceiling, it was like having our own porno movie when we were in bed… oh, that's what you said in your book…"

"It sure is," Marilyn said. "I still believe porno films should be shown on the ceiling, so people can fuck while they're watching them."

"I agree. However, I was frustrated and furious at him for coming out with such a crude remark at the wrong moment. Fifteen minutes after our argument he pretended nothing had happened and tried to kiss me. I jumped up and yelled at him. 'Don't you touch me, don't you dare come near me. After all, how could you touch something fat and ugly?' I also ordered him to remove the mirror from the ceiling immediately because I sure wasn't going to let him have a double view of me for quite some time. Remember I was spending the entire weekend with him, and obviously in his bed. He seemed to have forgotten the incident that same night, but I hadn't!"

"Oh?" Marilyn said. "How come?"

"Well, you know what?" Xaviera answered. "I actually turned completely *frigid* for the duration of a month, at least, with him. I could *not* manage to have an orgasm, no matter what he did to me. I was so screwed up and depressed. So I went on a crash diet and lost about fifteen pounds in a hurry, starving myself almost to death. Drinking eight glasses of water a day and seeing a famous dietician who gave me a thousand-calorie-a-day program. It helped and, once I was down to a hundred thirty, I felt great and was actually happy my man had given me shit a month earlier. Once I knew I looked better, I bought myself a new wardrobe, size ten instead of

twelve, and our lovemaking improved one hundred percent. I was a more self-assured woman, knowing I had regained my sex appeal… though I had learned my lesson the hard way."

"And," Marilyn asked curiously, "did you get a compliment at long last?"

"But of course… he bought me a beautiful bracelet and earrings, and apologized for having been so rude." Xaviera smiled.

"Look," Marilyn pointed to the dark clouds. "I know it's going to get sunny…" They left the coffee shop.

"Sure," Xaviera said in a low voice, pointing to something else—sprinkles of rain hitting the glass wall. They walked around the lobby, looking at the magazines and the paperback books, and then sat down in the deep-cushioned easy chairs that looked out onto the courtyard and pool area. "Let's see if the sky will clear up."

"Is the weather always like this?"

"No, it usually is very sunny and nice. We could go out anyway."

"I'd hate to be caught in the rain."

"Yes, it really takes the fun out of shopping. And I had already planned to take you to a wonderful outdoor restaurant for lunch.

"I'd love that!" Marilyn said.

"Do you mind sitting here?" Xaviera asked.

"No. I'm tired of the room. This is fine. We can talk here as well as any place. Turn the machine back on."

Xaviera pulled the tiny tape recorder out of her bag and pressed the RECORD button. Marilyn said, "Here we are again, folks, the dynamic duo on a crummy morning." They both laughed.

"So you can't give up cock completely," Marilyn said.

"Never, but I guess I am greedy. I love them both: cocks and cunts. But if I were put on a desert island and had a choice of a man or a woman… to keep me company… You see, when I am with a woman in bed she never has to tell me what to do. I have the fastest tongue in town. I can eat better than any man, so I'm told. There are so many women who have never had an orgasm with a man because guys don't know anything about eating pussy. It often takes a woman a long time to get fully aroused, and men don't realize that. They

think a lick or two will do, and then they ram their hard rods insid her and think the woman should come right away."

"You said you eat a girl better than most guys," Marilyn remarked.

"I think that men give the best blow jobs because they really know what it feels like to get one."

"That reminds me of a party I once had, in the 'orgy-time' days. Of course, Serge was there as well. There (were about ten people at my place. Mostly heterosexuals. Except for Serge, who had a gorgeous French-Canadian airline steward with him for the evening. His name was Lucien, I believe. Anyway, Lucien decided to go straight for the occasion and was carrying on with two chicks in my bedroom. Meanwhile in the living room I had a *menage a trois* going myself, and on the couch was a good buddy of mine, a very straight Lebanese Jewish banker, whose first orgy this was. Marc was his name, married and four kids—at home, of course. Marc loved pussy, and since this was his first group swing I had planted a gorgeous German blond girlfriend of mine smack on his face. So Marc was sort of half sitting, half lying on the couch—naked. My girlfriend had spread her legs over his face and buried his mouth and nose in her delicious crotch that I myself earlier that evening had sucked till it was good and wet. Marc was quite content with just eating pussy for a while, but Serge was *not.* Upset about the unfaithfulness of his lover Lucien, he roamed around the rooms restlessly. Cunts were not his bag, and what he wanted was cock. So even though I was rather busy in my own triangle, I noticed how Serge was slyly and slowly approaching Marc, who by now had a gigantic erection sticking up in the air. Just eating pussy was enough for him to almost ejaculate untouched. But Serge wouldn't like to see that 'come' go to waste in the air. So he kneeled in front of the couch and then bent his head over Marc's cock and slowly lowered his mouth over the head and the shaft. By this time I was so curious that I left my group and sneaked over to where Serge was. Boy, did he ever suck Marc's cock well! Deeper than even Linda Lovelace could do it. Slurping sounds came from his mouth. Within a few strokes, Marc

moaned, still with his face in Inga's pussy, and pushed Serge's head all the way down on his cock... his sperm shot right in Serge's throat. I could hear the gurgling sounds of him swallowing every drop of it. At that moment, Marc pushed Inga oft his face and to his great surprise noticed that it had been not a woman's mouth but a man's mouth that had given him this shattering orgasm. The expression on his face was worth a hundred dollars. He was shocked but... complimented Serge on having given him the best blow job he had ever had. So you see, no matter how straight you are, there is always a chance of being converted, if only for one occasion."

Marilyn nodded and said, "And with a woman, a good lesbian can do a far better job than any man, because she knows how it feels and she knows exactly what to do. Especially with chicks, like you said, Xaviera, they often take a long time to get there. Well, if one woman is eating another one, she knows how long it takes and she will understand that, she'll never get impatient, she'll keep eating her until her girlfriend comes. But if she doesn't get a full orgasm, she's not going to feel like, well, I didn't satisfy her. She just didn't come, that's all, but it was groovy anyway. Chicks have an understanding of what feels good and what's best. Not whether you come or not, that's not necessarily important. But when you're with a guy, it's an ego trip. If you don't come, he's going to get uptight and think he's not a good lover, and you feel as if you owe him an orgasm. So next time you try harder, and the more you try, the less you get there. Eventually you are both uptight and end up on a psychiatrist's couch."

"But then when you are with a man, you can fake it. No man will ever know for sure whether his wife is really as hot-blooded as she makes him think she is."

"Sure. It's easy. You don't even have to be a good actress to do it convincingly. Breathe heavily, make some noises, and he'll think you came, and he'll be proud and happy. But... it's so dishonest, mostly, for yourself."

Xaviera shook her head. "I'm not really a screamer, but there are other ways my man will know I am ready. It doesn't take much

for me to get turned on. Kissing alone gets me hotter than hell. I'm usually very fast, though. I come fast. My eighteen-year-old lover, Robert, had trained himself to come nice and slowly, not popping off like most kids that age. I like that because then I can come several times, but if it goes on for more than fifteen minutes my pussy gets sore. Unless, of course, we start all over, relax, and begin with oral sex orgasm to get more juices flowing. He must have one of the warmest, longest tongues I ever had!"

"You know, coming together is really a marvelous sensation, and I like my lover to hold off if he can so we can get it together... but don't get hung up when you each come separately. It takes a lot of experience and teamwork to get it together."

"Oh," Xaviera said, excited, "I like it when he quivers and he's just about to come and his balls swell up tight and he's holding back..."

"Yeah!" Marilyn said, moving forward. "It makes you go all sticky inside and you feel *ahhhhhhh.*"

"And sometimes after the orgasm the come just trickles out of your wet pussy and you feel it on your legs..."

"I think of come, hot creamy come, and it's so beautiful, so delicious..."

"You like semen?" Xaviera asked. "Oh, yes! When he pumps into you, it really adds to your orgasm—at least it does to mine. It's such a strange feeling, like somebody pissing inside you."

"Did you ever have that happen? Pissing inside you?" Marilyn's eyes widened. "Yeah, Oooooooh!" "I haven't."

"Haven't you?" Marilyn seemed amazed that she'd done something Xaviera hadn't.

"No," Xaviera said. "I don't think that really turns me on, too messy. I don't mind peeing on each other's genitals when we're in the shower together. That is quite exciting if he aims his warm pee against your clitoris—of course, you switch off the shower for a moment. I get off on that all right."

"It surprised me that you haven't. I just assumed..." "No, it hasn't happened. Most men just come and pull out. It seems to be physi-

cally impossible to keep a hard-on and pee at the same time. I've had some of the most erotic times when I had a full bladder and I didn't want to get up and spoil our fucking by going to the bathroom. It's like you're dying to explode and yet you're so horny that you'll take a chance of staying full."

"But I hate it," Marilyn said. "I can't come if I have to go to the bathroom."

"Talking of orgasm and peeing, listen to this story," Xaviera said. "I once had to rent a private twin-engine plane to get from Vancouver to Calgary, since there was an airplane strike going on in Vancouver. I had been stuck there for over a week and had to get back to Toronto to do a national TV show. The TV station offered to pay for the rental of a private plane. So I had to fly over the mountains and, once in Calgary, I would take a regular flight to Toronto. I was sharing the plane with a very important businessman from Vancouver, whom I had never met before. The pilot informed us the flight would be no longer than one and a half hours. So since I have a very small bladder, I took a pee before getting into the plane. It was midwinter. The mountains were covered with snow. Once in the plane and in the air, a freezing cold wind blew up from underneath our legs. I wore blue jeans and a suede jacket. The flight seemed endless, we supposedly had counterwinds. So, instead of one and a half hours, it took an hour extra. For the last hour and a half I had to pee so badly it began to hurt. In the beginning, I just squeezed my hands in between my legs to keep my crotch warm. It was the cold wind that made it all the worse. As time passed, I really started to get a pained expression on my face. The businessman was worried. I was embarrassed to tell the truth. I finally told him that I was not sick, but just had to go so badly to the bathroom. He then kindly offered me an empty plastic coffee cup he had in his attache case. As much as I had to go, I now started to blush from embarrassment and declined his offer saying that I would easily overflow his cup and that the whole scene was just *too* much, after all we were total strangers. Marilyn, when we finally arrived in Calgary you have never seen a passenger make a run from the plane to the ladies' room in a shorter period of time. You know

what? That pee, finally, after two and a half hours was the most *erotic* experience I have ever had. The feeling of relief and being able to finally *let go* was absolutely fantastic and beats any orgasm I ever had. By the way, the businessman and I did get quite intimately acquainted, and you know what? He insisted every time before we made love that he watch me pee, in the toilet, nothing too kinky."

"What do you think about group sex when you are in love?" Marilyn asked.

Xaviera thought for a moment. "I'm changing my attitude on that. It doesn't do as much for me any more as it used to. Lately, I have come to think more about sex as being basically an act between *two* people. It's hard enough to reach a mutual orgasm with two people, and I would say it's nearly impossible with three or more. Group sex is fine when you're *not* emotionally involved, and just go for the heck of it. When I am in love I don't need an audience or other participants. I don't mind when some guy sits there jacking off while I'm with a girl, as long as he doesn't touch us. And even if I were with the man I love, and he wanted a threesome, I would apply the same rules: watch, don't touch. I am too selfish and possessive. I want it all to myself. I guess a man is better off if I just like him and don't love him. Then we can have all the sex games in the world; otherwise it's: sit tight and take a firm grip of yourself. Sometimes afterwards, when I've made love to a girl and I am ready for a good orgasm, then I'll need a cock. So that's when I would like to call in the reserve troops to fill my juicy pussy up."

"Yeah, what I like about it," Marilyn said enthusiastically, "is the mental stimulation. Your old man is sitting there holding his cock in his hands, and he's digging it, digging seeing you with your face plastered between some beautiful girl's legs, and you're eating her and in his mind he's fucking you at the same time… sometimes not only in the mind, sometimes it's great to have him fuck you when you're eating her."

"Whenever I'm dancing, I think about people fucking, and when we took those photographs, well, I thought of a sexual sandwich, wishing some gorgeous hunk of man would hug us both."

"Tell me," Marilyn said, "was it just a regular fun photo session to you, or did it feel… well, good at times?" Marilyn seemed more serious than usual. She could feel her nipples perking up as thoughts of Xaviera naked floated through her mind.

"Well, to be honest," Xaviera said, "I keep thinking how good it was when I was rubbing my nipples up against yours."

"I liked the audience watching us," Marilyn said.

"That's what I dug about doing a film. I'm a little like you, an exhibitionist. That's why I get off on photo sessions like the one we did. I loved your blond pussy. I know I said that already, but I still can't get over how it looked like a little penis from a distance. Your hair is almost a skin tone down there. With you I didn't mind having nude pictures taken. Because I like you."

They got tired of sitting in the lobby—it wasn't the best place to carry on a private discussion. So they took the elevator up to Marilyn's room. The view from the balcony was worse than the view had been from the lobby—you could see the black sky. "Yecch," Marilyn moaned. Then she opened her purse and pulled out some pills. "Vitamins," she offered when she saw the inquisitive look on Xaviera's face.

"I thought maybe they were speed or something."

"God, no! I don't like drugs at all. Good food and vitamins and some grass once in a while."

Xaviera picked up a paper that was lying on the table and glanced at it. It reminded her of something she had wanted to ask Marilyn. "I remember reading about those gunmen in Las Vegas who made an attempt to kill you. I thought, oh, more publicity for Marilyn Chambers. Especially Vegas, they do anything there for a plug in the local papers. Was it just publicity?"

Marilyn shook her head. "That was for real. It was an extortion attempt for about sixty thousand dollars. We didn't owe anyone money, it was all a lie; so the gunmen tried to get the money from us by force, but fortunately, the security in Vegas is very tight and they got the guys—guns and all—the night they had threatened to kill us. Even Chuck was a little shook up about that one, and he's the guy who usually shakes people up!"

"Anyone with a name is open to things like that," Xaviera said, knowingly.

"We've gotten burned by too many people who were supposed to be our friends. I've really come to think that in show business there's no such thing as a really good friend. You can't trust anyone. I trust Chuck, the only person I trust in the world. He's my best friend!"

Xaviera moved closer to Marilyn and took her hand, rubbing her fingers up her small wrists sensuously. "You have another friend. Here in Toronto."

Marilyn purred, "Mmmm, I know..."

"What kind of a person are you, really?" Xaviera asked, her hand softly caressing Marilyn's palm.

"I... I guess you'd have to say I'm earthy and homey. I'm a Taurus, so I really like my home and cooking and plants and animals. I love to be alone for long periods of time. Not forever, but I need solitude."

"It's wonderful to be famous," Xaviera said, "but there is that curse of seldom having any privacy. You're always surrounded by lots of people." She said it as though she herself was now resigned to the fact—not happily, but with a kind of detachment, as though she remembered the really private moments which had existed before she became one of the most famous household names in the world.

Marilyn lifted her feet up, twisted around, and put her head in Xaviera's lap. Xaviera stroked her hair. It was a gentle, almost motherly, gesture. It made Marilyn feel warm and secure with her new friend. There was that thread of sexual excitement which had existed since the moment they'd met—that thread which was constantly becoming thicker—but it did not manifest itself yet. It was muted and at times disguised, but never less intense than it had been the minute before.

"I'm always surrounded by people," Marilyn said, "and I always have to be 'on.' It really gets to the point where you can't wait to be alone. I've had two houses in the past two years, and I've been at home in both of them a total of five weeks. So for me to go home is like a vacation of sorts."

Xaviera looked down at the pretty face. "Oh, I could curl up in front of the fire in your A-frame house in the mountains and learn to do nothing…"

Marilyn just blinked and smiled. "I'll bet we would have a good time," she said, with an undertone of excitement.

Xaviera asked, tickling Marilyn's chin, "Can you really relax? Most entertainers don't seem to…"

"I can relax, but I can't be idle. I couldn't stand living in one place all the time. I love the glamor of traveling and meeting people. Even if I lived in one place, I'd be like you, I'd go to acting school and dance classes and things like that."

Xaviera nodded. "I have a particular problem. I'm tied to one country. I love to travel all over the world. This way, however, I save a lot of money and I settle for trips to Montreal because it's like a little Paris to me. I love Montreal. It's full of horny people, groovy discotheques, beautiful shops, fantastic restaurants, you name it!"

"Hmm," Marilyn said, sitting up again next to Xaviera, "I should go there! Do you have as many fans in Canada as you have in the States? Are they as demanding?"

"Well, I seem to have fans wherever I go, any country. I've acquired a large number of friends and acquaintances—through the years. Some of whom were originally fans."

"I like meeting new people all the time and being the center of attraction, signing autographs and all, but I prefer to be alone with just a few select friends outside that—mainly Chuck. When I say I don't have any friends, that's not entirely true. It's just that I don't spend a lot of time with any of them. I'm a loner," Marilyn stated.

"Well, I am very much the opposite. Once I got a call from a guy who said he was a journalist from England and he wanted to do a story on me. He had a magnificent British accent and sounded quite witty. I invited him up and he turned out to be this gorgeous young man who was just a fan of mine, he'd never been a journalist in his life. We became great friends. Another time someone wrote about me in a paper that I hadn't had a home-cooked meal in years, because while I was living in New York as a hooker, I ate out every

night with Larry or someone else, for about three years in a row. So, I got a few friendly calls like: 'If you ever need a good home-cooked meal, just call us up and be our guest,' and indeed I made some great acquaintances through those invitations. So maybe subconsciously I need that homey atmosphere, a little like you do, but not for every night. I still enjoy going out for dinner at least twice a week, preferably with a group of friends, say four or six people." "Oh, I couldn't stand it every night, either. But I'm so seldom home, anyway. I'm always doing a show or appearances or am invited to all kinds of boring parties. So it's a groove to be able to spend three days at home, cooking for myself and playing the housewife. I'm definitely *not* cut out to do that every night. I tried it when I was married to Doug. Drove me up the wall. All we did was eat and fuck."

"So the fucking was the better part?" Xaviera asked with a sly grin.

Marilyn broke into laugher. "Looking back, I'm not so sure!" she said.

"Eating and fucking are the two best things in the world—well, maybe two *of* the best things in the world." "What else do you like?" Marilyn asked. "Animals," Xaviera said and laughed. "I really love animals. Did you see my ten gerbils and my guinea pig?" Those gerbils, like hamsters, have it made. I started out with a male and female in one cage. Just feed them sunflower seeds, lettuce, and apples, and treat them well, and they keep on multiplying. She has had about six litters so far. Now I have two cages with ten gerbils. You know looking at papa and mama gerbil humping away can get me hornier than a billy goat. They are so cute and clean and need so little looking after. The guinea pig is something else. He eats up everything he can get hold of… shits and pisses behind the furniture. He's too big to be caged, needs a lot of care. But he's an adorable plaything. So cuddly. Too bad he hasn't got a tail like a rabbit so I can get hold of him easier. I call my guinea pig Austin, because once I saw an Austin car and realized how much the car and my animal look alike. They both had a big frame on small legs or, in the case of the car, wheels. I am not too keen on dogs and cats, at least not in an

apartment building. One day when I have a farm or a big house, I might get dogs and cats." Marilyn smiled. "Yeah, I miss my little cat, Sammy." "I'm sorry if I carry on about animals, like some people do about their kids. I talk too much, right? I'm a natural *schmoozer* as they say in Yiddish." "I'm naturally quiet."

"We make a good pair," Xaviera said. "But sometimes even I sit back and listen. Recently my man and I were invited for dinner by a well-known screenwriter from California. His wife is a lovely Asian girl who is much younger than he. We had a most delightful evening and an animated conversation about antiques, overseas travels, the movie industry, writing, and so on. I became aware of how intelligent my man was and truly admired him for his knowledge. He usually is like you, kind of introverted. I knew then that we all need from time to time to be with totally new people to get into a higher intellectual, cultural plateau. Others stimulate us, and we discuss things we had long forgotten."

"We need to meet different people to increase our own awareness of what life is all about," Marilyn said.

"Right, whether they are professors, chemical engineers, musicians, garbage men... or movie script writers."

"Or ex-porno actresses?" Marilyn whispered.

Xaviera nodded. "Or ex-hookers?"

Marilyn smiled. "When people stimulate each other's minds, there is a good chance the body will be very responsive as well."

"I always find,that when I go out for an evening with a very intriguing person, I come home all ready to make love."

"Do you... do you find me intriguing?" Xaviera leaned back and nodded. "I'm fascinated by you," Marilyn said. "Why?"

"Because you're different from anybody I've ever known."

"Now, that is a stimulating statement."

"Will you kiss me?" Marilyn asked.

Xaviera kissed her. It wasn't so much sexual as it was dear, lovingly tender. It was a way of communicating. They both still felt that sense of passion deep within them, but neither seemed ready to do anything about it. "I feel I've made a good friend," Xaviera said.

"You have," Marilyn panted. She got up and went out onto the balcony. Alan, the young actor, was back at the pool. When Xaviera joined her, she pointed him out. Xaviera waved to him and he waved back. Then Marilyn—giggling, in a burst of silliness—took off her blouse and stood for just a moment, and then walked back into the room. As she changed into a halter, she asked Xaviera, "What's he doing?"

"Honey, I think he's ready to climb the wall here and give it to you!" Xaviera was laughing. "He's looking at me with a kind of question on his face, like do we want him to join us. I'll shake my head." And she did.

Marilyn rejoined her on the balcony. "I love being an exhibitionist. I love doing things like that. Guys like to be teased."

"Yes, but this Romeo here is going to pole-vault to Juliet's balcony with his cock in his hand the next time. That guy is really horny!"

With a hungry look in his eyes, Alan was staring up at the two sexy women, watching them as they sat in the deck chairs on the balcony. Marilyn opened her legs—wide—and put them up on the top of the railing. The man gazed up at her cunt, which was only covered slightly by her cut-offs. It was, anyone would have to admit, a provocative position.

"So many women just don't know how to suck a cock," Xaviera said. "I hear it from men, in letters, when I talk to them on the street, even. You know, it is funny, but when people meet me, they have no inhibitions about talking about sex. People just come up and say, 'Hello, my name is George James and I don't get off on the way my wife sucks my cock. What can I do about it?' "

"What do you say?"

"I say, 'My name is Xaviera Hollander and there is nothing you can do about it, it is what *she* must do about it.' Actually," Xaviera said with a grin, "I should say to the guy, 'My name is Josephine Glutz and how dare you talk to me like that!'"

"That would be funny. But you're right, the problem isn't him or his cock, it's that his wife just doesn't know how to do it properly."

"How did you get to be such a good cocksucker?"

"Practice."

"What kind? On a banana or your boyfriend or…?"

Marilyn giggled. "No, on my husband. I really wasn't any good at it until I married Doug. In fact, it really was the movies, *Behind the Green Door,* that taught me how to do a fine job on a guy. I would have to suck cock for what seemed like hours because they were getting everything on camera, and I could tell if the guys liked it because they would moan and shove it down into my throat. If it starts to go soft, you know you're doing something wrong. I would go home and do the same thing to Doug. Poor guy, he'd be sitting at home waiting for me to come and cook his dinner and I'd walk in and fall on my knees and start sucking his cock right there in the kitchen! And it would go on for hours! He'd starve, but I think he would rather have sex than food."

"So you took the tricks you learned at work home to your husband?"

"Yup. Doing those films taught me you can really savor sex, it can really be something else, something special, and doing it on screen meant nothing. But at home with my man, that meant everything in the world." "It's hard to imagine you as a married housewife down there in Hickory Creek…"

"Walnut Creek," Marilyn corrected, laughing. "Yeah, that was me really. I was just another newlywed and I went off to work every morning. Some women went to the city, San Francisco, to sit at typewrtiers or stand at teller's windows all day. I went to a porn movie set and sucked off guys with big cocks swinging on a trapeze."

"And that really didn't turn you on? It would drive me crazy!"

"It was acting. Sure, I felt something, I was turned on physically, but it wasn't emotional. I was very much into the whole faithfulness trip then, and I had to be with my husband to be really pleased." "Did he please you?" Xaviera asked. "Oh, yeah, sure. He had a good body and loved to ball, and his cock was always hard. That was the trouble, that was the only thing he was good at. Oh, I said all that in my book. The point is, really, that I learned to give a blow job on him, because I took my time, hours sometimes, and I learned just

how to tickle the underside of the tip until he was ready to come and then stop, and pull away, so he wouldn't cream but his body would shake, and he'd moan and I could see his balls getting bigger…"

"So you would give him blue balls, hey?"

"Ummm. Yes. He used to like me to nibble on the tip, just the tip, as he jerked with his hand, moving his cock up and down. He usually got off on that. He was masturbating in my mouth, and I was watching him and, at the same time, I turned him on by touching the tip of his cock with my lips, but he was really doing it himself."

"You were quite young then."

"That was over five years ago."

"Most girls that young don't know the first thing about sucking cock. I believe they should be taught. If they can't learn it in books, they should pay real attention to the boy, as you say, and then, too, the boy should not be afraid to tell her what it is he likes. If the chick puts her finger down under his balls and reaches a tender spot and he loves it, he should tell her. Most girls don't know that a boy likes to have his ass felt, and sometimes poked, with her finger. He has to tell her that."

"A lot of girls think giving a blow job really means to blow, actually blowing," Marilyn said.

"The guy should say, 'Honey, that's my penis, not some balloon!' They get the word *suck* and the word *blow* confused. They don't know they mean the same thing. You suck a cock, you don't blow one. You can blow *on* one, that's exciting to a man, especially when his cock is wet. It feels cold and makes him shake, and then when you put it back in your mouth, it warms him up."

"I was lousy at first. I *wanted* to do well, but I didn't know how. I was afraid I would hurt him. I think that's the biggest fear a chick has, that she will bite it."

"Or it will bite her!" Xaviera exclaimed.

"Right! Chicks don't realize how tough and strong a cock is, I mean, it pounds inside a cunt for hours on end, why can't it take a little teeth?"

"Sometimes men like a little pain with their cocksucking. They like a little biting—love bites—and nibbling on their balls. Testicles are sensitive, but you can pull on them just enough to cause a little pain and not really hurt the guy."

"I think a guy should watch."

Xaviera blinked. "How so?"

"I mean once in a while he should sit up and watch her doing it."

"Or look in a mirror."

"Right. That adds another dimension, looking. And he can see what she's doing or not doing, and maybe he can tell her what he'd like to *see* her do, rather than what he wants to feel, and she may do better than way. I think it's exciting to be lying between a guy's spread legs and have his prick head in your mouth and look up and see him smiling down at you. It's so dominating!"

"I'm the other way. I like to kneel above him and have it in my mouth and look *down* at *him* looking up at *me*. But I suppose you really get off when a guy orders you how to suck him?"

"Oh, yeah," Marilyn said with wide eyes. "I like him to slap my ass and say, 'Chew on the head!' or maybe 'Lick my nuts while you pull on that big dick!' Things like that. But what I'm really getting at is a chick should really be aware of how her man is responding to what she's doing. If she can't tell, I mean if the guy doesn't make a sound, then she should ask him. Just whisper, 'How am I doing? What do you want me to do? I love sucking your cock and I want to please you...' That will turn him on, and he'll react."

"I agree. And girls should learn the basic makeup of the penis, where it feels the best and all. They should read *Xaviera on the Best Part of a Man*. That's a bible to cocksucking. You need to know basic sexual anatomy. You'd be surprised most girls don't know how sensitive the head of a cock is. They write and ask why does my boyfriend come the moment I put my lips to his cock? Well, it's probably because they only lick at the head and that drives him right to orgasm. They don't know to put their lips down on the shaft and gently lick the tip with their tongue. You need to know some cockology!"

Marilyn smiled. "What a groovy subject to teach in college. Cockology III. Or Advanced Cocksucking. I wonder how many horny college boys we could get as demonstrators? The classes would be for girls only, and we would have the guys come in and line up and drop their pants and we'd teach the chicks how to suck all of them, doing each one a little differently."

Xaviera swooned. "I love that idea. The trouble is, would we ever give up the boys ourselves and let the class participate? Or would we hog the whole load, so to speak?"

"Hmmm. It depends on the boys. And their cocks."

"I can see it," Xaviera said, holding her hands up to indicate the sign, "MARILYN AND XAVIERA's SCHOOL FOR FELLATIO..." not a bad title, hey? Or how about "HAPPY HOOKER HUMPING COLLEGE?"

"I love it."

"I'm gullible," Xaviera suddenly said.

"Why do you say that?"

"I was just thinking how many people have turned out to be con artists rather than friends. So many rip you off because they see you have some money or some fame. I have always trusted people, and they could always trust me. I've been honest with them and helped many a friend in need. I've gone out of my way to be kind to people—even in my books, by not revealing their true identity. I had a close girlfriend once who told me she would be proud to be mentioned in my book, and so I wrote a nice story about her, mentioning her first name only. A few months after publication she sued me, and I didn't have it in writing that I had her permission to use her name. And she had been a good acquaintance for years. I was very hurt. By the way, she dropped the lawsuit a few months later. The only ones who got richer were the lawyers."

"Doesn't that make you harder? Isn't it hard to trust anyone after that? How can you still be gullible? That's why I try to avoid close entanglements with people—close friendships—because they always seem to turn out rotten. Everyone I know, one day they're

close pals, the next day they're bitter enemies. I'd rather not get involved with a person."

"Well," Xaviera said, "it hasn't made me harder, but it has not been an easy thing to live with, so I try to laugh it off."

"Should we go down to the pool?" Marilyn asked. "I think it's too close to lunchtime," Xaviera said. "Yeah, I think you're right. Shall we go shopping right after lunch?"

"I have an idea. Let's not stay here any longer. Let's go to a cozy restaurant I know. You'll love it. I'll run home and change, and pick you up in about an hour." "Terrific," Marilyn said.

Xaviera stood up and said, "You say that you don't need close friendships. What about the kind of buddy-buddy relationship I have with Serge?"

"I confide in Chuck, as you confide in Serge, I guess you'd say. But I don't need anyone else. When you confide in other people, in lots of people, it gets you in trouble. I'm skeptical. When it comes right down to it, I think most people who want to be your friend will take advantage of you. I want to remain a mystery to everyone except my lover," Marilyn said, looking directly down at the man in the red trunks. "I don't want anyone else to know me very well."

"But you're telling everything in this book, and in your first book...."

"That's different," Marilyn said, "that isn't like talking to each person on a one-to-one basis and developing a close friendship. I want my private life to be really private. I tell on paper just as much as I want them to know, but I want my private hours to be really private. I'm always entertaining people, and being the center of attention at parties, but it's for business reasons and part of show business. The real Marilyn Chambers is the one at home behind the locked door." "Green door?"

Marilyn laughed. "Sure!"

"You know," Xaviera said, "one other thing. I find it hard to imagine you don't have the need to tell things to a girlfriend. There are certain things a woman can only tell another woman."

"I never really had any girlfriends, ever. I'm very dependent on men. I would feel that I'm cheating on my man if I were to keep secrets I only shared with a girlfriend. And that's usually just gossip, which I don't dig."

"You mean like in the film *Emmanuelle,* where the women lie around the pool chit-chatting about their men's sexual escapades or idiosyncracies?"

Marilyn nodded. "Yeah. I hear chicks say, oh, he doesn't fuck me enough, he's a rotten bastard, he doesn't know how to eat me, I can't stand being in the same bed with him! And then, in the next breath, when the guy walks in, the chick says: 'Hey there, sweetheart, I missed you!' That's terrible. Why can't they go directly to their man and say, 'Look, I just don't get off on the way we fuck, I think we should do this and that…'"

"It's very hard for people to be honest like that. It's rare when people are, I think."

"Well, I'll be honest right now and tell you I'm dying to get out of this hotel!"

"Be back soon," Xaviera said, kissing Marilyn on the cheek, grabbing her bag, and heading out the door.

Marilyn looked down at Alan, still at the pool, opened her halter, showing him her beautiful rounded breasts again, and stepped inside the room to change.

Xaviera drove her red Audi Fox through the streets of Toronto like a maniac. Marilyn held her breath and, from time to time, gasped, "Oh, Xaviera, careful, watch that car."

Xaviera reassured her, "Honey, I drive the way I live and eat and do almost everything in life, fast and furious and risky. I like to take chances when I am alone in this car. but would never risk your safety. When I drove through Europe my friends didn't call me for nothing *La reine de la route,* the queen of the road. know my little Audi Fox like the palm of my hand. I find driving a very sexual experience. I hate slow driving and, in a few years, I probably will buy myself a nice sports car. But with the speed limits and so on, what fun is there in having, say, a Corvette if you can't jack it up anyhow?

The steering wheel is my slave and if I didn't have an automatic car, I guess the gearshift would be my *cock*."

Marilyn relaxed, closed her eyes, and smiled. "Yes, madam, I know there can only be one captain on the ship, so go ahead and I'll shut up."

Xaviera and Marilyn were on their way to Toronto's Yorkville shopping district. Xaviera's mind was still on the subject of friendship. "You tell your true friends your sexual feelings, problems, or desires?"

"No," Marilyn said, "and besides, I said I don't have any true friends. Do you relate your sexual feelings to Serge? Do you two talk about sex much?"

Xaviera stopped for a red light. "Yes, very often. A true friend is somebody you can tell anything to. Serge used to get me turned on some times with his horny stories. You know, he would show me a nude painting or picture of his latest stud, his latest trick, or tell me his latest adventure, and I would get all excited. We occasionally talk about sucking and fucking, but we discuss any other subject that comes to mind. We have a lot in common, such as our interest in the theater and music. He joins me on opening nights at the theater. We go to the opera or ballet together, to the gay beach in the summer, play tennis, and so on. I guarantee you that it is not only sex that is on our minds."

"You have fun with him."

"He's like a brother," Xaviera said, giving the driver of the car next to her a dirty look for pulling into her lane as the light changed. "I'm more myself with him. With others I have to be La Hollander, you know, always 'on.' "

"Well, our work is our life, we work twenty-four hours a day. I can't work at being Marilyn Chambers only from nine to five."

Xaviera turned onto Yorkville Road. Looking for a parking place, she said, "Well, I don't have to be *The Happy Hooker* all the time. Actually, I started to hate *The Happy Hooker* because people see me on the street and say, 'That's the Happy Hooker.' I wish they would say, 'Oh, that's Xaviera Hollander,' and think to themselves,

the author of *The Happy Hooker*. I've been out of hooking and into writing for four years now. That's why I called my second book *Xaviera!* I know it's hard to pronounce, but that's all right. I'm a woman, a person, then..."

"You don't know how long it took me to learn to say your name!" Marilyn giggled.

Xaviera hit the brakes. She'd seen a parking spot. Marilyn said she didn't think they'd fit in it, but Xaviera knew her car and her ability to "get into small spaces." She parked the car with no problem. Rolling up the window, she said. "I'm a woman, first, that's what I'm saying."

Marilyn opened the door and stepped out of the car. The street was colorful, filled with little shops and hundreds of people loaded with packages from boutiques and stores. A mixture of tourists and locals, kids in jeans and sandals, coiffured chic women and well-to-do men in elegant suits and vests. Everyone friendly, everyone looking happy. The sky was clear and the air was fresh.

Xaviera took Marilyn's hand and led her down the street. "Now, I'll show you Toronto's best side—the Fifth Avenue of Toronto."

Marilyn held her hand tightly and whispered, "I think I've already seen the best Toronto has to offer." Xaviera loved the compliment, smiled, and then, together they disappeared into the throngs of people to become just Marilyn and Xaviera, shoppers, girlfriends out for an afternoon of fun.

They could be porno stars and reigning queen of sexy paperbacks later. There was plenty of time.

They sat at a small table, in the outdoor restaurant Xaviera had told Marilyn about. Someone had recognized them on the street and had asked for their autographs—and so they began talking about what they felt about the kind of attention a star gets. Marilyn sipped her iced tea. "I *need* attention. I've always liked being the center of attention. I don't care if it is in high school being the head cheerleader or making a dirty film. If that's your nature, you'll be like that in everything you do."

"I guess I need attention, too, but only once in a while," Xaviera said, slowly stirring the ice cubes in her glass of water. "I don't always want to have to live up to the sex symbol image. I like to go out with no makeup sometimes, put on a pair of big sunglasses and pull my hair back so no one recognizes me. I don't even try to work at being this sex symbol and yet people will say, aren't you the Happy... and I say yes, I guess there is nothing that will hide you if they want to find you. You said you have to work at being Marilyn Chambers twenty-four hours a day. Don't you ever go out looking like you just got out of the shower?"

Marilyn shook her head. "No. Do you?" "Yes, sure. You should see me after my acting lessons sometimes. If it's late and I'm beat, I can look like the frazzle-dazzle of the world. And I don't care if people see me like that."

"I always want to be at my best. It's what I said in my book, about the image of a star these days. My fantasy is to keep up the image of the kind of star they had when Hollywood was great. I think people really want that."

Xaviera leaned back in her chair and looked up at the sun. "You mean you get dressed up to go to the supermarket?"

"No, I don't really get all dressed up, but I won't go with my hair in curlers. I just want to look young and fresh all the time. I want to look good."

Xaviera took off her sunglasses and looked at Marilyn. "But you *are* young!" she said.

"They think of me in different terms, as being young and pretty and clean and fresh. It would blow the image if I went schlepping around like any suburban housewife in a pair of Bermuda shorts with rollers in my hair. I like to look natural, but good."

"But you always look natural."

"Well, my image is kinda soft, and in this business it's very easy to become a very hard kind of person."

"Or very blase about everything..."

"Right. You have to think of your fans and what they expect of you and what they think of you, and if you're not aware of that, then you're sunk."

"I've had that problem. You've been in this field a shorter length of time than I have," Xaviera said. "I've been in it for four years."

"I've been in it for seven years!" Marilyn retorted. "I started modeling when I was fifteen."

"But when did you do *Behind the Green Door?*"

"About four years ago."

"That's when you really got famous, right?"

"Yes."

"So maybe we've been in it for the same period of time. But I guess more people read *The Happy Hooker* than have seen your films…"

"Oh, sure," Marilyn said, sounding a little edgy. A natural bit of rivalry was coming out in them. "I think people recognize someone they've seen on screen before they recognize the face from a book cover. I would say we're about equally recognizable."

"Having been on all the talk shows, in the States and Canada, I'm much more easily recognized than you, I think. Also because you have the girl-next-door look and I have a distinct look, the Dutch girl with the bangs, people will never confuse me with any girl next door, although certain hairdressers have invented the Hollander haircut because many women like to look like me."

"We sound like we're going to get bitchy!"

Xaviera laughed. "Well, why not? A little womanly chit-chat, a little jealousy, feeling of competition, that's a good thing. We should get out any bitchiness if we have it in us."

The waiter brought their diet chef salads. Marilyn thanked him and said to Xaviera, "Maybe you want secretly to be a movie star and I want to be a famous author."

"But I did star in a movie!" Xaviera said. *"My Pleasure Is My Business."*

"And I wrote a book!" Marilyn replied.

Breaking into laughter, feeling ridiculous, they began to eat their salads. There was a cool breeze and even though the sun was hot, it was pleasant. "How do you feel about autographs?" Marilyn asked after a woman had come up to their table and asked Xaviera to sign her name. Xaviera had done it, but she didn't seem pleased.

"I don't like it when I'm having lunch or dinner or in the middle of the night. One time I was having dinner with a date and this man came up and demanded my autograph. I said 'I would be glad to, but can't you see I'm having dinner with a friend here? I will be happy to give it to you later.' And do you know what he said? He said that I am public domain and I had no right to refuse him!"

"Do you refuse now?"

"I don't refuse now, and I didn't refuse then. I just wanted him to wait until it was convenient for me. If I'm in the middle of eating chicken with my fingers, I don't feel like putting my greasy hands on a pen or finding a napkin."

"It doesn't bother me."

"I usually supply the paper and the pen, too, because they seem never to have one or the other and I hate to sign matchboxes or napkins." Xaviera paused as she took the last bite of ham from her salad. Finally, she said, "Oh, you know, Marilyn, maybe deep down inside I'm like you. Maybe I always want to be *The Happy Hooker*. I'm trying to change the image slightly, but I still like to be recognized."

"Why change the image if that's what people are looking for?" Marilyn asked.

"Because I'm no longer a hooker," Xaviera said. "I don't mind— in fact, I love—the image of a sex personality, of a sex symbol, but to have the image of a hooker now is untruthful."

"I suppose you get calls from girls asking about how to become hookers. I get letters from all kinds of girls wanting to be porno actresses."

Xaviera wiped her lips with the napkin and moved away from the table slightly. "They call and ask how to turn tricks, how to suck a cock, how to find men. One time, I even got a call at three in the morning. 'Do you know where I can find a rich man to be my sugar daddy? I'm broke.' Do I need that? I'm usually kind, though, be-cause I have some sympathy for these girls, I can understand them, but there should be a limit. So I tell them not to bother me, I am out of that business. End of conversation. I now have two unlisted

phone numbers and switch off the bell at night. My answering service gets to speak to some of the kooks."

"That's why we live such private existences," Marilyn said, finishing her food. "Sneaking around and wearing disguises…"

"Do you go in disguise?"

"I wear big hats and things like that. You know, looking really funky."

"But that doesn't go with what you said about looking like a sex star all the time."

"There's a difference," Marilyn said, making her point.

"If I go to the corner grocery in old Bermudas, someone may recognize me and that blows the image. If I go to the corner grocery in a black wig and a floppy hat, chances are no one will know who it is, they won't even look. I mean I don't always get dressed up and try to look really sophisticated and elegant. I'll wear hot pants or slacks like I have on now, or some striking dress that gives a sexy little girl look. I'm trying to mix the image of being a young sexy chick with the image of being an elegant Grace Kelly type."

"I think you do that," Xaviera said. "You did that the first time I met you, at dinner. You were reserved, but you were also very sexy. That's it. You have to be able to be different people at the same time, but always sensual."

"Soft and sexy?"

"Uh-huh." Xaviera took a sip of water. "Now, in my case, people think I'm sometimes a bitch, so I let them believe it. They often say, you look so much softer in reality, in your pictures you look so hard. I think that back cover photograph of me on the original Hooker book is so matronly. I look almost like a prison guard, and yet men seem to love that one. Through the years, I have become more mature-looking and thus better-looking. Maybe photographers who know me well spoiled me with their terrific pictures."

"That's what's exciting about you," Marilyn said. "You seem at times so hard and dominating, and yet you can be so soft and warm and feminine."

"It comes from most people only reading me, never seeing me. They don't get to meet me in person. On TV you're something in the middle, not quite real, but more than just a photo. And then they say, oh, she's got brains too."

"You should have your own TV show in Canada." "How did you know I wanted that?" Xaviera asked, surprised.

"I… I didn't," Marilyn confessed. "I just think you'd be terrific."

"I'd love to be the host of a show similar to Johnny Carson's or David Susskind's. Probably we'd end up talking about sex anyhow, because it's tough to get away from sex when you have me around…" Marilyn giggled and nodded her head. Xaviera slapped her on the shoulder playfully. "I didn't mean it that way! I mean nobody would want to appear on my show and discuss nuclear physics only! But since sex is a subject everyone ought to know about and so few do know about, I think a forum would be advisable with, for instance, a psychiatrist, a social worker, a housewife, a career woman, a nurse, a factory worker, whatever."

"A kind of question-and-answer session?"

"Yes, establish a subject for each program and then put it to a forum. The subjects could be quite varied. Just open any newspaper and the headlines are about rape, lust, murder, child molesting, rape clinics, sex and drugs at schools, sex among the geriatrics, sex in jail, abortion laws. You know we had a well-known case about a reputable doctor, a Jew, who had suffered through years of concentration camps and made it to Canada alive. Well, he was for abortion and thus became a famous abortionist. And then, somehow, some woman turned him in and now the poor man is in jail for many years. Thousands of women are protesting to get him released. They are all for *abortion*. Some day they'll change the law, and hopefully they'll let him off. As if Auschwitz isn't enough imprisonment for anyone? Women's lib is usually for abortions. The Catholics in Italy are even becoming more liberated and voting for abortion and the pill. So you see there are plenty of subjects I would love to put my teeth into, not necessarily all about sex. For instance, there was a program here all about women in jail, about female rapists, women

who sexually assault other women. The discussion concerned what could be done to ease the problem of sex in jails."

"Almost half my fan mail comes from prisoners," Marilyn said, "and it's so sad. They are just dying for sex. I have this picture of all those men walking around with their cocks hard day and night because they can't get any kind of satisfaction."

"I've had lots of questions from men in prison, women too. Some of the letters I answer in *Penthouse* are from prisoners."

"Same thing with my column in *Genesis*," Marilyn said. "And I get letters from midgets and dwarfs telling me they have ten-inch cocks and they really want to screw me, or they want to know how they can have a normal relationship with a girl like me when they are deformed or something. It's hard to find answers to those questions." "Don't you think some of these letters are fake, or at least have a tone of wishful thinking in them?" Xaviera asked.

Marilyn nodded.

"I've said for years, since my first book brought in the fan mail," Xaviera went on, "that we are not experts and we can't give the answers like real doctors do, but I'm not sure they know all the right answers, either. We can only offer advice that comes from experience, that's all, by using our common sense…"

"I am always amazed, reading the letters, at how many people are still so messed up about sex. With all the literature we have now!"

"It's sad. I get so many letters from fat people. A man will write, for instance: 'Dear Miss Hollander. I am so fat, I am three hundred pounds, and my wife complains about our sex life. I have trouble putting my penis into her vagina. What am I to do?' signed Fatso. So, I can't help but write in a semi-serious attempt to help him. 'Dear Fatso. Either you lose weight or else try this position: Put your wife on her back on the bed. Shove one or two pillows under her buttocks, then you climb in between her legs, while she holds spread open; stay on your knees and don't fall all over her. With lots of pillows underneath her, you will be able to find the entrance to her vagina. Good luck.' Another guy will write and say he and his wife are both one hundred pounds overweight and his cock keeps

slipping out—what should he do about it? In that case I give him a very simple answer—lose weight. Maybe I recommend some diet or a visit to a reliable dietician. Stop eating so you can start fucking again. But it's very tough for people to change their habits or attitudes. Eating is often an outlet for sexual frustration and oral gratification."

"Chewing cigars."

"Biting nails is a form of masturbation, and even babies, sucking a thumb," Xaviera said. Marilyn moved her fingers to her mouth and pretended to bite. "Now, stop that!" Xaviera said, laughingly. "No, truthfully, people twirling their hair, biting their nails, it's all oral fixation. It's the vicarious replacement for masturbation."

"I think kids should be taught about masturbation when they're young. I mean really be told that it's a common and good thing. Little boys seem to—"

"They're always playing with themselves," Xaviera cut in.

"That's what I was going to say. Boys seem to get to it instinctively, but girls don't. Did you see the girl, in *Emmanuelle...* ?"

"With the lollipop?"

She said, "Nobody taught me. I just found out about it. I have been really amazed that books teaching women how to masturbate have been selling like crazy. Women in their forties and fifties are masturbating for the very first time."

"They didn't even know where or what the clitoris is for!" Xaviera said. The bus boy was clearing the table. He seemed to shudder a bit, but kept a straight face. Xaviera eyed him intently. "Women think only a big cock should go in there, not their fingers or a dildo...

"Sex education leaves a lot to be desired, especially for the young," Xaviera said. "Some kids like him," pointing to the bus boy, "even at his age, still don't know what sex is all about. I could tell he knew, he looked pretty aware."

Marilyn agreed. "I think anyone who works on this street should be pretty aware. The people here are hip." Marilyn asked, "Have you talked in schools?"

"Yes. I have given numerous lectures in high schools and universities. I talk about all kinds of things, like hygiene and cleanliness—I say to the girls, 'You don't want to go around looking like douche bags... but use them sometimes, too.' In other words, some chicks really smell like the fish market, and I think they should be taught cleanliness in school. Women's lib with unisex is one thing, but sometimes the unisex fashion can be a hell of a turn-off for the young men, in particular at schools or universities. Ninety-five percent of the girls wear beat-up jeans and sloppy sweaters, usually no bra and long straight, shapeless hairdos. From behind and as well up front, I have trouble telling who is the boy and who is the girl. So... I advise women to be more aware of their femininity, not necessarily every day, but at least when going out on a date. Show your legs, show your curvy, streamlined body. Be a bit of a cock-teaser, but don't cause your date blue balls, either. Men like to get turned on by legs, boobs, and bottoms and a fresh smelling body. You know who has no problem getting laid on campus?"

Marilyn shook her shoulders. "No idea."

"The young handsome professors. They are the ones with experience and most in demand. Doesn't every schoolgirl fall in love with her teacher anyway, at some time? They are also the ones who have to be most careful not to get caught. And the poor teenage boys, with or without pimples and premature ejaculation, are the ones who go home, having paid for the hamburger, drive-in, and beer and then... they can jerk off and fall in love with their right hands. Now, do you understand why the majority of fans are in the age bracket of fourteen to nineteen? Because *we* are their *living wet dream.* They read our books and fantasize about us. *We* would never let them down on a date? If only they'd ever have a chance to date us. So they write us hot, passionate letters and by writing and rereading their letters they get excited all over and maybe jerk off as well."

"I think some kids, in particular in small towns, are still all hung up about virginity. Especially with the influence of religion and conventional rules. Guys still want virgins for wives, and that's

ridiculous. And girls are still holding on to their virginity until the spiderwebs set in. (Joke!)"

"And a double standard," Xaviera added. "Men don't believe that their wife really lost her virginity because she put a Tampax in and made a mess of things. But it shouldn't matter, whether it was a Tampax or the biggest cock in the world."

"Male chauvinists," Marilyn said, "will always be around. I like the chauvinistic male, sometimes. I almost got killed for saying that in my first book. The women of the sisterhood wanted my blood. What do you think of women's lib and male chauvinism?"

"I'm a female chauvinist," Xaviera said. "Not quite a pig, but definitely a female chauvinist. Because I'm the one who can tell a guy, honey, I feel like fucking, so let's fuck. Maybe I say it in the more gentle manner, depending on the circumstances. Which is the opposite of you, right? You play hard to get…"

"I tease," Marilyn said with a twinkle in her eye. "But I'm not hard to get, I don't think. I'd make myself available for the right person."

"Who would the right person be?" Xaviera asked.

"No one knows that until they find out it's them," Marilyn said.

"I won't ask any more," Xaviera said, signing the check. Then she said, almost inaudibly, "But I'll find out."

They left the restaurant and strolled through the shopping district. Xaviera looked into the window of an exclusive boutique on Cumberland Court and said, "Shall we maybe blow some money in here?" Marilyn eyed a beautiful pair of faded green pants with matching jacket, and later fell in love with a blouse that left little to the imagination. Xaviera bought a light purple see-through silky blouse with black satin hipster pants and some kind of naval decoration.

After spending the rest of their money as well as the rest of the afternoon in one of Toronto's most expensive shoe stores, Marilyn and Xaviera drove back to the hotel. Xaviera went up to Marilyn's room to use the phone, and while Marilyn unpacked the clothes she'd bought, Xaviera called in for her messages. Xaviera told Mari-

lyn that her acting class started at six, and it was already after five, so she would go there directly from the hotel. "What's happening later?" Marilyn asked. While she was changing back into her hot pants, her delicious ass and cheeks smiled invitingly at Xaviera, who was sitting on the bed.

"I have classes until late, and then there is a dinner engagement that was arranged weeks ago. I wish we could get together again tonight..."

"Tomorrow," Marilyn said, holding up a blouse she had bought. "Like it?"

"Put it on, let me see you in it," Xaviera said.

Marilyn turned around, removed her halter top, and slipped the new blouse over her slim frame. She turned around, and her hard little nipples peeked through the material. "Umm, you look delicious," Xaviera said, and opened her arms. As Marilyn turned around and around, her legs spread slightly apart. Xaviera began to feel a warm glow through her vagina and lower abdomen.

It wasn't the blouse that turned her on, as much as the barely covered pubic patch. The jeans hot pants seemed to cut right through Marilyn's moist slit; undoubtedly the tightness of the material was causing a constant clitoral stimulation. And then there was her ass. As Marilyn bent forward a bit, Xaviera could almost see her tiny asshole, so little was there that was covered. In other words, Marilyn was beginning to drive Xaviera totally crazy.

Well, Xaviera had been in control so long that it was about time to let all brakes loose. Xaviera surprised Marilyn by pulling her suddenly toward her and slowly beginning to unzip her pants, revealing a perfectly flat belly and, at the end of the journey, a lovely blond patch of pubic hair.

Xaviera flicked her tongue from Marilyn's navel all over her belly. Marilyn stood in front of Xaviera, who remained seated on the bed, her big warm breasts with firm nipples pressed against Marilyn's upper thighs. Then Xaviera turned Marilyn around and when finally the pants were on the floor, she pushed her tongue from Marilyn's waist down to her ass and moved away from the bed,

almost crawling on the floor to eat her delectable pussy around the world—but stopped teasingly short before orgasm. No words, just soft moaning sounds of utter contentment.

Marilyn trembled slightly as she moved closer to the woman she had been more and more attracted to over the past few days. She let Xaviera wrap her arms around her and then softly kiss her on the neck. "It was a beautiful day," Xaviera whispered.

"Yes, thank you," Marilyn said. She could feel her pulse starting to race. There was a tingling—that feeling she knew so well—down between her legs. Boy, this sure was a surprise attack. She had wanted this woman so badly, and yet she knew nothing would happen unless Xaviera took the initiative. And now... had she ever taken the initiative! She had kidded her a few times about making love to her, about seeing how good she was in bed, but Marilyn still had been a bit insecure about whether she was Xaviera's type or not. Now, in her arms, feeling her warm feline body pressed close once again—Marilyn wished that time would stand still and that she could just linger and live out her fantasy of being made love to by Xaviera.

Meanwhile Xaviera ran her fingers through Marilyn's hair. Marilyn pulled her head back and looked Xaviera in the eye. Then she closed her eyes as Xaviera kissed her eyelashes and then her lips, lovingly and fully. Marilyn felt her mouth being penetrated by Xaviera's fast and probing tongue. Xaviera caressed her nipples, her earlobes, sucked her tongue, and gently bit her upper and lower lips. Marilyn's nipples felt like diamonds pressing against Xaviera's softness. Marilyn moaned slightly and put her hands on Xaviera's buttocks. And then the phone rang.

They broke apart. Marilyn looked a little embarrassed—or was it upset? She wanted to rip the phone out of the wall. She went to it and answered. "Yes? Sure, just a minute." It was for Xaviera.

Xaviera, also annoyed, sat down on the bed and took the receiver. "Hello, who is this?... What?... When is Larry coming to Toronto?... What do I care anyhow?... How should I know, there's no book fair in Toronto, it's in Halifax this month... Yes, I know

you called me this morning, hysterical, so I hung up... No, I didn't read it—just another rip-off, I can't even get mad with the old man any more... I'm doing a book right now with Marilyn Chambers, the girl from the soapbox. Boy, does she ever have a box... yummie, yummie. What?... Well... I'm going to eat her pussy and do everything to make her feel good. You're jealous, huh? She's a bit of a masochist... I only do that to you... You like that, huh?... Mmm, she's here in a very sexy blouse... I could just squeeze her firm nipples... two minutes ago she wore the tightest hot pants, where I could see her pussy lips... of course, I took them off meanwhile. Now you're raving jealous, huh?... Marilyn, she says she just read your story in *Penthouse* and saw your flick, but she doesn't believe you lost your cherry like that... She has a terrific ass, just built for a good spanking, and if she begs me I might even whip her ass with a nice leather belt, but only after I eat her hot pussy out..."

"Tell her it is a truthful, minute-by-minute account o a horrendously funny experience," Marilyn said, wondering who in God's name Xaviera could be talking to.

"Yes... I'm going to the Halifax book fair... Listen, you disturbed a great session here. When I see you I owe you ten whippings. Yes, I'll tell Marilyn hi for you. *Ciao.*"

Marilyn flopped into a chair. "Who was *that?*"

"This is some story. This girl—talk about freaky fans—this chick, Frannie is her name, years ago she called up Larry originally to get hold of my number. She had fallen in love with me reading *The Happy Hooker,* but the publisher only gave her Larry's number and not mine. She was a twenty-four-year-old virgin, daughter of a judge, a screwed-up chick, yells and screams on the phone, crazy, really nutso, hysterical at times, but writes good letters, studies psychology and psychiatry, of all things, sends me dozens of 'Snoopy' drawings each month, and now teaches psych at some school. When she didn't get through to me, she became a fan of Larry's, and he slowly, but surely, in four unusual, uneasy private lessons took her virginity. She basically digs sadistic women and she was afraid of cock. She'd go berserk if she saw a cock, and yet she wanted to lose

her cherry! Larry eventually fucked her and wrote about it in his book, and she's a fan of the two of us now, for years on end. And a masochist of the worst kind."

"What does she think of me?" Marilyn asked. "Well, she likes you, she liked your movie and the story in *Penthouse*. But she is a masochist. She has dreams and fantasies about Batman and everything else, but in a woman's shape. Every few months she comes unexpectedly and unannounced, eight hours driving from Poughkeepsie to Toronto. She brings whips and chains and paddles and likes to get the shit beaten out of her, preferably in front of other people. Sometimes when she calls to say she's in town, I keep on putting the phone down. Drives her wild. In the beginning, I refused to whip her, but the more I refused, the crazier she got, and I eventually had to throw her out of the apartment... so she'd lie in the hallway like a dog."

"She probably got off on that," Marilyn said. "Of course. She dug it. She would lie out in front of the door for hours, and the neighbors, who were nice people, said, 'Xaviera, we are understanding and we put up with a lot, but this is too much.' Then she would come up about every two months with a young undertaker, this platonic boyfriend of hers, and they would sleep in the same bed but never fuck. At the most he got half a blow job out of her and share expenses, since she is rather poor. Her parents don't give her a penny. They kept coming back, again and again, and I ended up beating the living shit out of her, dripping hot candle wax on her back, tying her down, yelling and screaming at her, while her boyfriend snapped all these Polaroid shots of her. The more welts her ass showed, the prouder she was. She begged me to beat her so she'd bleed. I just couldn't do it. It's hard enough to beat a young sick girl like she is."

Marilyn felt a surge of excitement fill her body—she could picture Xaviera standing over the girl with a whip. Or standing over *her* with a whip.

"It was a crazy scene," Xaviera remembered. "I would drop red candle wax on her ass and then photograph it with a normal cam-

era, but she would have the picture enlarged and send it to me. She would also hid a copy in an old shoebox so her suspicious moth wouldn't find out about her masochistic tendencies." "So she's still in touch with you?" "More so with Larry. She's always giving me the latest information on Larry's activities… like a courier… woo, woo, woo… she speaks like that, woo, woo, woo, hey, hey, hey. The more you tear her down, the more hysterical she gets, always laughing, like a hyena. When she gets on my nerves, I hang up on her in the middle of a sentence."

"Does no one ever screen your calls?" Marilyn asked. "No, I answer all of them myself." "I don't usually answer the telephone," Marilyn said. "I leave that to Chuck."

"I love answering the phone. I love people's voices, and if I still get an occasional obscene phone call—it happens less and less since I have two unlisted numbers—I still have the tendency to talk back horny, but I am a real cock-teaser because I can pretty well hear from the guy's voice and his breathing whether his is ready to drop his load. I say coolly, 'And a good day, sir,' hang up the phone, and leave *him* hanging."

"But you still see this girl Frannie?" Marilyn was fascinated by that relationship.

"Yes, she still comes up here once in a while. She's a fan of the worst kind. I refuse to eat her, I refuse to do anything except whip her. And I do that because I know that's what drives her wild. She masturbates like crazy while I whip her. She lies on her stomach and jerks off. She has the same body as you—very slim, smallish boobs, very boyish. She doesn't have your face. Yours is beautiful. She just isn't sexy, though there's nothing wrong with her body. It's her awkwardness in walking and talking. Before she gets here she stuffs herself with tranquilizers to 'seem normal.' Lately we've been quite friendly. I even play tennis with her and we go for a swim, I don't mind being chums once every two months. She is actually an excellent tennis player and loves to jog as well." Xaviera looked at the clock. "I have to go, I'm late already for classes." She picked up her bag and walked to the door. "I'll ring you later, hey?"

Marilyn nodded. Then Xaviera pressed her hand to Marilyn's right breast and said, "Later," and kissed her lightly on the lips.

Marilyn walked to the bed after she'd closed the door and lifted her new blouse over her head. Her nipples were like little rocks. She felt as though Xaviera's hand were still touching her. She picked up her shorts from the carpet and threw them over the chair. Then she fell back on the bed, spreading her long suntanned legs wide. She fingered the small gold chain around her waist, then let her fingers slide down to her pussy. *I'm going to whip her ass with a belt only after I eat her hot pussy out.* That's what Xaviera had said on the phone. That's what she had told Frannie she was going to do to her, to Marilyn. It sent shivers through her body. *I'm going to eat her pussy and spank her ass.* Marilyn had just barely gotten her fingers into herself when she jerked violently on the bed. Xaviera didn't know it, but she had given her a wonderful and exhausting orgasm.

Marilyn fell asleep on her side, hoping that the next day, their last day together, they would do more than talk about it. She hugged the pillow and pretended it was Xaviera's warm, firm body.

THURSDAY

It would be the last day together for some time; Marilyn was off to New York on Sunday to begin her book tour, and Xaviera was about to leave for the country, where she was preparing a huge birthday party on Sunday for a hundred and fifty guests. There were lots of things to be done: buying booze, making phone calls, getting the food and soft drinks together, hiring a bartender and maid. Marilyn was worried that the day would go by uneventfully and they would have to separate. Xaviera, however, was in a cheerful mood, knowing that whatever happened between them would be her doing, her decision.

They talked about favorite actors, an eventual singing career for Xaviera, voice lessons, directing, movies. Xaviera told Marilyn she'd like to play Blanche in *A Streetcar Named Desire* more than anything in the world, and that she was doing a scene from it in her acting class. She felt sympathy for Blanche, an aging woman with delusions of grandeur and a preference for young, beautiful boys.

"Do you and your man screw every day? And does it make you happy?" Marilyn asked.

"No one can make love every day and get bored with it. It's the anticipation that's so great, and there's an art to make it a feast."

Marilyn liked that. "A feast," she said, softly. "That's beautiful, and you're right, that's what it should be. You should make it something special. A lot of people fuck every day and enjoy it, but they don't know how much more terrific it would be if they held off a little, like it's really a prize, a holiday!"

"Should the woman hold off sometimes, do you think?" Xaviera asked.

"Oh, sure. Teasing is what I love to do."

"Well, I've made it a rule not to be submissive, but I think that's part of a woman's function, not to turn down her man. If the man is horny, I never say, oh, not today, maybe tomorrow. I wouldn't want to hurt his feelings, so I would do it, even though maybe I wasn't really into it right then. However, usually once he gets started, it only takes me a few minutes to get in the mood. Besides… it's usually *me* who is the horniest one."

"If you love someone, you mean," Marilyn asked, "you make sacrifices for them?"

"Yes, but they're not really sacrifices. After all, you end up liking it anyway."

"But why not teach your man that there's more to it than fucking—that you can go on with foreplay all night long and maybe jerk it off as a finish or something? I wouldn't let him fuck me if I didn't feel like it, but I sure would teach him that there are different ways I could please just him." Marilyn stood up and looked out of the window, down to the pool. "Let's say the man wants to fuck every night and you don't want it every night, you like it better every now and then, you savor it. I think there comes a time in any married life or relationship when you realize that you ought to do more than just balling. It's time to diversify your life. How do you go about changing him?"

"By the way, Marilyn, how about just telling your man that he doesn't have to prove his virility and masculinity every night? There really is a lot more to love than sex."

"You mean that you don't even have *to* please him by hand or mouth?"

"Yes, just be tactful and don't hurt his ego. I'm sure there are nights that you, as a woman, are horny and *he* is *not* and yet he obliges you.

"Of course, each person is different. Each libido is different. Some people work their sex drive off during office hours, closing

big contracts, dropping dead at forty from a heart attack or a stroke. Others are constantly horny, like rabbits and mice. I know a nice couple. The man is a real Viking, Danish, married to a lovely blond Canadian girl. She loves her man. They're in their mid-twenties and *always* horny. I swear, he fucks her at least three times a day. She goes to work with a raw vagina or even bleeding, and he… well, he sleeps a lot while she pays most of the *bills*. I always ask her, 'But why don't you say no?' She answered, 'The few times I refused or tried to refuse, he threatened to walk out on me and get some strange pussy!' She loves the man—and does whatever he says. He's a nice chap, but by God, who needs a satyr, a sex maniac, as a husband? And even though she fucks him whenever he wants it, he still manages to have some outside action. Besides… he has a huge hard cock that seldom goes down. No tenderness in his fucking. If that is what their love is all about, I feel sorry for my girlfriend. No matter how nice a fellow he might be in between screws with his pants on. I don't think he means to hurt her. To him it is natural. He has the urge and she is there. That to him is 'love'—but how unemotional and unromantic."

"You know," Marilyn said, "fucking is probably my least favorite sex act. I mean just plain fucking. I think most of the readers of your books, Xaviera, are people who did nothing but just fuck until you came along and showed them there was more to it."

"And when they saw your movies, they learned a few new things, too, I should think!" Xaviera exclaimed.

Marilyn sat on the edge of the bed. "They read it and see it on the screen and then the guy asks, how do I get my girl to do that to me? They're scared that it's a little kinky because they think they're the only ones wanting to tie each other up or something like that. And all the while their neighbors have been pissing on each other for years. Really. I knew a couple once who thought their best friends were the most prudish uptight people on earth. They went on a camping trip with them to the mountains one year and in the middle of the night heard strange sounds. They peeked through the tent and saw the husband standing on a tree trunk pissing into his wife's mouth as she lay naked on the ground."

"I love it!"

"Me, too," Marilyn said.

"Your friends told you about it?"

Marilyn nodded.

"When?"

"Oh, just a few months ago. Why?"

"Well, I wondered, because it seems that in the past few years people have been talking to each other about sex, and that's a good thing. Before, they used to just clam up. Now girls go up to their friends in the swimming pool and say, 'My husband doesn't fuck me properly.' Maybe they should tell their husband instead."

Marilyn shook her head. "But a man's ego is very touchy," she said.

"But I think you can direct a man without hurting his ego. I've had cases where someone was eating me roughly, or shoving his finger up my vagina without really lubricating it. I obviously was not really nuts about what he was doing, so I'm like a traffic director. I say, now, baby, if you really want to please me, fine, I'm not too demanding, just go easy, be gentle, kiss me, caress me, light my fire. So you teach him step by step. In some cases the fellow might get mad or become temporarily impotent for a half-hour because he thinks, that bitch, that aggressive cunt... but once he starts to do what I suggest, and realizes that he is really pleasing me, he will regain his stiff cock and get turned on by himself. Some men have accused me of being too analytical about sex, but that was only in unemotional relationships, where the guy was a lousy lover or one of your famous wham-bam-thank-you guys... I hate to waste my time with a lousy lover, the least I can do is to give him some education. I analyze the situation and try to make it better. Of course, there have been men I sized up before ever going to bed with them, and if I didn't like their attitude from the start, they wouldn't set foot in my door. Some men's heads are like coconuts—you have to hammer them hard until they crack."

"A hard cock on a hard skull?" Marilyn asked jokingly.

"See," Xaviera said, "I would rather hurt a man's feelings for half an hour or so, because once he's been taught, he'll love you for it and

the hurt feelings will be replaced with horny feelings. How would you handle it?"

Marilyn said, firmly, "Honesty is the best policy."

"But do you mean honest in a softcore way or in an X-rated, hardcore way?"

"What? I don't know what you mean."

"I mean, do you come right out and say, 'Look, buster, your cock doesn't go in like that!' or do you say, 'Darling, let's move this way...' You know, the more subtle approach."

"It depends on the guy," Marilyn said. "If I told a certain guy he was doing something wrong—subtle or not—he might haul off and sock me..."

"—which you wouldn't mind, maybe?"

Marilyn smiled. "Well, maybe. I was... well, I used to be more selfish and cynical. With Doug, my ex-husband, he didn't know much about sex, but he was a good learner. He kinda walked around all day with a hard-on and was ready to ball anytime I wanted. But when I told him he was doing something wrong, or when I told him he wasn't pleasing me, he would respond in a positive way, never getting his feelings hurt... or maybe he did once in a while, but the next time around he was terrific, he always corrected himself." Marilyn sighed and said, "Gee, we must sound so *strong* here, like we're two prima donnas who have to have sex at its best... but the truth is I want to be a good lover and I want my lovers to be good lovers. Why settle for something less than best? The point is everyone can be the best, if they really work at it, if they really care enough to be good lovers."

"Yes, that's why I'm always honest and suggest things to lovers that I think will benefit both of us. If you feel like having your pussy licked and eaten before getting fucked right away, you just turn your face around, turn your pussy toward the guy's face, or if you want to be rimmed, if you want your ass eaten out, you lie on your stomach..."

"Yeah," Marilyn said, "and that's the subtle approach." "A good way to do it," Xaviera pointed out, "is if your man is in the bathroom and you are all cleaned up and smelling like a rose. Turn on your

stomach and spread your legs slightly apart. He comes into the bedroom and sees your ass slightly up in the air and he gets turned on right away, because most men love asses and buttocks. Then you ask him coyly to give you a little kiss, and in his innocence he might kiss you on the lips, then you purr, no, darling, I want a little kiss down there. So he gets the message and kisses your buttocks and then proceeds to eat your thighs, and if he's a good pupil, he keeps it up because you move your legs and buttocks and moan and he knows you're digging it. Then he puts his tongue in between your buttocks, all the way up your sexy asshole. If you want your toes sucked, you just wiggle your feet toward his face, and if your feet are flexible, grab his nose or earlobe and play with it. Eventually you put your big toe in his mouth, and he'll get the picture. These exercises are not for men who are bad lovers, they are for men who need to get the hint to become more imaginative."

"The ones who are bad, you tell them outright?"

"Yes. The ones who are bad, they need the coconut method. That's for the ones who are really lousy and selfish. Some people have no imagination. You hold your toe to them and they think you want them to polish your toenails."

Marilyn laughed and stretched out on the bed, opposite Xaviera. She knew her cut-offs allowed Xaviera to get a good shot of her pussy. She spread her legs suggestively and said, "If you had the chance to ball any one man in the world, who would it be?"

"Marlon Brando."

"Why him?"

"Because he has it all. He's the perfect animal. Something sadistic about his grin. Because he's obnoxious and contrary. He's earthy. He's a little old to be a sex symbol in most people's eyes, but I don't care. He might be fifty pounds overweight, but he's a sex symbol to me, all right. I think I would love his mind above his body. And I've heard some great stories about him."

"Really? What?" Marilyn was all ears.

"Can't tell," Xaviera shook her head. "I won't tell stories unless I hear them first-hand."

"Darn. All right, what woman would you want?"

Xaviera thought for a moment and then said, with a certain amount of delight, "Julie Christie."

"That's what *The Happy Hustler* said in his book. You two have the same taste!"

Xaviera smiled. "Well, Julie Christie or Susannah York. I think Julie Christie is more sensual. I liked Susannah York particularly in *The Killing of Sister George*. And Julie, well my favorite was *Darling*. She is so feminine and yet kinky. How about you?"

Marilyn thought for a moment. "Well, this is ail-American bullshit, I know, but it's the truth. I'm like everyone else. Steve McQueen or Paul Newman."

"How about your favorite woman?"

Marilyn blushed. She turned her head and said, "Xaviera Hollander."

"Oh, *weee!*" Xaviera tossed her hands up in the air and reached out and took Marilyn in her arms and kissed her. "Well, you didn't have to say that... nobody will believe you meant that."

"But... but I did."

Xaviera looked into her eyes. "You really did?"

Marilyn sighed. Her head filled with the words "I might whip her ass, after I eat her hot pussy."

Xaviera stretched languidly out on the bed. She sighed and said, "Getting up so early makes me horny. It would be nice to start making love very slowly, still kind of half-asleep, just moving like on waves."

Marilyn went to look out of the window, watching the people beginning to gather at the pool in the sun. "Mmmm. I know. But I'm horny all the time."

"Is that so?" Xaviera asked. She unfastened her new sexy blouse that she had bought the day before. It suddenly seemed too tight. Marilyn could see the white line where Xaviera's bikini had gone, the narrow white line connecting the white of her full breasts. Marilyn was dying to see Xaviera's nipples again. She had found them beautiful at the photo session. But she didn't dare ask Xaviera to

take off her blouse. She only hoped for it. "What are you thinking about?" Xaviera asked, kicking off her sandals, relaxing on the bed.

"Oh, I don't know," Marilyn said, sinking into a chair. "I was thinking…" "Hmmm?"

Marilyn blushed. "Oh, I was thinking about how tan your muscular body looked when we were swimming in the pool and what a good breast stroke you have. You Dutch are usually good swimmers and skaters? And then I thought of the photos we did together and how kind you were to me. It got me horny. And about a certain fantasy I have… oh, never mind."

"Wait," Xaviera said, interested. "Come on, now, you promised to tell me whatever came to your mind. And I promised you the same thing. Right now I love the way your nipples stand out through that little crocheted top you're wearing, and do you know I can see your pussy from over here?"

Marilyn blinked. "Really?" She went to sit cross-legged on the chair facing Xaviera. Her cut-off jeans were very cut off. In fact, all of her shaved pussy was visible except for the little blond hairs just above her vagina.

"I don't mind the view," Xaviera said with a wink. She could feel her nipples hardening.

"Oh, these shorts are really going," Marilyn said. "I mean, they have about a week left, but you know how you grow attached to a pair of cut-offs or jeans? You can't part with them!"

Xaviera had to laugh. "You look as though you've already parted with them!"

Marilyn giggled and looked down to see her cunt spread so far her clitoris was visible. "God, you know why they're so stretched around the crotch?"

"I can't imagine," Xaviera replied. "I always…" She stopped herself. "Come on, no holding back. I once wore panties with the pussy cut out so my lover could stick his cock into me anytime we wanted to. You know, in the phone booth, talking long distance."

Marilyn held her head high. "I usually wear these when I masturbate."

"Oh, so you've stretched them with your hand in your pussy?"

"I usually use my vibrator. Or one of them."

"I'm not nuts about vibrators," Xaviera said. "I have a very sensitive pussy, and some of them really hurt."

Marilyn purred as she leaned back in the chair. "Oh, for me the bigger the better. I couldn't bring them up to Canada because I thought Customs would take them away. But I had one in my purse, and I used it last night."

"Really!" Xaviera stretched out more and fluffed the pillows under her head. She crossed her arms over her ripe and nearly visible breasts and said, "Tell me about it. I need a good horny story."

"Oh, there really wasn't anything to it. I just sat on the balcony out there and used the vibrator. I slide it into me and push the shorts aside. I like how tight they feel then, especially around my ass."

"But what do you think about?" Xaviera asked. "Do you have real fantasies, or do you dwell on the actual scene you're in, for your masturbating?"

Marilyn didn't answer for a moment, as though she wasn't sure whether or not to be honest. She decided. "Matter of fact," she said, softly, with a glimmer of sensuality in her eye, "I did fantasize last night."

Xaviera's hand moved down to her black hipster slacks and came to rest between her legs. "You must tell me."

"You tell me your fantasy, I'll tell you mine?"

"Right!"

Marilyn sat up straight and waved her hands in the air. "I've *never* told anyone this story before! I mean, it's kinda crazy, it's really kinda dumb. Maybe you won't like it."

"Who cares if I don't like it or not?" Xaviera said. "I want to hear what Miss Marilyn Chambers, porno star and soap box queen, thinks about when she masturbates!"

"And then you promise to tell me what La Hollander thinks about when she masturbates?"

Xaviera nodded. "Deal."

"Deal," Marilyn said. After a long pause, she said, "Well, I just may as well tell the whole thing. I've had this fantasy since I was in high school. Really. Nothing has ever changed it. I love it. It's like I could write it all down this minute."

Xaviera quipped, "Would you like a pad and paper?"

Marilyn giggled. "No," she said, softly, leaning back in the chair, putting her feet on the floor. "I'd rather just kinda relive it…"

Xaviera didn't say a word. She watched the beautiful girl sitting in the sunlight with her breasts and pussy showing under her clothing and waited to hear the story Marilyn had never told before.'

"Well… when I was in high school and had this fantasy, I never really thought of a specific location," Marilyn said, "I mean, it was always just some place. But after I moved to San Francisco I once went to a house, one of those wonderful Victorian mansions high on a hill, and since then it's been the place in the fantasy. You see, I get to town and I'm broke and hungry and depressed and I love to be dominated and I don't know where to turn. I don't have a family or anything. I meet this guy and they call him Master. Master. That's all, because he has this wonderful power over women. I'm drifting around the streets in hope of finding a cock to satisfy me. So he comes along and he's incredible. Tall, masculine, but not the macho stereotype. He has sensitivity in his eyes. They're deep green and accent his mane of brown hair. He invites me to the house, the mansion, where he lives alone. We're walking down the street and he asks me if I like to ball. 'No.' I tell him.

"What do you do?"

"I suck cock."

"He doesn't blink an eye. He opens the door to the place and I walk in, and its beauty knocks me out. I feel as though I'm in some gothic novel. He tells me—orders me—to take off all my clothes. So I strip and he looks at me and then looks down to his crotch."

"And he's hard, hey?" Xaviera asked.

Marilyn's eyes remained closed, her hands near he pussy. "Oh, yes, it's bulging out of his jeans. I can see the head, the outline of the ridge, it's so hard. We go to a room where there is only a mattress

covered with a beautiful patchwork quilt on the floor. In one corner are his boots and a belt. In another is a framed picture of himself with an erection. He's incredibly handsome. His beard and mustache are perfectly trimmed. His waist is slim and his thighs strong. His balls are thick and hairy."

"I think I'm going to like this story," Xaviera said, pressing her legs together.

"He has a leather wrist band on his right hand. He leaves the room for a moment and comes back wearing a long blue robe, a velour robe, and smelling of musky cologne. 'You really give good head?' he asks me.

" 'The best,' I tell him. 'Show me,' he orders, almost defiantly. It makes me want to really prove myself, to suck him like he's never been sucked before. He pushes me back on the mattress and lifts the robe to his waist. He is naked under it. His cock is perfect—I mean, it fits him, fits his body, his aura. It isn't a real long one—about seven inches—but it's extremely fat—thick—especially at the base. I can't wait to get it into my mouth…"

Xaviera watched as Marilyn spread her legs slightly more and let her fingers slide against the delicate lips of her pussy.

"He pulls the robe off as I'm playing with his penis. He's arrogant. He spreads his legs and props his arms under his head, as if to say, *Go on, I dare you to make me come!* And that makes him more attractive. I'm fascinated with him. I take his cock in my mouth and shove it right down my throat. He doesn't react, the bastard. He doesn't even move his hips. He just lies there watching."

"I've had guys like that," Xaviera muttered, breaking the spell for a moment.

"I suck at the tip for a long time, rubbing my tongue under the head, waiting for some response from him. His balls are so drawn up they look almost flat against his hairy groin. And still, just a stare from his dark eyes…" Marilyn slid a finger into her pussy. "Oh, I lick at the shaft and then tongue his tight balls and then down between his legs, flicking the tip at his hairy asshole, but still no response. I'm getting off on that, but I'm acting like it's bothering me. I love that

he's not reacting! His cock is as hard as steel and he's breathing hard and I can see goose pimples on his ass. But nothing. Just the stare.

"I try some more, sucking up and down his fat cock until my lips actually hurt. Finally I pull off and he smiles. *Smiles!* Then he says, 'Come here, bitch, get on me like this . . ' He pushes me up on top of him, into a sixty-nine position..."

"Mmmm," Xaviera moaned, "of all the positions of fucking and sucking in the world, sixty-nine is my favorite."

"Oh, yeah, mine too," Marilyn said, bringing her legs together for a moment, as though she hadn't been aware that she'd started masturbating in front of Xaviera. But she got back into it. "My pussy is directly over his beautiful bearded face and I sink my mouth onto his cock again. And this time I get a response, but not one I'm counting on..."

Marilyn gasped and tossed her head back. Xaviera opened her blouse and ran her left hand over her naked breasts, feeling the nipples piercing her palm. Marilyn whispered, "Master brings his arms around my buttocks and presses my cunt to his face as he sits up on the mattress. My body feels as if its going to bend and break. The force in his body pushes my head down hard on his groin and his cock is lodged in my throat. *'Cock-sucker!'* he yells into my pussy, and it reverberates through my body!

"Then he stands up. He holds me tight and lifts me into the air and my pussy is pressed against his lips. I grab his thighs near his ass, keeping my head glued to his cock. He holds me there, up-side down, blood rushing to my head, feeling dizzy and excited and freaked out!" Marilyn clamped both her hands between her legs and said, "Oh God, I'm sorry! I'm getting carried away. I get really excited whenever I think about him. He's like some mythical figure who..." She stopped dead. She realized she was staring at Xaviera's big beautiful breasts. "It's turning you on, too?" she asked. Xaviera only nodded.

Marilyn closed her eyes and continued. She felt good, warm, with the sun shining in on her body and Xaviera watching her and getting off on her fantasy. "I still suck his cock as hard as I can, up-

side down. I spread my legs in the air so my cunt opens wider under his lips, and I move my feet wildly so the lips of my pussy contract and spread and his tongue can flick my clitoris. Oh, God, it's so incredible. He slaps me on the ass. A good hard *slap!* I squirm, loving it. He slaps me again and I feel as though I'm going to come…" Marilyn stopped and sat up. "Oh, I *am* going to come if I don't stop saying all this! You're terrible for making me do it."

Xaviera smiled. "Should we talk about the weather in Toronto? All right, it is sunny and warm. Now, that's boring. Back to your fantasy. I was just getting horny when you stopped!"

"Do you want to see my vibrator?" Marilyn asked. Xaviera's eyes answered for her. Marilyn jumped up and opened a drawer. She pulled out a pink vibrator, shaped exactly like a penis, about eight inches long. "You brought that in your purse?" Xaviera asked, astounded.

"Oh, yeah," Marilyn said, casually. "I keep it inside a big flashlight. A dummy flashlight. No one ever asks about it. One of these days I'm going to stick the whole flashlight up my cunt."

"A man had me do that once," Xaviera said. "In fact, many times, the same customer, years ago. I used to call him 'the flasher.' That was way before we had streakers and flashers in our daily vocabulary. He was rather handsome, but he had some strange nervous tick that scared me every time. In any case, I never really let him touch me. He used to come late at night. All he liked to do was to turn out the lights while he would hide somewhere in the dark, put a flashlight up my pussy and then I had to aim it around the room until the beam hit his cock. By this time he was, of course, jerking off in his corner, and I had to keep on shining the flashlight on him until he came. I had forgotten about him until now. You made me remember. I don't think I ever mentioned him in any of my books."

"I love toys," Marilyn said, sitting down again. "*I* should try a flashlight sometime…"

Xaviera cut her off. "Now tell me the end of your fantasy."

Marilyn nodded. "It always ends a little differently, depending on how fast I reach an orgasm."

"Take your time," Xaviera said softly, putting her hands under her head just the way Marilyn had described Master as having done in her fantasy.

"Well... he holds me to him with one hand as he slaps my ass until it's so red it looks like a fire engine. I really get off on it, the pain, the domination..."

"He slaps you hard, calling you a little bitch, a little damn cocksucker," Xaviera said, getting into Marilyn's head, getting into the fantasy.

"Yes, oh yes..." Marilyn moaned, sliding the vibrator into her pussy, pushing the crotch of her cut-offs aside. "We fall back to the mattress and pull away from one another. He jumps up and stands against the wall, next to the picture of himself. He orders me to crawl to him, and I do. My ass stings. Then he tells me..."

Again Xaviera cut in: *"Lick my picture, kiss it."*

"Oh, yes, Master," Marilyn moaned, switching on the vibrator in her pussy, "yes, I'll lick it, I'll worship it..." *"Kiss my picture and then kiss my cock,"* Xaviera said in a low tone, watching Marilyn masturbate intensely.

"I'll kiss it... oh, God!" She twisted her head back and smiled as she felt ripples of pleasure rush through her body. "He slaps his cock against my cheek and I try to suck it, but he won't let me. He makes me beg for it, he asks me..."

"...to say, *Master, please let me suck your cock, please give me your cream...*"

Marilyn was unaware it was Xaviera talking. It was Master. "Oh, please, Master, please, let me suck your cock, please give me your cream." The vibrator slid into her cunt, the rubbery cock shaking and moving within her. "The next thing I know is he's kneeling over me, over my chin, and his balls are brushing against my lips as he pulls on his cock with his hand. I stick my tongue out and lick at the underside of his balls. He moves down a few inches so his cock is hanging over my face. He takes it in his right hand and starts slapping it against my lips."

"You try to get it into your mouth, but he won't let you," Xaviera said, feeling her blood rushing. The fantasy was becoming reality—was Xaviera becoming Master?

"Yes," Marilyn said, lost in passion, "and he holds it against my face and I try to suck it, but he hits me with it, stinging my cheek. He won't let me get it into my lips. He keeps slapping my face and telling me I'm beautiful and he knows how much I want his cock and his cream."

"Please, say please, may I suck it?" Xaviera ordered.

"Please, let me suck it!" Marilyn begged.

"He beats it against your face in a rage now," Xaviera said, taking over as Marilyn felt the whole world spinning. "You become more excited every time the cock hits your face. Your pussy is dripping. You dig your nails into his buttocks. He pulls on your hair. You are fighting back tears..."

"Oh, God, yes!" Marilyn cried out. "Yes, I want it, I want him to come... I want you to come... with the dildo up my cunt, I want you to come with the dildo up me..."

"It's going to come, baby," Xaviera said, shuddering. She had reached the point of no return. She felt her body shaking on the bed.

Marilyn brought her feet into the air and pushed the vibrating cock even further into her pussy. *"He's coming... now! I'm coming!*

"*Oh, God!*" Marilyn screamed. "Come, yes, come... it's hitting my face... oh, give it to me, let me suck it... oh, God, in my hair, in my eyes..."

"On your breasts, on your hot cunt. He's standing up and shooting it all over your body. You're covered with it!" Xaviera dropped her head back to the pillows and gasped. She felt damp between her legs.

"Ohhhhhh," Marilyn moaned. "Now I can suck it, the last drops..." She collapsed, her hands falling to her sides. Her feet rested on the carpet. The dildo was still vibrating in her pussy. The fantasy had become so real, so marvelous, better than- last night. Finally she lifted her head and said, "I... I came. Oh, it was wonderful."

"I know," Xaviera said softly with a grin. "I don't even remember... it seemed so real." Marilyn let her head fall back to the chair again, and she removed the vibrator from her wet pussy and set in on the floor. She brought her knees up and wrapped her arms around them, and giggled like a schoolgirl. "Gee, that was fun! I never counted on that."

"I did," Xaviera whispered, knowingly, wisely. "What?" Marilyn asked.

Xaxiera stood up and smiled as she closed her blouse. "Aren't you going to tell me your fantasy?" Marilyn suddenly asked as Xaviera looked out of the window into the fresh sunshine.

Xaviera ran her fingers through Marilyn's hair, gently. "I already did," she said.

As Marilyn and Xaviera walked down to the pool area there were only a few people out.

"They must still be sleeping or fucking, or having breakfast," Xaviera said.

The pretty teenage girl who handed out the towels smiled at them. She knew Xaviera from a previous visit and was a devoted fan. A few young men in jeans were ogling Marilyn and Xaviera from the outdoor terrace, but other than that, they felt relatively secluded at the corner of the pool. Xaviera rubbed suntan oil all over Marilyn's body. "Oh… it feels so good," Marilyn moaned.

They stretched out under the sun for a while. A girl walked by, followed by her boyfriend. She was obviously angry about something, and as they passed Marilyn and Xaviera, the girl said, "Terry, keep your hands off me. Stop pushing me. Don't… don't talk to me. I don't want to swim, I don't want…" Her voice trailed off.

"Lover's quarrel," Xaviera said. And then they hear the guy saying something about his girl being a 'col fish.' "I don't agree," Xaviera said.

"What?"

"The cold fish business. I don't think there are really that many frigid women. The problem is usually lousy lovers—male lovers, I mean."

"But there can be problems that make it difficult or impossible to get it on or enjoy sex."

Xaviera said, "Yes, but they are usually psychological. There are very few physical reasons for what they call frigidity. In some women a hooded clitoris can be the cause of never achieving orgasm. That can be corrected by female circumcision… but I think

most so-called frigid women can be taught how to become better lovers and more responsive, to enjoy a healthy sex life. I'm working on another book right now, entitled *Supersex*. What *Xaviera on the Best Part of a Man* did for men—explaining about the male sexual apparatus—this new book will do for women."

"It is not only about women, huh?"

"No," said Xaviera, "it covers subjects about women, lesbianism, penis envy, fantasies, techniques, and lots more."

"Sounds interesting."

"To get back to frigidity," said Xaviera. "The psycho-pathological reasons are the most difficult to cure. Take a girl who was raped when she was ten years old, say by her father. She either ends up with a father complex and loves it or she may never be able to enjoy sex in her life. But the term *frigid* is often stupidly applied to a woman who has a selfish husband, who just fucks her and doesn't try to please her. And if that particular woman grows to hate sex and never knows what an orgasm is, she is automatically called 'frigid' or 'cold.' " "You think if a guy just fucks his old lady to get rid of his sperm that's bad?" Marilyn asked.

"That's not only bad, it's boring. A lot of women don't get turned on that way—you yourself said you don't. I'm talking about women who do not have orgasms, whether they try to masturbate or not. There are many reasons for true frigidity: rape, fear, hate, lack of sexual education, ignorance as to the function of her own body, general conservative upbringing, in which the parents taught the girl never to touch herself, that sex was dirty and that she should never let a boy touch her down there. Even in this day and age, parents in certain families bring their children up like that. In general, I think frigidity can be cured by spending time with a good, considerate lover, who would honestly like to deflower a girl and teach her the art of loving. Every man I know prefers a girl with at least some experience." "How about impotent men?" Marilyn asked. "I've cured a lot of them. There are various degrees of impotency. Most of it is temporary because of drunkeness or depression. There's the guy who can't ever get a hard-on, which is more difficult to cure, and

then there is the guy who is hard forever and fucks and fucks and fucks but can never come. That's still another form of impotency; he can't please a woman very well—it's like having a fucking machine in your body."

Marilyn giggled. "I'll bet a chick with a vibrator can make your pussy hurt. I love vibrators and dildoes. I told you—didn't I?—that Chuck said they would probably take my vibrators away from me at Customs, so I just smuggled one in."

"Did you know that Customs confiscated the film of our cover shots from Neil? They took every roll he had brought along from New York to use for our picture session."

"Why?"

"They said he had to buy Canadian film."

"Then I'm glad I didn't try to get through with my dozen dildoes. They would have told me I had to buy Canadian content cocks!"

Xaviera laughed. "Listen, did that really happen to you, what you wrote in your book? About the hatbox?"

"Yes," Marilyn said, "the makeup case, you mean. All the vibrators went off in the hotel lobby and it was so embarrassing, seeing the small suitcase jumping around."

"I thought that was so funny," Xaviera said. "Do you think sex toys are good?"

"Oh, yes, I love them! I have some dildoes this wide and this long…" She held her hands apart at unbelievable lengths as Xaviera's eyes widened. "They're really a challenge. One time I did this scene, it was wild, the guy stuck his whole foot inside me!"

"That's no toy," Xaviera said. "How far did he put it in?"

"All the way, the whole foot."

"The big trend in California now among the gay boys is fist fucking."

"It's beyond that already, it's practically your whole arm. There's a gay film playing in New York now, Fred Halsted's *Sex Tool*, which is supposed to be really S&M, really gruesome, and I've heard that in it a guy takes two fists up his ass."

"Next they'll be taking two feet!"

Marilyn drew her feet up. "To me it's like really fun to stretch your pussy and your ass. Have you ever taken a foot?"

"My darling," Xaviera said, "I'm afraid for once I'm a bit less experienced than you. I've only had—I'm very square, you see—toes."

"Ummm," Marilyn whispered, "toes can be the start of feet!"

Xaviera laughed and said, "Let's swim. I'm getting hungry." Then just before she jumped into the gleaming water, she muttered, "Damn diet."

Marilyn swam up to her and put her arms around her neck. "Did you ever have a snake? Like Georgina Spelvin?"

Xaviera went under, came up, and floated on her back. "It's funny you should ask. I met two gays at a jet set party in Montreal who had a full-grown boa constrictor; actually he was a well known gay fashion designer in Montreal. I believe he fed the boa one rabbit a month and a chicken or so."

"My God," Marilyn said, swimming alongside her.

"Anyway, my gay friend Serge and I had that snake around our necks and, after the first scare wore off, it was so sensual to feel the cold skin sort of flow around your body. The boa was very friendly and obviously loved the warmth of a human-body. At one point he dug his head inside my decolletage and went underneath my armpit. But what did those guys do? Obviously, when they were alone they used to put the snake's tail up their ass. He was taught just to sit there and they would shove the slivery cold tail all the way up their asses as deep as they could take it. They invented all kinds of sex games, so I have been told."

"Yeeeeeeeeeeeouch!" Marilyn screamed, giggling, splashing in the water, "That's unbelievable!"

"Don't say ouch, you might like it!" Xaviera moved to the side of the pool and held onto the concrete and kicked her legs. "He was peaceful as long as he was well fed, and he'd let them fuck around with him for hours. And you know, his tail was not as big as a dildo, it was thin at the end and then got gradually thicker and thicker, the right shape.

"The fashion designer who actually had trained the snake took it all over town with him. To openings of art galleries, discotheques,

restaurants, boutiques. He would just drape the boa around his neck. I tell you, if you try to keep that body hanging around your arm over fifteen minutes, it gets very heavy. After several months the poor boa died. For some reason the owners had not fed him enough, and he got pneumonia and died. Guess what his two owners did?"

"No idea, buried him?"

"No. They wrapped his body in a spiral shape so his head was on top of his body as if he were still alive. Then carried it into the refrigerator and stuck one big red rose between his head and the rest of the curled-up body. They left it there, and it didn't decompose. One evening they gave a party and a famous model, who had just flown in from Paris and didn't know about the boa's existence, went to the fridge to get herself some orange juice. Can you imagine what happened? She screamed her head off and fainted on the spot when she saw the snake staring at her. The fashion designer decided it was finally time to bury the snake."

"To get back to that snake's tail. I must admit that I'm addicted to hoses and things like that," Marilyn said. "I'd like to lie on my back under that waterfall there and let the water hit my pussy until I come."

"But the thought of us getting tossed out of here wouldn't be so nice," Xaviera kidded. She looked around and then said, "Come over here." Marilyn followed her to the place where the lukewarm water was shooting out of a hole in the wall, where the newly chlorinated water fed into the pool. "I love spigots in swimming pools," Xaviera said. "If you place your body just right..." She positioned herself so the forceful jet of water hit directly into her bikini bottom, directly into her pussy "... you feel the rush on your clitoris."

Marilyn tried it as Xaviera put her arms around her, pressing her fingers to her nipples. "Oh, wow!" Marilyn exclaimed. "This is wonderful!" Then she turned around and let the water hit her ass. She pulled her bikini bottom down so the water could hit her full force, and turned around again letting it bubble in her pussy lips. "It's... wonderful," she moaned.

"Don't go too long, or you'll be coming all over the place," Xaviera said. "You know it's also a good exercise to prevent cellulite on legs and hips. Just let the force of the water massage those spots, and you'll see how it makes holes in your skin during the massage."

Marilyn moved away, pulled herself up, and sat on the edge of the pool. She hadn't felt so horny in weeks. Xaviera looked up at her. "I was in Acapulco once, hanging onto the side of a swimming pool like this. I was very horny—the sun was burning on my shoulders—and the water felt so great. It took me five minutes to find the spigot, because some of the holes didn't have any water coming out of them, so I had to search for one with a thick spray of water. I had pulled down my bikini like you just did and nobody was in the water, but there was this old man in a chair who all of a sudden struck up a conversation with me. He was above the pool. Since we had talked earlier, I politely tried to carry on a conversation. As I got close to orgasm, I didn't even know exactly what he was talking about because my clitoris was throbbing and I was about to come like crazy. The furthest thing from my mind was this sixty-year-old man who was telling me some boring story, and then his much younger wife came by. Fortunately she was very hip. One look at the expression on my face and she knew instantly that I was up to something. So she told him, 'You silly old goat, why don't you leave her alone?' At that moment, I closed my eyes and trembled with my long-awaited orgasm. When I was able to catch my breath again, the old man was apologizing and stuttering and his wife was still trying to pull him away, and I said, 'Excuse me, sir, what were you saying?' It was so funny."

"I know how it feels now! I've never done this in a pool."

Xaviera said, "I'm a freak for swimming pools or bathtubs with Jacuzzis. Whirlpool baths."

"I don't like them," Marilyn said. "I find I need smaller streams of water, more concentrated, more water pressure."

"Like a Water-Pik?" Xaviera asked. "They hurt. I've tried it. It's like a needle."

"No, but a Jacuzzi is too big."

"You have to get your cunt in the right place. You have to be a little bit away from it."

"A garden hose is terrific," Marilyn said. She looked at the waterfall. "Do you think they're strong enough?"

"No, I don't think so. There's nothing worse than being under water that's not strong enough. That just teases your clit. Those are just dribbles. I've answered women who have written to me in *Penthouse* that the best way to learn to masturbate is just to sit in the bathtub."

"Why in the tub?" Marilyn asked.

"Because you don't need any gadgets there, forget your dildoes. Clitoral stimulation is what counts."

"How do you do it? You can't get your cunt up under the faucet."

"I'll show you," Xaviera said, climbing out of the water. She sat next to Marilyn on the hot concrete and rolled back. No one was watching except for the two young men at the cafe. "You put your legs up like this…" She spread her legs and lifted them. To any onlookers it could have been a new yoga position. "The secret is you don't let the tub run full of water because once the water covers your crotch the strength of the stream diminishes. You fill it to hip level so you don't have to lie on the cold bottom, then you adjust the water, the temperature, and the flow. Well, it's a bit acrobatic…"

"Your ass is up against the front of the tub?"

"Yes, right underneath the faucet. And if you're lucky, you'll experience one of the longest orgasms you'll ever have. You hold on to the side of the tub or the water handles and just wriggle around so your clit gets nicely stimulated."

"I think it's hard to beat that thundering orgasm in the swimming pool." Marilyn said.

"In some old European bathtubs you have a problem because the water comes out of two separate spigots, the not and the cold do not mix. So, either you have a flaming hot cunt or a frozen one."

"How about electric shavers?" Marilyn asked unexpectedly.

"What about them?"

"I use it as a vibrator. Keep the razor part covered and press it to your pussy."

"Not my trip," Xaviera smiled.

"I like lots of vibrators. I like using one in my ass if I'm getting fucked. Or one in my cunt if I'm getting fucked in the ass."

Xaviera said, "Now they have one made just for that. It has a battery, is long and rather thin and rubbery. You can shove it up your anus while your man is fucking you. This little thing up your ass will be doing a dance all of its own. It's fantastic."

"I once had a vibrator that was about five years old. The thing made so much noise, it sounded like a jet engine in trouble. My man made me throw it away. I really loved that one."

Xaviera laughed. "I guess you get used to it like a pair of old jeans or slippers. You don't want to get rid of it unless it falls apart."

"It shook the whole room!" Marilyn dangled her feet in the water and splashed. "Actually, I hate noise. Why can't they make vibrators that are silent?"

"I like the ones with five different attachments, five different heads of various shapes and material."

Marilyn said: "Those don't work right."

"I like those. But I don't like them too strong."

"See, with me, they're not strong enough."

"You seem to be somewhat addicted to the mechanical do-it-yourselfers. Don't you think you can get the same orgasm, if he eats you well, as you can get with a vibrator?"

"No," Marilyn said, "they're totally different."

"Well, psychologically, I guess when he does it, it's a better orgasm. That's why I like the real thing as opposed to sex toys. I'm not crazy about dildoes. I've done it, I've had double dildoes and all that, with lesbians sometimes, but I don't really like those big fake cocks. I do realize that once you're used to the fantastic speed of a vibrator on your clitoris, it's a hard act for any man's tongue to follow. If you're addicted to vibrators, you really ought to lay off them for a while to appreciate a real tongue again."

"You always seem to write about how much you like huge cocks and big dicks. Are you hung up on them?" Marilyn asked.

"I like the sight of them," Xaviera said. "I like a meaty big penis, with a nice mushroom head. I don't like long skinny cocks. Rather short and stubby instead. Also the penis itself should be hard and rigid, and I definitely don't like to see a soft inch in the middle. But size isn't all that important. I'll tell you quite honestly that men with really big cocks often prove to be lousy lovers. Maybe because they just assume that since they are hung like a horse with their eight-to-ten-inch cocks, they can fuck like a horse. Most guys with big penises just bang the hell out of you, and they're usually rough lovers. But I have had some men with average cocks or even really small ones, and they have done everything under the sun to please me. Of course, they know they're not giants because of their small size, but they have come to realize that they sure can make up for their inadequacy by far better foreplay and technique. But... I still prefer my lovers to be well endowed and have a gentle love technique."

"I love looking at big cocks. I think that's why I want to see gay men making it. They all have such great bodies and such big cocks—fantastic, at least the ones in gay magazines have." Marilyn could feel her pulse rising again.

Xaviera said: "In *Boys in the Sand,* a gay porno flick, there was a great black dude with a marvelous big chocolate-colored cock. Even soft, he looked so sexy, because the damn thing just never shriveled up—it stayed thick and was like a great sausage. If I were a straight boy looking at that movie, I would have turned gay. What a turn-on that movie was. Hey, Marilyn, do you like to look at the male nudes in *Viva* and *Playgirl,* and does it turn you on?"

"I look for the biggies," Marilyn laughed. Xaviera said, "I often receive letters from jealous men or disappointed wives who ask me how come those guys in *Playgirl* or *Viva* are so big while they are still soft, and how come they—the men—or the husbands of the wives who are disappointed—can never match those models' sizes when soft? You know, Marilyn, the answer is quite simple. Those

guys are not really totally soft. They have what you call 'semi-hard-ons.' In other words, a bit of K.Y. jelly or Johnson's baby oil before-hand does miracles. Maybe some sexy chick stimulates them and they jerk off till the cock is good and hard, then the cameraman is ready to shoot just as his cock begins to go down a little, because the *law* says you can't show a hard erect penis.

"By the way, they just banned a *Penthouse* issue in Ottawa for distribution throughout Canada because of a pictorial essay of two lesbians eating each other. It was actually quite artistic, like most *Penthouse* pictures. Nothing crude. But just hinting about lesbian-ism and oral sex between chicks is a taboo. However, if some chick shows her entire vagina and inner and outer lips wide open—a so-called snatch-to-catch shot—no objections."

"Yes," Marilyn nodded, "I guess the censors get quite confused with what should get the green-light or the red-light treatment."

"I know Al Goldstern, who owns *Screw* magazine, and he gave me a lifelong subscription to *Screw*. It's a fun, hardcore porn maga-zine, but it leaves nothing to the imagination. Maybe I like to fanta-size a bit instead of seeing the hardcore stuff."

"I jerk off when I see porno. I love it. I like gay porno the best. I saw an eight-millimeter film once of boys getting it on that drove me nuts."

"Gay boys suck cock so well," Xaviera said. "I don't really get too excited seeing a guy eating pussy on a screen, because often they do such a sloppy job. Somehow a closeup shot of a widespread vagina with the outer and inner lips fifty times enlarged just doesn't look so appealing. As much as I like to go down on a good-looking woman and love to eat her cunt out, I still don't particularly like the looks of it enlarged on screen. I think a naked hard cock is far more exciting to look at. . ."

They went back to their lounge chairs and called over the wait-ress from the outdoor cafe. "We'd like to order lunch and have it sent to Room 215 in about twenty minutes," Xaviera said. Marilyn ordered a chefs salad, and Xaviera said ditto. And an iced tea and a large glass of water. With ice.

"The best porno movie experience I remember was the time I saw *Boys in the Sand* and *Deep Throat,* on a double bill, no less. Porno flicks in Canada are illegal, at least hardcore, but this was a private showing." Xaviera rubbed some cream onto her face and closed her eyes as she lay in the noon sunlight. "There was a scene where this beautiful blond boy is fucking a big black cock. It turns out to be a dildo, but you don't see that in the beginning, you think he's fucking this big black dude while sitting on top of his cock… all you see is the cock going in and out of his anus, and his hand going in a wild jerky movement around his own white cock. Then the wide-angle lens comes in and there is this black dildo including balls planted on the floor, standing up in the air in constant erect position, and blondy is riding it, high and not so dry. Boy, I was so horny I wished I were a boy. That gay movie sure was one hundred times more exciting than Linda Lovelace with her shaved snatch. And it was *her* film most people thought they'd enjoy most. Strange how many girls dig gay guys. I know quite a few straight chicks who are real fag-hags and love their company."

"Did you ever have any drags working for you when you were a hooker? We had a few transvestites in *Green Door.*"

"Transsexuals or transvestites?"

"Transvestites," Marilyn said. "They can be pretty weird. They used to dress like girls, but they were one-hundred-percent guys. Eventually in *Green Door* they were all naked and stripped off their dresses only after they lifted their skirts and showed big hard-ons to the surprised public!"

"I knew a few transsexual hookers who already had the tits done, but still had the cock working for them—occasionally, because with all the hormone treatment it got more difficult for them to actually come. I know a lot of gay transvestites—or rather, drags—here in Toronto; they're mostly hustlers or strippers, and few customers find out the trick because they usually stick to blow jobs for twenty dollars. The prices are lower than in New York, and sometimes they get beaten up if a client finds out the truth. One day I became friends with this person who'd had a sex change, who already had

become a woman. Her name was Nicky. She was absolutely gorgous. Tall, slim, elegant, beautiful reddish-brown hair. She looked like a deer, like Bambi, with big sad brown eyes.

"Nicky came to me originally because she wanted to write a book about her life and wanted me to be her ghostwriter. She had several tapes typed out and loosely put together. But the poor girl was so screwed up that not one page made sense. I had to refuse to do her book and referred her to a writer friend, a guy who got along fine with her until she disappeared to Los Angeles and left him without paying a nickel for months of work he had done. Stupid deal—no contracts, no lawyers, just a handshake. But basically her story was the following.

"All his life, even as a young boy at the age of four, Nicky had felt like a girl. His mother dressed him very girlishly until the age of six when he went to school, but still kept his hair long. Nicky never played boys' games, preferred to play with dolls, try on his sister's clothes, and loved nylon stockings and high heels. Yet those are simply transvestite inclinations. With Nicky life became pure hell as he got to be a teenager. He was very effeminate and hated to get undressed with the boys during sports. Yet he never felt the urge to touch another man sexually, at least no *gay* tendencies. In fact, he felt only comfortable among women, his mother's friends, sister's friends, aunts, etc. Women all loved and adored him. Nicky felt horrible in his man's body and had run away from home several times. He came from a small town in western Canada. He knew he was not homosexual, and yet the boys called him a sissy, queer, faggot, queen, and so on. His parents put him in reform school. He ran away. Nicky then began dressing in drag at the age of fourteen and started to deal in dope, became a stripper in a sleazy strip joint, became a hooker, and went under psychiatric treatment for years. He then knew that he actually was a woman trapped in a man's body and, through years of hooking and stripping, he saved enough money to get a partial sex change in New York. He had his breasts fixed and began hormone treatment. He then ran into trouble, got arrested several times, and spent his last penny on bail and lawyers' bills.

"Between fifteen and eighteen he lived as a transsexual and, after all the arrests, stopped hooking and began to work for various massage parlors where there was less chance to get arrested. Finally he had his sex operation done and his penis and scrotum removed and replaced by a vagina. But Nicky was supposed to keep some form of diaphragm inside her vagina to keep the space open or... do a considerable amount of fucking. What happened? She forgot to wear the ring and did little fucking because... through the years she had become a true fag-hag and now, as a women, she craved their company. But the gay boys who liked Nicky when he was still somewhat of a man lost interest in her as a woman. And even if they were interested, *sex* was out of the question. After all, they wanted a real guy with cock and balls. Dear Nicky got all confused. She was happy as a woman, but her cunt had closed up. So now she's a sex change with nothing. She never has an orgasm. She was so frustrated that she tried to commit suicide at least four times in one year. She became a heroine addict for a while and is one of the saddest, loneliest girls I know. Sometimes she bounces back and takes off, like when she left for California. She wanted to become a movie star. The last I heard of her, she still works in massage parlors and turns tricks. But she can't get fucked and mainly does blow jobs and hand jobs. What a life, huh?"

Marilyn looked pensive and said, "I guess you're better off just being gay and liking yourself and your own body and someone of your own sex than having to go through hell like that Nicky. Was it easy doing your first film *My Pleasure Is My Business!*" Marilyn asked.

"I loved it. Great teamwork, like a family: cameramen, grip, script girl, makeup, hairdresser, director, co-stars. It was fantastic. Hard work and long hot hours under the shining lights. A totally new experience. I loved being in front of the cameras. Remember, I've done hundreds of TV appearances in the past few years, so I'm not camera shy. At first I was afraid I'd have to learn dozens of pages of script each night. It was all easy to remember, and there was only a little script at a time because of all the retakes. Patience is one thing

I had to have, for sometimes the heat of the lamps was unbearable and the close-up scenes and retakes seemed superfluous. But then again, I wasn't the director. He knew best. The difference between TV and movies is that on TV you often are asked to look into the lens. On film you do anything to avoid looking at the camera. You're in a different world and can't flirt with the camera because it's ultimately the eye of the viewer."

"Did you have a rough time?" Marilyn asked. "What I'm saying is, I've heard hustlers and hookers find it very easy to have sex with any client, or almost anyone. But they have a rough time making a porno film. Harry Reems and Grant Tracy Saxon were arguing about that on the Lou Gordon show recently. Grant said it was true—he had been a hustler for a long time, performing sex acts like crazy, but when he made a porno film, he had some trouble getting it up. He said it freaked him out. And Harry Reems said he didn't know if he could keep it up just because someone had paid him. He said what happened to Grant was what happened to every hustler or hooker who tried to have sex on camera, that performing in the bedroom and on the set are two different things."

Xaviera said, "For me it was the opposite, my hooking experience helped my acting. Every woman is a bit of an actress at times in bed, and if she isn't, men call her a lousy lover. I didn't have any trouble…"

"But your film is R-rated, that's a difference. I just thought of that, there was no hardcore porn in it. Just some simulated sex, that's no sweat."

Xaviera shook her head. "There were two versions, X and R. The X-rated version was for certain countries in Europe and for Japan."

"Oh, I didn't realize that," Marilyn said. "Real porno film sets are so different, the atmosphere is so relaxed, and when it's time to fuck on screen nobody is uptight, it's a lot of fun."

"This was not that relaxed. But you were right in your book when you said it's like fucking the audience, that's exactly how it felt doing those scenes. Even in the non-sex scenes, you know the eye is out there watching, you, the camera is following you. Doing four

or five takes is hard, but great discipline, and being on the set every morning at five a.m. isn't easy, either, but there's something magical in it. I liked the attention, too, the way the hairdressers and costume people fussed over me, things like that. But the hardest thing was getting the lines down correctly—not the memorizing, but how to say them. The right projection and movements."

"That's what's so different about live theater. *Mind with the Dirty Man* was the longest-running play in Vegas. We did two shows a night, and I did it for nine months straight. That's discipline."

"You love that, though, because you're a masochist. But you really know what acting is all about. At its utmost. I've been afraid of being on stage because I don't have a very good memory for long Shakespearean speeches. If it's gonna be stage work, I'd prefer comedy sketches or a musical. I like to sing, but I sure won't put Barbra Streisand out of business."

"Your concentration level has always got to be up," Marilyn said, knowing well what she was talking about. And your energy has to be as strong as the first night you did it. You owe that to the audience. In fact, you owe them the same performance you did on opening night or better. And your hair and makeup have to be the same every night; it's discipline, a routine, and exciting."

"I should think a film is more exciting because if you do a show you're doing the same thing every night, and you must get pretty bored doing the same thing over and over again. With a film, every day is a different shooting on a different set or scene."

"Films are a lot different," Marilyn said. "You get one chance and that's it, not like in a play, where every night you can correct the night before, or try to get better."

"On film you can be sure it's good. They edit and retake until it's perfect. On stage you can't go back and do it a second time."

"And even if you hate the guy you're playing opposite," Marilyn said, "you have to really believe you love him. You tell yourself that. And, in turn, tell the audience that."

Xaviera nodded. "That's why Liz Taylor and Richard Burton must have had such a great but difficult time working together. In real life

they had this love-hate relationship, and yet on the silver screen they had to be great lovers." She thought for a moment. "Well, come to think of it, they usually played in very emotionally loaded films about couples with lots of marital problems. Take *Who's Afraid of Virginia Woolf?* Marvelous acting and a lot of yelling and hysterics."

Marilyn laughed. "Should we go up for lunch? I think it's about time."

"Okay. My stomach is rumbling."

The food hadn't arrived when they entered the room. Marilyn left the door unlocked so the bus boy could get in with the cart. She went into the bathroom, slipped off her bikini, and put on her cut-offs and thin T-shirt. When she came back into the room, Xaviera was sitting on the bed in her bikini looking voluptuous.

Marilyn sat down. "Do you want children some day?" Xaviera asked her.

"Well, I never really thought of it," Marilyn said. "I would love to have a child some day," Xaviera said, smiling.

"Yes, I'd like one, too, but I'm not sure whether I can be a good mother. With a career like mine, it's nearly impossible. When you have to go away for three months and say, 'Bye kids, see you then,' it seems wrong somehow. I wouldn't be a good mother now. I will when I'm older, maybe."

"Some mothers I know," Xaviera said, frowning, "will never leave their kids alone, not for an hour. Remember I told you about my black girlfriend from Barbados? Well, she and her old man, a famous French-Canadian musician, went up to the mountains to make a baby. Really, they lived there for a few years. They worked on yoga, were into health food, etc., to make a healthy baby. The baby was a real bear." "A... bear?"

"Yes, a bear of a baby boy. Light-skinned, gorgeous, and big. Indeed, he turned out to be a beautiful baby, and very healthy, all that mountain air and the good food they fed him. But they spoiled him silly because they have never let him out of their sight. For the first three years of his life he could break things and throw glasses on the floor and just do whatever pleased him. He was a real little tyrant.

Finally, though, he was getting a bit too much for them, so my girl-friend had one of her sisters flown over from Barbados to live with them as a babysitter. It seems that now he finally gets a bit of train-ing and is taught what discipline is like. But the mother still treats him like something precious, like cut glass, and he gets his way with anything he wants. Like masturburbating him." "You're kidding!"

"No. Maybe it has something to do with her culture, with being black, because for instance in many African tribes it is quite com-mon that the mother will masturbate the children to calm them down. This girl, she used to suck his little penis and play with it when he cried. She's been sucking his cock since he was less than a year old, but told me she stopped doing it a year ago. Now he's three and a half, and the kid has no qualms about standing in the middle of the living room when they have guests and pulling down his pants. Then he begins to play with his little wetter. At least, lately her sister has been teaching him not to make a public display of himself. After all, we all know little kids can begin masturbating at a very young age. Just teach them not *to* do it in front of guests!"

"That's what I call a very far-out education," Marilyn said.

"Well, my girlfriend is a very far-out exotic lady and a wild ti-ger. She loves dancing and has lots of temperament. Her son, if he is anything like her, will be a true little animal. I love that whole fam-ily; they sure are different."

"She has to be…" The phone rang and Marilyn picked it up. "Yes?" It was the dining room. "No, we ordered our lunch to be sent up here. Yes. Right. Oh, can I have wheat toast instead of white with my salad? Thanks." She looked at Xaviera as she put the receiver down. "They set up a table for us outside and wondered where we'd gone."

"I knew that chick didn't have all **her** marbles," Xaviera said, remembering the waitress who'd taken their order.

"That's what we haven't talked about," Marilyn said.

"What's that?"

"Food and sex."

"Sperm tastes bad if a man drinks a lot of booze."

"Acne," Marilyn said.

"What?"

"Someone once wrote me and said she heard if you have acne you should put sperm on your face, it heals it practically overnight. She wanted, to know how to apply it."

"What did you tell her?"

Marilyn giggled, sitting cross-legged on the bed next to Xaviera. "I just had to write a funny answer, I mean, like she should take it and just kinda smack it on her face."

"Smear it like night cream," Xaviera said.

"Mmm, right."

"A good thing for potency is to eat lots of creamy things, like whipped cream, caramel, and chocolate mousse. The next day the sperm will taste better and it gets you more aroused when it tastes so good."

"Anything sweet," Marilyn said. "I've noticed anything with sugar will make a guy's 'come' taste wonderful."

"Sweet things in general, chocolate, cookies, cake, pastries, peanut butter, honey, they'll help. And if you've been fucking all day, when your tongue is on your toes, all you need is to have a Melba toast with a good smear of honey on it. You'll get energy. Or a bite of peaau' butter, but that's very fattening."

"I wonder if honey makes a woman's pussy sweeter, like it makes a guy's sperm sweeter?" Marilyn asked.

"I should find a girl who would tell me," Xaviera said softly, teasingly.

Marilyn was about to say something, but the phone rang again. "Yes... yeah, ice water and an iced tea." Marilyn stood up, next to the bed. "No, a chef's salad. Listen, we gave her a simple order, and it's all messed up..." Suddenly she realized that Xaviera's finger was moving between her legs. "Well... uh... yes," she said and put the receiver down. She looked down at the bed and said, softly, "They're redoing the whole order.... they... they messed up..."

And that was the last word. Xaviera slid her finger into Marilyn's pussy and Marilyn fell to the bed, into her arms, and their lips met in a passionate kiss. Marilyn's head reeled and her mind thun-

dered with Xaviera's words, *I might whip her ass after I eat her hot pussy…"*

Xaviera opened Marilyn's cut-offs and slid them off. Marilyn's naked buttocks gleamed in the sunlight streaming into the hotel room, and Xaviera feasted her eyes on them before she brought the palm of her hand down against the naked flesh. *Slap!* The harsh, fast sound echoed in the room. *Slap!* She hit again. Marilyn moaned. She shut her eyes tight… *and whip her ass… and whip her ass… and whip her ass.* "Mmmm," Marilyn murmured, feeling the woman's ripe lips again moving over hers. She let Xaviera slide her tongue into her mouth and then she felt her hands running through her long hair, pulling slightly, hurting just enough to cause her to want more, finally resting her hands on her tight breasts.

And then, in one fast move, Xaviera had ripped Marilyn's T-shirt off her body and she was totally naked. Xaviera moved away slightly. "Ummm, you look beautiful," she said softly.

"What about lunch?" Marilyn asked, smiling. "This is a little appetizer," Xaviera whispered, and then pressed her head down between Marilyn's legs, to kiss ever so lightly the pussy she had teased so long and desired so much, the pussy with the little line of blond hair that had intrigued her so… and, now, the pussy that tasted so good. She moved her tongue in, expertly, darting it back and forth against Marilyn's hard clitoris. With her right hand she tickled her anus, and her left ran circles around her breasts, never touching the nipples, teasing still. Finally, she lifted her head and lay back. Marilyn knew what she wanted.

She unfastened Xaviera's top, and the luscious breasts fell out. She pressed her face between them, feeling the warmth again, feeling the excitement, the sheer pleasure of such beautiful big tits against her cheeks. She kissed them, licking them, and finally sucked on the nipples as they grew taut. She sucked like a little girl, moaning and gurgling, and Xaviera held her in her arms, still tickling her pussy and her anus.

Marilyn moved her face up from Xaviera's breasts to kiss her again, and Xaviera gently forced her entire body up, so Marilyn was

on her knees, over her, straddling her. She brought her fingers up, tightened them in the shape of a drill, and forced them between Marilyn's open legs. Marilyn shot straight up in the air as Xaviera's fingers filled her pussy as a cock would. "Oh, God, God!" Marilyn squealed.

Xaviera said nothing. She pressed her hand further into the moist vagina, and slapped her ass, hard. Marilyn felt the sting and her whole body tingled. *Do it again! Oh, please, Xaviera, do it again!* Then, suddenly, the hand was pulled away, her pussy was no longer being stimulated by the fingers. Xaviera yanked her body down to her face, so Marilyn's pussy pressed against her mouth. Her tongue slid in where the fingers had been. Marilyn squealed as she felt an orgasm rising. Then Xaviera hit each buttock at the same time, stinging them, making them red and hot. Marilyn bit her tongue to keep from screaming in pleasure. *Yes, yes, I'm going to come... I'm going to come!* She looked up at the ceiling and felt the whole room starting to spin. Xaviera was eating her, her tongue doing a dance in her cunt, deeper than any tongue had ever reached. The hands kept slapping her ass, hurting her now, and she loved it, this was what she had wanted, this was what she had dreamed about and feared would never happen. *Oh, God, I'm coming.*

Marilyn shuddered, locked Xaviera's face between her creamy thighs, and then collapsed backwards, falling into a sweating ball on the bed next to her. She took a deep breath and purred like a kitten. The orgasm had come from deep inside her, from her soul. She was still feeling it. She was shaking and excited, and yet she felt strangely peaceful and relaxed. She opened her eyes and focused on Xaviera's purple bikini bottom. She knew she wanted what was underneath...

Marilyn slipped the bright-colored garment off Xaviera's shapely legs and tossed it on the floor. She looked at the inviting vagina, this famous pussy she had dreamt of so often. She noticed the neatly trimmed appealing triangle; how her pelvic area seemed so high in the sunlight; the surrounding alabaster skin, which was emphasized by the darkness where she was tanned. Marilyn let her fingers run through Xaviera's pubic hair, and then she slowly crept toward it, on

all fours on the bed, her nose leading her like a police dog, until she found what she wanted and forced her way in…

She slid her tongue between the moist lips of Xaviera's womanly cunt. She thought it tasted like morning dew, sweet and fresh, and she wanted more. She plastered her face between the strong legs as they wrapped tightly around her and moaned as she felt Xaviera pulling her hair again. She pushed Xaviera's legs up with her hands, until she had her lips on her anus, licking her, tickling her, and finally sliding her tongue into the forbidden passage. Xaviera held her legs in the air, closing her eyes, and finally let them drop as Marilyn came up for air, her face red and wet and her eyes full of lust.

They looked at each other—no words were needed. They instinctively knew what they wanted. They stretched out on the bed, Marilyn with her head at the foot of the bed, Xaviera with her head on the pillow. Marilyn's cunt was only inches from Xaviera's face. Xaviera's legs were slightly spread open, enough for Marilyn to lick her gently at the start of her pubic hair. They reached around and pulled each closer to the other, hugging one another's tight buttocks, burying their faces between their thighs, locked together in a firm sixty-nine position.

It didn't take long. They were both so excited, so pent-up with desire, they reached a simultaneous orgasm. Xaviera had been holding back—she'd been on the brink since the moment she had reached up to tickle Marilyn's pussy while she was on the phone. And Marilyn had not quite recovered from her first orgasm, she was still coming, her mind still reefing from the knowledge that they were finally acting out what she had thought would only be a dream.

Xaviera moved her tongue in and out of Marilyn's tight pussy with lightning speed. She massaged her ass and boyish cheeks. She felt Marilyn's tongue caressing her thirstily, licking out every inch of her pussy, and Xaviera felt soaked to the gills down there and knew Marilyn's face had to be covered with feminine fluids, her love juices. She pulled Marilyn's ass to her, tightly, digging her fingernails into the flesh, causing the pain Marilyn liked so much, feeling her

sense of consciousness slide away for the moment as waves of pleasure rippled through her body and sent her on a roller coaster down the river of passion.

Marilyn moaned and came again. She lifted one leg slightly into the air and then shuddered and held Xaviera tight. She finally pulled her head from between Xaviera's legs and gasped, "Oh, God!"

Xaviera was back on earth. She opened her eyes and smiled. Then she took Marilyn and rolled her over on the bed, again, until they fell to the floor.

"Fantastic!" Xaviera exclaimed, but started to laugh when she realized what had happened.

Marilyn giggled and pressed her face back between Xaviera's legs, tasting her beautiful full cunt once again. "I never want to break out of this position," Marilyn said.

"Oh," Xaviera said, rubbing her ass cheeks, "you've got the most delicious clit, small but delicate, and hard to find."

And then, without warning, there was a knock at the door. Both women looked up, still entangled in a sixty-nine position, bare naked, their faces wet with the juices of each other's cunts, and watched as the most startled young waiter in the world pushed in the cart with the salads.

"Don't mind us," Marilyn said, sitting up, her legs spread.

"No, we're just doing a book," Xaviera said with a grin. Marilyn broke into laughter as the blushing waiter stood with his mouth open. "Well, come in further," Xaviera said, standing up, her naked shining breasts reflecting the sunlight, her big nipples gleaming from perspiration.

"I... here's your lunch," the waiter stuttered. "I... I'm sorry. The door was... it was unlocked..."

Xaviera thought for a second of putting on a robe or her bikini or even wrapping herself in a bedsheet, so the poor young guy wouldn't feel so embarrassed. But this was fun, and something he could tell his friends—who of course would never believe him—and remember forever. Marilyn thought nothing of it. Being the exhibitionist she is, she jumped up, sat cross-legged in the chair near the

window, and said, "Ummmm, food! And they got it right—wheat toast."

The waiter was destroyed. Overly excited and still very stunned, he didn't know whether he wanted out of there as fast as possible, or whether he was waiting for an invitation to stay and join the party. Two gorgeous women who'd just had their faces plastered into one another's cunts were now going to sit naked at the table and calmly eat their lunch. It was something that only happened in the movies.

"Thank you, that'll be all," Xaviera said, sitting down across from Marilyn.

"Looks delicious!" Marilyn said, looking at the food as well as Xaviera's snatch.

The waiter looked at them. "I'll say." Then he walked out of the door wondering if he'd dreamed it all.

"What was it like?" Marilyn asked.

"Hmmm?" Xaviera was enjoying her salad and the serene sight of Marilyn so calm, and composed and naked in her presence.

"Well, how did you feel? I mean, was it good?"

"Baby, it was fantastic. Your pussy is… lovely… and young."

Marilyn felt a tingle go through her cunt right then. "I wanted it so badly. I'd been thinking of it all the time, since the night we met. I told Chuck at dinner that I wanted to get it on with you. I loved your boobs, and the way you looked me over from top to toe with your big green eyes. Your eyes and boobs turned me on most."

"Thank you," Xaviera said, softly. She admitted it—she loved flattery, especially from someone as gorgeous as Marilyn Chambers. "I think I wanted you specially since the photo session. I really got horny for you and that little shaved blond pussy then."

"You know the tape recorder is still on? Do you… do you mind?"

Xaviera shook her head. "Not at all. How about you?"

"Oh, no, I'm digging it!" Marilyn exclaimed.

"Then it stays on." Xaviera took a bite of salad and then said, "You know what started it today? When you got up to answer the phone and I could see your shaved pussy sticking out of those

shorts. Well, I should go back. First I thought of the designs embroidered on your shorts, then of what was underneath them, and then I thought of your smooth buttocks halfway exposed. It was driving me crazy, how you had been walking around in those since we came up from the pool. I just couldn't help reaching up for that cute little pubic snatch..."

"Pubic snatch," Marilyn said. "That's a new term for it. I kinda like that."

"Also, that body lotion you'd put on at the pool. That got to me, too, that scent."

"I got off on the fact that you stayed in your bikini," Marilyn said, "and didn't change into your caftan or anything. And you have some suntan cream on, too."

"I love that stuff. I like to give massages with it, to guys especially, rubbing it all over them, putting my fingers up their ass, between the balls, massaging the balls. I saw you by the phone and said, 'I'm going to let my fingers do the walking.' "

"Your fingers? Your *tongue* did all the walking!" Marilyn drew her legs up and shuddered. She was feeling excited again.

"My fingers first did the walking, then my tongue stopped doing the talking and took over for my fingers. You have the tiniest pussy!"

Marilyn looked flattered. And surprised to hear it. "Really?"

"Yes! And you have the hardest clitoris to get to, very small, tiny and hard... so exciting, and what a challenge to get there. No wonder you shave around there..."

"Easier to get to?" Marilyn asked.

Xaviera nodded. "Lovely nipples, too. T felt like really grabbing you. At one point, when T put my hands down behind you, I really felt that if I had a cock at the moment, I would have jammed it inside. That's when I felt I needed a dildo."

"Yeah, right," Marilyn purred. She was holding her toast in her hand, not eating it, just kind of waving it around in the air, slowly.

"You were a delicious appetizer for lunch," Xaviera said. And then the phone rang.

Xaviera reached behind her to grab it. "Hello? Yes, this is Xaviera Hollander. Who is this? What... my new book... *The Best Part of a Man*, a penis book, all about cocks, about pricks... yeah, you like that, hey? If you only knew who I'm here with..."

Marilyn whispered, "Who is that?"

Xaviera covered the mouthpiece. "Some guy from New York, I never heard of him." She took her hand away. "Yes, I'm here with Marilyn Chambers, the movie star... you know who she is? Sure, then you saw her cunt up there on the screen... well, I have it right here in front of me now. We're sitting here naked playing with each other... yeah... doing a book together here. It's really nice and exciting... where are you calling from? Your office? Where are you sitting?"

"Is he beating off?" Marilyn asked.

"Are you beating off? Oh... you're at home... naked? What are you wearing... a pair of shorts, how nice. Oh she's just wearing a little gold chain around her hips... she's naked, yes, and her pussy is just dripping wet right in front of me..."

Marilyn was dying, curling up in excitement and laughter. Xaviera could barely keep her voice straight. ". . . in airplanes? Does she ever do it in airplanes? Honey, she's the only way to fly! What's your biggest fantasy... tell me... two women? Well, what do we do... we make love, we play around. The way my tongue slithered down her lovely clit just now was delicious... are you jerking off? Well, get it nice and hard... how big is it? You're kidding! No? Well, with a size like that, I should think you could suck it yourself... do you? Good for you. Circumsized, too, huh? That's nice... is it glistening with 'come' now? Big purple head... yeah... gonna cream all over the phone... you don't believe you got us both at the same time? What's your name... Ted? Hello, Ted. Marilyn says hello, too. My fantasy? Well, my fantasy is that I would sit right on top of you right now, sit on your face... then on your fifteen-inch cock... and while I put my cunt down on your prick maybe I'll put Marilyn on top of your face and you can eat her pussy. What's another fantasy of yours? No, that's not a good fantasy. A guy fucking me from

the back? Yeah, that's nice, you up front and somebody else from the back. I've done that. I wrote about that in my book, remember that? You ready to come yet? Because we have to eat, the waiter just brought us our lunch. No, I can't... but it was nice of you to call... not really, but have a good time, make it quick and good. Byebye." She hung up the phone.

"I don't believe that!" Marilyn screamed. "I get off on those calls," Xaviera said. "To think this guy goes to all the trouble to find my number in Toronto and then gets the answering service who tells him to call me here at this hotel and then he gets me when I'm bare and I'm with Marilyn Chambers, of all people—he gets two for the price of one phone call." "He must be dying. Just dying."

"He'll get over it," Xaviera said, "in about ten years. We have to keep that in the book just so he can prove to his friends that he wasn't lying." "Oh, I love it!"

Marilyn had finished eating. She stood up. "Wow," she said. "There's a whole group of hungry young guys out at the pool. I'm going to walk out onto the balcony..." And she walked out there and gave them an eyefull. She came back into the room and told Xaviera, "When I rubbed my tits they went berserk."

"I know. I saw. Come here. Let's talk some more, relax after that meal..."

Marilyn walked over to her. She took Xaviera's hand and then had a brainstorm. "Hey, if we hung the bedspread over the railing on the balcony, we could lie down naked and get a nice and even suntan!"

"Sure. We can lie on some towels and pillows. I'll rub you with your lotion."

Marilyn grabbed the spread. Together, naked, they folded it over the balcony railing, much to the dismay of seven very horny men sitting down at the pool, looking up. Grabbing the bottle of suntan oil, Marilyn handed it to Xaviera and flopped down, face first, on the pillows. Xaviera applied the lotion evenly at first, gently massaging her back and shoulders and finally her shining tight ass. A finger crept down between the cheeks. Marilyn moaned.

"They guy on the phone said his fantasy is for me to sit on top of his cock and get fucked from the back."

Marilyn said, "You mean a double fuck?"

"Yes. I wrote about it once. I had one."

"I know a girl who had two in her at once, in her pussy."

"That's heavy," Xaviera said, squirting some oil onto Marilyn's legs.

"Oh, that feels good," Marilyn sighed.

"My poor pussy would be numb with two of them. I'm delicate down there."

"Not me." Marilyn giggled. "I'm used to... oh, God, well... two, three, four..."

"You're kidding!" Xaviera said, slapping her playfully on the ass. "You have a tiny cunt."

"But I've had three dildoes up there at one time. I'm a very flexible chick."

"Well, then," Xaviera said, "the only thing you're missing must be obscene phone calls."

"I make up for them with my fantasies," Marilyn said. She stretched out as Xaviera moved close to her in the sunlight. "I feel we're at one of the nudist camps you talked about."

Xaviera laughed. "Right, and soon someone will come along and tell us we're exciting all the men!"

Marilyn giggled and kissed her. "This has been a wonderful time we've had together, hasn't it? I wish it wouldn't end so soon."

"We could spend tonight together if it were not for my lousy wisdom tooth. I've had this appointment for weeks. Is it as hard to get dentist appointments in the States?" "Yup."

They heard a voice and turned in the direction of the sound. It was Bobby, the bellhop, on the next balcony. He was standing, looking down at the pool, saying something to the maid. Marilyn stood up and waved, and then disappeared again behind the bedspread. The boy looked perplexed—did he just see a naked Marilyn Chambers waving at him? And then Xaviera did it. "Hi, there!" she called and disappeared.

Marilyn and Xaviera shared their little joke. "I love bellhops, just love them," Xaviera said.

"They're always horny and so young. The ones in New York hotels always seem to be a hundred years old. Here they're all very young indeed."

"Yes," Xaviera said, putting her arms around Marilyn's neck, rubbing her earlobe slightly. "The horny ones come to your room and say they just have a minute because they have to get back on duty, and so you tell them to just sit on the couch or stand next to it and open their pants. In Europe they have chambermaids, usually young and fresh girls, and they will sometimes accidentally walk in on a couple lying in bed fucking. So the couple will say, come join us, and they all fuck together. In Germany they call those girls *Zimmerkaetzchen* or room kittens. Hotels can be very sexy places."

"Yeah, I've met plenty of horny dudes who work in the hotels where I stay when I'm on the road.

One time while I was in Washington, D.C., I was feeling particularly sexy, and I decided I wanted to see how many guys I could screw in a 24-hour period. I thought it would be a challenge. I was going to order a couple of bottles of wine from room service, but first I asked for someone to bring up a wine list so I could make a selection. (The wine wasn't the only selection I was planning to make.) The guy on the phone sounded fairly hip and could kind of tell by my voice or vibes what I was thinking, especially when I said, "Please send up someone sexy." It always seems to me when sex is the subject, nothing much needs to be explained.

There was a knock on the door. I had on my sexiest outfit, which was totally see-through, and I open the door. A young black man walked in and stopped. He tried desperately not to look into my eyes or through my dress. He handed me the wine list and looked me over, while I took my sweet time reading the list. He told me that I had a beautiful body and it was a shame that I had it so covered up. I asked him if he would like to take a closer look, perhaps, kiss my breasts. He loosened his tie and nodded. I slowly slithered out of my wrap and used it like a scarf, around his neck, pulling him closer to

me. Since black men are usually well-endowed, I was anxious to see what the rest of that beautiful black male had to offer me. He spoke with a slight accent, which indicated that he was from Africa. That made him all the more exciting to me because he was the real thing, straight from the jungle, grrrr. I asked if I could see his penis and he obliged right away. Then he told me that he'd never had a white woman before in his life. Oh, wow! Why do I have all this good fortune?

That got me extremely excited, and I took a look at his rock-hard cock. A real biggie! We fucked until he had to get back. He was afraid he'd be missed. I asked if he would send up one of his friends. He laughed and said he'd send everyone he knew. That night I fucked ten different guys, each three or four times, of all different races; blacks, Japanese, Chinese, a Cuban, even a genuine Indian. It was one of the best nights of my life, believe me. And the next time I'm in Washington, I hope to do better!"

"That must have been a wild night!"

"Yeah, did you see the movie *The Night Porter*, speaking of hotel workers?"

"No I heard that it wasn't very good."

"Well, the masochism in that was really a turn on."

"We had a film called *Ilsa Shewolf* here in Toronto—honest, that was the name of it—about the Nazi female sadists in concentration camps. It showed all the tortures, castrating men, cutting their balls off, etc. It wasn't a hardcore porno flick, but guys were sitting in the audience with raincoats on a summer day, All that pain, and everyone was jerking off. Some people in the audience fainted or puked. They always had a full house, but eventually the censorship board banned it."

"I really think the X-rated movie industry has failed *to* do a good bondage movie. They've got loops, the eight-millimeter versions, but they're all crummy. I think someone should do a good S&M film."

"I think men are more suitable for good S&M movies," Xaviera said, "and I mean homosexual S&M films."

"Chicks could make a good one, too. Once, I had a guy put Tabasco sauce in his mouth and eat me out like that. Just before a show, and I had to go on stage and sing and it burned for hours!"

"You must have given *one* hell of a performance!" "Yeah," Marilyn said, breathless, feeling Xaviera's hand moving down between her buttocks, to play with her pussy from behind. "But the best part of it was later, I shoved the entire bottle up there and it felt like the hottest cock in the world." "Ouch."

"I've had Ben-Gay in me, too." "Ouch again."

"And hot chili peppers. In my ass, too. It's a trip." "Have you tried the Alka-Seltzer thing?" "What's that?" Marilyn asked.

"I've never done it, but all I hear is how terrific it is, but someone I know told me recently it could be dangerous. You apparently take an Alka-Seltzer and stick it in your pussy and you fuck with it foaming inside you." "It just fizzes and fizzes?"

Xaviera tickled the lips of Marilyn's vagina. "Yes, just tickles and fizzes and it's supposed to cause an orgasm."

"Wow!" Marilyn put her head down on the pillows and closed her eyes. "I knew a chick in Los Angeles who had two guys fuck her at the same time, one in the cunt and one in her ass, and they came at the same moment, but when they did, she kept telling them to stay inside her. So they did. And then they did what she wanted—both pissed in her at the same time!"

Xaviera slid her fingers into Marilyn as the girl turned to kiss her. She shook in pleasure and then put her head back to the pillows. Xaviera moved her hand up to her buttocks and stroked. Marilyn said, "I hate to know you have to leave soon. I won't see you for so long…"

"Maybe you'll come back to Toronto to go on a promotional book tour together with me? Lots of hotel rooms to share."

"Maybe," Marilyn said. "Say, what are you planning for the future?"

"What do I want to be when I grow up?" Xaviera asked.

"Yeah." Marilyn put her head on her hands and looked at her. The sunlight made Xaviera's hair look almost white, a blond that was nearly goldish.

"I wouldn't mind pursuing an acting career, though I'll always be an author with lots of stories to tell. But for years I've had those damn immigration problems, so I can never plan my future for more than a few months at a time. No long-range plans." "I'd love to do a film with you." Xaviera agreed. "Fact is, someone should be photographing this right now!" She turned to see whether Bobby was holding a camera—he was gone, probably in the next room masturbating or fucking, she thought. "It might be fun to do a record album together."

"A real horny one. It's almost like we're doing that now, with the tape recorder on." Marilyn looked into her eyes. "Will they let us tell the truth about all this, like what we're doing right now and saying to each other?"

"Why not? Nothing the matter with saying my tits are big enough to fill your mouth… !"

"Oh, they were, they are!" Marilyn said. Xaviera turned over to face the sun. Her luscious breasts shone in front of Marilyn's gaze. "They're dynamite!"

"We should do a movie playing sisters," Xaviera said, dreaming aloud, "We could play sexy sisters in a sexual comedy, but we'd probably turn out to be incestuous sisters, and incest is yet another taboo of our society."

"You could be a businesswoman and I'd be your secretary," Marilyn said, "or I'd be the little girl and you're my chaperone."

"Domination, huh?"

Marilyn put her head on Xaviera's breasts., "Yes," she moaned. "I'd come crawling on my knees, crawling into your office to take a message on my knees and licking your feet and shoes while I'm there."

"Do it now," Xaviera said.

"What?"

"Lick my feet and then my cunt."

Marilyn moved her head down to Xaviera's toes and sucked them one by one and then moved up to her vagina, slowly licking the pubic hair, and parted the lips with her tongue. "Oh, that's it,

that's right," Xaviera said, looking up to see nothing but a huge ball of golden yellow in the sky. She felt her blood rushing.

"Oh," Marilyn said, "tell me what to do. You have to leave soon and..."

Xaviera sat up. She offered her breasts. Marilyn took them in her hands, looked at them, watching the nipples turn hard, and then kissed each one. "I love your tits," she whispered.

"I'm thirsty," Xaviera said in a sexy tone of voice. "Go get me some water. On your knees."

Marilyn's pulse was racing. She crept toward the balcony door on her hands and knees. "Get me that water," Xaviera spoke louder now, slapping Marilyn on her fanny, "and fast!"

"Yes, oh, yes!" Marilyn moaned, moving a few more steps, into the room now.

"Faster!" *Slap. Slap.* Xaviera's hand came down, the flat of her palm hitting both of Marilyn's cheeks, reddening them, stinging them. Marilyn moaned with pleasure and reached up to the table and grabbed the ice, water. She knelt on the floor as Xaviera brought the glass to her lips, drinking a little. As she swirled the ice cubes around with her tongue, Marilyn knelt between her legs, nuzzling her nose in her pussy hair.

"Here, Marilyn," Xaviera said, holding an ice cube she had pulled out of the glass, "spread your legs and hold, them open."

Marilyn obeyed.

Xaviera fell to her knees and dropped the ice cube directly into Marilyn's spread juicy box. "Ohhhhh! Jesus!" Marilyn squealed. Xaviera slammed her head between Marilyn's outstretched legs and took the ice cube into her mouth. Then she slipped it back into Marilyn's hot pussy as it melted, and again swirled it around in her mouth. She kept it up until it had turned to water, moving the cube from the girl's hot cunt to her warm mouth. And then she moved her head up to face Marilyn and kissed her.

They locked arms around each other and rolled over together on the floor. They were at the doorway to the balcony now, and sun hit them as they felt their vaginal lips pressing together. Marilyn

brought her leg up over Xaviera's, and Xaviera reached down to caress her cunt as their lips met with passion.

"If I had a ten-inch cock right now, I'd ram it up your beautiful ass," Xaviera said in a low voice, filled with excitement.

"Oh, yes," Marilyn responded, "and you could fuck me, fuck me forever..."

"Come outside again, in the sun..."

Marilyn followed Xaviera out onto the pillows. Then, like two silly schoolgirls playing an exciting game, they squirted suntan cream all over each other's bodies and rubbed it in by rolling around entangled. Squish-squash. Hands cupped around each other's slippery breasts, they then turned to face each other's feet. Marilyn licked Xaviera's toes and her ankles and knees and thighs and finally locked her head into the sweetness between her legs. Xaviera spread Marilyn's legs with her hands, so her tongue could lash out at her anal opening, pressing it hard, ordering it to open slightly for the tip to penetrate.

Marilyn was on the brink...

"Oh, yes, yes," Xaviera said, urging her orgasm.

Marilyn bit her lip to keep from screaming in pleasure. She felt Xaviera's tongue moving rapidly between her pussy lips suddenly, and she bucked her hips into' the air and felt the sunlight burning her breasts. The tongue was as good as any cock she'd ever felt, and she couldn't remember an orgasm that had caused the sensation this one had—the sun had turned black for a moment and she had thought it was night. Then everything went bright silver and she lost all sense of time and space, a sexy Alice lost in a wonderland of sensuality.

Xaviera didn't release her. She was determined to give Marilyn an orgasm she would never forget. She kept her lips pressed between the Ivory Snow girl's' pure-as-snow thighs, and sucked every bit of delicious honey from her depths.

Marilyn finally lifted Xaviera's head from between her legs. Her orgasm had lasted hours, she thought. She didn't know what to say. Her body smelled like cocoa butter, and her head was beaded with perspiration. She looked at the woman with loving eyes, thankful eyes, submissive eyes. Xaviera kissed her, sat back, leaning up

against the railing which they'd covered with the bedspread, and opened her legs. Marilyn knew what to do.

On her knees she slid her oily fingers into Xaviera's lucious love nest and started sucking on her breasts at the same time. Xaviera held her breath and looked up at the sky. She knew she could come easily. She knew she was ready any time. And she knew this would be the last time with Marilyn Chambers for a long time. She wanted it to be good…

Marilyn moved her fingers with dexterity, sliding them in and out of Xaviera faster than any penis could move. She rubbed her clitoris and the outer vaginal lips. She sucked on her breasts, taking her nipples gently between her teeth, then licked her tits slowly all over. Finally, she buried her head between them as Xaviera wrapped her arms around Marilyn's shoulders. Marilyn put both hands between Xaviera's legs, spreading the lips of her cunt, moving her other hand faster and faster, her fingers rolled up, sliding her cock-like fingers inside Xaviera's wet flower that had now opened for her stem to enter all the way deep.

And Xaviera came. She jerked her head back and then looked down while it was happening, watching Marilyn's joy as she stared at her fingers inside Xaviera's cunt. She watched Marilyn move her entire body along with her hand, as if she were fucking her with her entire body, not just her fingertips. And then, finally, Marilyn collapsed between Xaviera's legs, and Xaviera curled around her. They said not a word. They lay curled up together on the pillows on the balcony for a long time and even dozed off for a while, so exhausted were they.

The sun was hot overhead, but the real heat came from their minds and bodies and souls. They had connected, they had made contact. They were friends, sure, and relatively new ones at that, but for a few hours they had been lovers. Lovers—a term which no one has yet to define completely, for it means something different in every situation. But with Marilyn and Xaviera it meant the physical and spiritual culmination of their attraction for one another, and the end to a perfect four days. Four days they would never forget, for in that short time they had shared many precious moments.

They had made love—with their hearts, with their minds, and with their beautiful bodies.

It was Sunday. The phone rang in Marilyn Chambers's suite. Chuck Traynor answered. "It's for you, Marilyn," he called to the bathroom.

Marilyn came out in jeans and a skimpy top. She'd just finished packing her cosmetics for the trip back to New York. "Who is it?" she asked.

"Xaviera."

Marilyn took the phone, thrilled. "Hi! Wow, I didn't think I'd talk to you again. Happy birthday!" She listened as Xaviera explained that her tooth—or the place where it had been—still ached, but that wasn't going to let her have a lousy day—in fact, she was sure the party was going to be an incredible success. "But everyone wants to know why Marilyn Chambers is not coming," she said. Marilyn apologized again, and told her once again what a wonderful time it had been, and how she'd never forget it.

"So they have a book," Xaviera said, "and we have something much better out of it—a memory."

"Yeah," Marilyn said, smiling. "Only everyone will share it when it's written…"

"Then we'll have to do it again, privately this time, and not write about it. Okay?"

Marilyn said that was fine with her. She wished Xaviera well, thanked her for showing her a beautiful new city, and told her she would look forward' to the next time they'd be together.

"*Ciao.*"

Marilyn whispered, "Bye," and hung up.

In the lobby, as they watched the man pile their luggage into the limousine, Marilyn and Chuck were approached by the bellhop, Bobby. He asked if Marilyn would sign a copy of her book, and when she walked over to the desk with him and started to write in his copy, he asked, "Is it true?" His eyes were wide.

"What Miss Hollander said."

"What did she say?" Marilyn asked.

Bobby blushed, but he got the words out. "When… when she left on Friday, I asked her what you had been doing… well, what had been going on on the balcony with the bedspread over it."

Marilyn smiled as she closed the pen. "And… ?"

"Miss Hollander said, T gave her a slap on her lovely ass and she took off on a dildo into the sun.'"

Marilyn gulped, ready to explode into laughter. That was Xaviera, still turning everyone on with her funny stories. So Marilyn felt she had to live up to her image, too. "Bobby, that wasn't it at all. It wasn't a dildo. It was you. We drugged you, laid you out on the balcony with your pants down, screwed you like crazy, and then put you back out into the hall before you woke up."

Bobby gasped. "Oh, come on," he said. "Don't I wish!"

"I remember it well—and you were swell!" Marilyn handed him the autographed book and said, "Take care of yourself as well as you took care of us."

"Miss Chambers?" he asked.

"Yes?"

"Did you two… did you really make it together?"

Marilyn smiled again. "Her tongue was faster than any vibrator I've ever had," she said, nearly shocking herself that the words had come out.

And they worked—he stood there, frozen, hardly breathing, stunned by her words. She figured he probably would never forget them. She sure wouldn't.

Before she got into the car she took one last look at the hotel. The balconies were all the same. But she would always remember the one draped with the bedspread.

Once in the limousine, she said to Chuck, "And I was so scared, so afraid. How ridiculous."

"You liked her, huh?"

"Liked her?" Marilyn said. "I loved her."

And then she thought to herself, / *still do.*

Xaviera stood smiling as over a hundred people toasted her on her birthday. She danced and talked and kissed the men and the girls and laughed and sang. But her mind seemed to be preoc-

cupied. Serge edged his way over to her, his camera in his hand. "How's about a picture of the birthday girl?" he asked.

"No, Serge, I don't feel like it." She sounded a little down. "Did you ever feel you had so much more to do in the time you had been given, and you just didn't get to do it all, say it all, experience it all?"

"Yes."

"That's how I feel now. Four days with Marilyn was not enough. There was still so much more to be said and shared and talked about. And there was... well, we could have taken advantage of all that precious time..."

"Here you are," Serge said, "in the midst of all your friends, having a good time, you can dance and do anything you want to do to make you happy, you could sleep with anyone you want tonight, and you're standing here telling me you're missing Marilyn?"

Xaxiera nodded. "That's it. I miss her. Yes, I do. You've got your new lover, but I miss mine."

Serge put his arm around her. "Hey, don't look so sad. Just think how rotten it would be if you didn't miss her. Think what a waste of time it would have been. Think how good it was, and cherish that."

She thought for a moment. Then she smiled.

Serge took her hand and led her back into the big house to cut her cake.

"Okay, Serge," she said, lifting up a glass of orange juice, ready to toast his champagne. "Where is your baby? Oh, over there..."

She walked over to the tall blond young man who stood outside on the porch, alone. Taking his arm, she pulled him inside toward Serge.

"Hey, you two are in love, huh?" She said, as a smile finally broke on her face.

"Here's a toast to *love* and, as they say in Hungarian, *Egge Sheggedre,* which means, good health! And now... let's cut my fabulous birthday cake and cheer up. Who knows what this year will bring?"

She kept one of the candles and sent it to Marilyn.

❤

Afterword

I'M VERY PROUD to say that my mother was Marilyn Chambers. This woman was my best friend and also an icon. She would get a kick out of this book being republished! She shared many stories with me and I'm happy the rest of the world can get a glimpse into the life of this beautiful person.

Unfortunately, she was taken from us too soon but it brings me great joy to see her legacy and legend live on, just like she would've wanted.

– McKenna Taylor

CPSIA information can be obtained
at www.ICGtesting.com
Printed in the USA
LVHW020020160222
711186LV00003B/211